IRELAND
AND THE ARTS

Jack O'Connell
Seattle
28 May 1985

A Literary Review Special Issue
Published by the Namara Press,
a member of the Namara Group.

Publisher Naim Attallah
Guest Editor Tim Pat Coogan
Layout & Production Namara Features

© Individual contributors

ISBN 0 7043 3452 6
Printed by Newgate Press Ltd, London
Photosetting by MC Typeset, Chatham, Kent

Namara Press
Namara House, Poland Street, W1

The Literary Review

Editor Gillian Greenwood
Business & Advertising Bridget Heathcoat-Amory

A year's subscription, 12 issues:
UK £10.80
Europe £12.50
Surface Mail outside Europe £11.40
Airmail outside Europe £19.00

Overseas customers are requested to make
payment either by International Money Order, or
through a British branch of their bank.

27/29 Goodge Street, London W1P 1FD
Tel 01-636 3992 Telex 919034

IRELAND
AND THE ARTS

Edited by Tim Pat Coogan

A Special Issue of
Literary Review

Contents

General Introduction

Tim Pat Coogan

Almost every day of my life I am reminded of the great paradox of the Irish psychology, the intertwining and warring impulse that has given us the great heretics and the great priests, both constantly swallowed by the timelessness of Ireland, both still shaping the times.

When I go for a swim on the east coast of Ireland at Sandycove, Co. Dublin, I pass James Joyce's tower. When writing off the west coast, on the Aran Islands, a glance through the window and my eye inevitably falls on Teampall Benan standing stark on a limestone crag above the house. The church, the smallest in Western Europe and probably the most durable, was built under the influence of St Enda around the end of the fifth century, after he had been ordained by St Patrick. Though he only got beyond Galway Bay Enda was probably the first monastic voyager to set out from the mainland of Ireland – predating Joyce – into foreignness, but using the traditional triad of the Irish emigrant – cunning, exile, and a clamorous silence to gain his ends. The achievement of both men's antipathetic vision leaves its mark yet on Western culture, particularly, needless to say, on the Irish psyche.

Well, what are the times for an artist in the sad, indeterminate, depressed, somewhat blurred-of-vision Ireland of today? What are the priests and heretics turning out between them?

One obvious answer is that while the missionary, or Enda tradition still sends forth its emissaries all over the world, those of the Joycean stream may still be heretical, but no *non serviam* declaration is required. Irish publishing is flourishing – as much as any industry 'flourishes' during recession – and by an enactment that looks a remarkably enlightened piece of legislation against the background of pathological antipathy displayed towards the creative spirit in Ireland less than twenty years ago, writers and artists are encouraged to live in Ireland through being declared tax-exempt.

As usual, an infrequently acknowledged factor in Irish affairs still

plays a major role – climate. There are mind-moulding forces at work in those grey swirling mists, coming in from the south-western Atlantic, where Europe gets most of her weather and Ireland much of her agriculture and hence her literally insular characteristics, amongst which another paradox is visible – we are a maritime race which largely ignores the sea and lives off the land, with all the economic and character-forming consequences of this.

Heredity too plays a part of course. Outcroppings of the past sometimes snag one's awareness in shocking, unexpected ways. The records of St Mary's Blind Asylum at Merrion, beside Joyce's Strand in the South Dublin suburbs, for instance, show the huge percentage of the inmates who even up to our times come from only two of Ireland's thirty-two counties, Mayo and Roscommon. In famine times they were two of the poorest and most turbulent areas in Ireland. Heavily garrisoned as a result, VD was particularly rampant in these counties. Intertwining with the effects of famine, glaucoma reached epidemic proportions, and even today as the traffic jams of modern Ireland inch past its walls the effects can still be studied over a hundred years later in St Mary's. Behind what walls of the subconscious are similar race memories stirring one wonders, under the level of today's visible happenings in Northern Ireland?

What the light of contemporary artistic investigation shows in Ireland today is that the great simplicities of the turn-of-the-century Gaelic renaissance, to which the turbulence and terror of the famine period formed such an immediate backdrop, are gone. Gone too are the equally great simplicities of the succeeding disdain for the native regime, its censorship, its clericalism, for the cultural suffocation of the isolation induced by Ireland's neutrality during the Second World War period and the stultification and economic stagnation of the fifties.

Gone too, alas, is the bright hopeful tone of the sixties when a combination of a new generation growing up and out of the shadow of the 1916 revolution's ageing decision-takers, improvements in education, the coming of television and the paperback revolution seemed to be the harbinger of new departures in the economy, North–South relationships and, in the wake of Pope John and Vatican II, a liberalization from the great exaltations and great depressions of Enda's tradition also.

I remember with that accursed facility of phrase that affects the Irish – leading them so often to describe all and analyse nothing –

christening the new, vigorous, innovative, albeit crass decision-takers who stepped on to the political stage then as 'the Men in the Mohair Suits'.

Generally speaking the mohair suits did not or could not fulfil their sartorial promise. Vietnam, joining the EEC, the oil shock, the bloody uproar in the North fell dully on tele-mass-conditioned minds and the hopeful dawn clouded over into apathy and anxiety – at least politically.

But the Old Artificer's tradition did not wither under the bland-ness, the boredom, the inflation. The tradition of Joyce still hung in the air over his tower and his town. Although they may not always keep their promises the Irish are still men of their words.

True, the North's troubles did not yield any memorable writing of the first rank – though young Bernard MacLaverty with his novel *Cal* may be a breakthrough and some of the poetry such as that of the two Seamuses, Deane and Heaney or of John Montague, owed its origins to the troubles, but no Behan or O'Casey emerged from Long Kesh. The spell of anguish from 1969 to the time of writing must be the longest revolutionary period in Irish history to pass without throw-ing up a major writer from the Irish revolutionary tradition.

Somehow the Irish situation seemed to require an extra dimension of justification, in either international or national recognition. Writers tended to be wary of 'the troubles'. Watchful of their lecture tours, their publishing contacts, fearful of becoming enmeshed not alone in politics and polemics, but unfashionable politics and polemics at that. The neglect was partly just sheer incomprehension. Southern writers were incapable of visualizing the hates and intensities of Belfast which they had not experienced. Northern ones knew them only too well and came South, or emigrated to forget.

There is enormous life and vibrancy in the arts, publishing, in painting, in music. Irish actors go abroad and are acclaimed to a degree that has almost become a cliché. What creates the apparent sense of blandness is the lack of a stated central theme. Ireland is two societies, North and South, and the preoccupations of the two are dissimilar. Southern Ireland, though it encourages the artist, also grapples with the problems of youth, unemployment, governments that yield to pressure-groups and are buffeted off course in attempting to solve the problems of the economy.

Northern Ireland encourages nobody as it fights to the death, as old traditions and old enmities work out their bloody complex

inexorabilities amidst confusion and ambivalence. Which is the terrorist? The one in the uniform, or the one with the anorak? It depends on how you answer the question 'Whose law and whose order?' Whether you are a 'them' or an 'us'?

Are you of the Protestant and British tradition trying to maintain what is left of your privilege, your Anglo-Protestant heritage and your British links? Or are you one of history's dispossessed? One of the Catholic and Gaelic tradition of whom Seamus Deane wrote:

> The unemployment in our bones
> Erupting on our hands in stones.

For unemployment spreads through Northern Irish society like poison yeast, but mingling with sectarianism the red it generates on the ledger of affairs is not the red ink of bankruptcy, but the heart's blood shed as the dispossessed learn the deadly art of trading up from stones to bombs and bullets.

The very success of the earlier nationalist revolution has helped to perpetuate the political vacuum in which crime and violence flourish. The Nationalists withdrew from the House of Commons, leaving only a tiny rump of Irish parliamentary representation, all Unionist, to make its case. Plugged in as the Unionists are to those currents of old blood and old money that link the Unionist cause to the British Establishment, their small representation is the effective, dominant one. The larger Irish case has no constituency and is misheard and drowned out in the screams that follow the bombings and the shootings. No political structures exist to bridge the gap between the very evident friendliness towards Ireland that exists amongst the average Englishman or woman, and hardline, traditional official attitudes.

How then do the artists make sense of the dichotomies and discordancies? One discovers with surprise as one examines the scene that they do it very much in the way that Joyce and Enda went their separate and intertwining ways. They quest, they respond, they try to make new departures, to make sense of their befuddled environment, and by their differing paths they tend to find themselves coming back to a common wellspring, a differently expressed, but shared consciousness of being Irish.

For some writers in Ireland today, perhaps the majority, given the scale of the Northern tragedy and the size of the tide of human misery that swells through gaol, ghetto and graveyard, a charge of evasion

could be levelled as they turn to the past, to translations for inspiration rather than attempt to confront the present.

The sense of race and place that runs through Irish artistic expression today is displayed by many things. Attitudes towards the North, the difficulties of identity and communication. The fact that the language used is another tongue, yet their native language is to many as foreign both psychologically and in practice, as the language of another country. Their language is to some a difficulty, a hindrance to communication.

For some the sense of identity is a cross to be borne and struggled with, as with Brian Friel in the extracts printed in this journal from his diary, kept appropriately enough as he wrote the highly significant play *Translations*. To others the rhythms of the past are a natural form of expression to be brought forward, even in a stridently anti-traditional milieu such as the international rock scene, the Irish contributions to which are described herein. To others it is a question of relating old names, old places, traditional thought-forms to contemporary challenges, as does contributor John Banville striving with the implications of the place name Mucker!

In editing this supplement I found the references to the Irish tongue, if not to the writing in Irish, remarkable – for Irish is commonly held to be a dying tongue, spoken daily as an original means of communication by possibly as few as 30,000 people, and with less than two per cent of parliamentary and civil-service business transacted in that tongue. The position of the artist writing in Irish was poignantly put to me by the Irish-language poet who said 'we can read them [English writers, poets] but they can't read us'.

He might have gone on to speculate as to how many of today's generation of readers, be they artist or artisan, would in an era of unemployment when a dun, grey practicality is the ordained colour of the times, have the inclination or the opportunity to make the effort to learn to read. Yet as one peels away the layers, it is clearly some sense of identity to which Irish writers are addressing themselves

It is then a consciousness of being Irish rather than the consequences of it that seems to preoccupy many Southern writers, song writers and composers. Very often of course some fear the Yeatsian contamination of being involved in the sounds emanating from the 'foul mouth', polemics and propaganda. A very old dilemma for the Irish writer, struggling with his creative urge, his sense of nationality

and the fact that so much of Irish nationalism has been struck before his time, often with great cruelty, on a medallion of history whose obverse side inhibitingly reads 'Anti-British'. It was his knowledge of all sides of the dilemma that led to Seamus Deane's contributing to this supplement such a fine piece of writing on the Irish problem of the artist and conflict, still as sharp as ever.

There is then a discernible 'roots' syndrome, a tangible move backwards. Readers of this *Literary Review* supplement will, I am sure, be struck as forcibly as I was at how often – without I hasten to add, any suggestion from me as Editor – contributors, when asked to contribute 'something', struck shared grace notes of race and place in their unconnected ways.

'Aha!' do I hear someone say, 'but you know your men, you know who to ask.' Perhaps. There may have been some subconscious bias. I was overtly conscious only of the pursuit of excellence – and the fact that in Ireland one is by definition far better off offending a bank manager than a poet! One may merely put paid to your reputation – the other can see to it that it lives far too long! Of course, one is as vulnerable to attack over those one leaves out as over those one puts in. It's a subjective, idiosyncratic process. And in any event I've long since come to the conclusion that Ireland, like Texas, is a state of mind.

Even when they were not being consciously 'Irish' writers automatically proffered work on themes that would be immediately recognizable as Irish: John McGahern on the gauche, repressed sexuality of an Irish provincial town; Bernard MacLaverty on a religious dilemma. Old moulds may be repainted, as in crafts, publishing or in theatre, but they are not yet broken.

Despite a prevailing angst, and a feeling of depression, the sheer psychic energy of the Irish has not diminished. On the contrary in painting, in music, in publishing, in writing, even in the much-troubled Irish language itself, the level of output is far higher than it was even in the early sixties. To see what influences this output, what forms it is taking, I can make no better recommendation than that the reader – read on!

gŭin′ea, *n*., (gĭn′ĭ), (Guinea, Africa, supposed origin of gold for coin manufacture) 1. British gold coin issued 1663 to 1813 and from 1717 valued at 21 shillings 2. (colloq.) a unit of value equal to one pound and one shilling.

Guin′nĕss Ma′hŏn Invĕst′ment Mān′agĕment, *n*. (Gĭn′ĭss Mȃrn) A profitable home for the earnings of literary figures.

gŭmp′tion, *n*. (colloq.) Enterprise, resourceful spirit, shrewdness, ready practical sense. – adj. gump′tious. (O.N. gaumr, heed?)

T.W.N. Guinness, Director,
Guinness Mahon & Co. Limited,
32, St. Mary-at-Hill,
London EC3P 3AJ
01-623 9333

The Golden Ages of Ireland

Peter Harbison

Dr Peter Harbinson is a noted archaeologist and traveller who has written a number of books including the definitive Guide to the National Monuments of Ireland. *He contributes regularly to several international publications.*

Like any other country, Ireland has experienced its cultural valleys and peaks since man first settled there around 7000 B.C. There have been centuries at a time – particularly during the prehistoric period – when little seems to have been stirring, but these are the doldrums which act as the foil to bring up the crests in even higher relief. It is often difficult to identify the constellations which lead to the rise of any particular civilization or culture, but looking back at the archaeology and art of early Ireland, one gets the impression that the high points often correspond to the periods when Ireland was in contact with advanced cultures in other parts of Europe. For although Ireland might resemble a small and furry terrier begging for attention in the north-western corner of a map of Europe, as it turns its back on England and the Continent, the reality is that Ireland in the remoter past kept in close contact with what was going on in the neighbouring land masses by use of the sea, which traditionally connects more than it divides. When the Vikings came down from Scandinavia to found the city of Dublin in 841 A.D. and moved southwards from there to harass the coasts of France, they were using the same seaways which had linked Ireland with areas along the Atlantic littoral back into the mists of prehistoric time.

It was these sea-borne movements which led to one of the first high points in the cultural story of Ireland – the imposing megalithic tombs of the Stone Age. Most famous of these is Newgrange, which has achieved an international reputation in recent years since the discovery that the rising sun penetrates along a sixty-two-foot

passage into the very centre of the burial chamber for a mere seventeen minutes as it rises above the horizon on the shortest day of the year. The famous pharaonic temple of Abu Simbel is said to have been designed to facilitate a similar phenomenon at a different time of year, and even though the same cannot be said for the pyramids, they share with Newgrange the feature of a passage leading to the burial chamber near the centre of a vast man-made mound. But if we compare the historical dates for their erection with the radiocarbon dates which Newgrange has produced, we find that Newgrange was built centuries before the pyramids were even a twinkle in the pharaoh's eye, and a thous)nd years before the completion of its more refined cousin – the Treasury of Atreus in Mycenae.

Professor M. J. O'Kelly's recent book on Newgrange has demonstrated the sophistication of the techniques used in the building of Newgrange which, as an achievement of Stone Age man, has been compared, not without justification, to the erection of a cathedral in the Middle Ages or the sending of a rocket to the moon in our own day. The carvings at Newgrange, too, reflect a sense of design and a quality of execution which has few equals anywhere in Europe in the prehistoric period.

Although the Stone Age was followed by what archaeologists call the Bronze Age, it might in Ireland's case have been better described as the Golden Age or, rather, the first of the Golden Ages. For Ireland in the last two thousand years before the birth of Christ distinguished itself by producing a truly dazzling assortment of gold jewellery, sometimes simple in shape but with attractive geometrical ornament, and always executed to a high standard of craftsmanship.

In the second millennium B.C., the gold was in thin sheets, but by 700 B.C., the ornaments were often made of massive gold, attesting surely to the availability of a very considerable amount of raw gold at the time, though sadly leaving none for us to pan today! Indeed, Ireland would seem to have had such a surplus of gold at the time, that it was in the position to export either the raw material or the finished product. Much of the gold, however, stayed in the country, and most of what has not been melted down over the years now forms one of the star attractions of the National Museum of Ireland in Dublin which, it is said, houses one of the three best collections of prehistoric gold in Europe, along with the National Museums in Athens and Budapest.

Ireland has the reputation of being a Celtic country. When the first

Celts – or speakers of the language which is the ancestor of the Gaelic still spoken there today – arrived in the country is a matter much disputed among archaeologists and linguists. But we can be sure that the Celts were firmly entrenched in Ireland during the Iron Age, which started around 500 B.C., so much so that the country was entirely Celtic in its language, laws and institutions by the time St. Patrick brought Christianity to it in the fifth century A.D. The most imposing remnants of Celtic activity in Ireland in the centuries preceding St Patrick other than objects beautifully decorated in the curvolinear Celtic style, are the great stone forts. Of these Dún Aengus, perched on the edge of a precipice falling hundreds of feet to the Atlantic below on the western Aran island of Inishmore, has been rightly described as one of the most magnificent and barbaric monuments of western Europe.

The Romans may have come to Newgrange as visitors or worshippers, as some of their objects have come to light around the great mound, but they never came to Ireland as conquerors. Did they consider it scarcely worth their while, or was it that they believed that the Irish were impossible to subdue? Nevertheless, the Irish benefited from the Roman presence in the neighbouring island to the east, not only because it was from there that they took captive Patrick, who was subsequently to become their national apostle, but also because it was probably from Britain that the Irish derived the Christianity and the art of writing which was to lead to the country's second Golden Age, the Early Christian period from the fifth to the twelfth century A.D.

The monasteries which sprang up throughout Ireland a generation after Patrick's death were to foster a brilliant art, and it was from these small mustard seeds that grew the movement which sent Irish missionaries to Britain, as well as to the continent which had recently been so badly savaged by the barbarian invasions of the fifth century.

Cardinal Newman once neatly described these Irish monasteries as 'the storehouse of the past and the birthplace of the future', for they were not only responsible for preserving valuable remnants of Latin culture and older Irish pagan myths and sagas, but through their manuscripts they contributed to the culture of the court of Charlemagne, and thereby to the beginnings of European culture as we know it today.

The cultural impulses went both ways, however. Developments in the Carolingian empire found their echo in the religious carvings

16

found on the great stone High Crosses of Ireland which began to become common within the walls of Irish monasteries in the ninth century; and possibly also in the nearby Round Towers which form such conspicuous landmarks in the Irish countryside today. But before these monuments came to be erected, Ireland had been decorating sumptuous manuscripts and producing its gold and silver metalwork which embody the highest excellence of craftsmanship ever attained in Ireland represent an achievement with which the rest of Europe had nothing to compare at the transition from the Merovingian to the Carolingian epochs. Two of the best known of the manuscripts are the Book of Durrow and the Book of Kells. It is uncertain whether they were illuminated in Ireland or northern Britain, but it was certainly in an Irish cultural milieu on either side of the Irish Sea that they were created. Their correspondent in metalwork is the Ardagh Chalice, to which some art historians denied an Irish origin until a second and similar example came to light three years ago at Derrynaflan, Co. Tipperary. But such metalwork brilliance was not confined to objects of religious use. We find it also on secular ornaments such as the Tara brooch which demonstrates the mastery of the old Irish gold- and silversmiths of the eighth and ninth century in fusing a variety of different decorative elements together into a single and almost miraculous whole on an unbelievably miniature scale. Some of these smaller portable objects have been found accidentally within the last few centuries, while others remained in the hands of hereditary keepers until placed in museums a little over a hundred years ago. Many of them are now delighting continental art enthusiasts as the exhibition of Irish treasures move around on its successful circuit from France to Germany, and thence to Holland and Denmark.

It took Irish art some time to recover from the ninth and tenth century Viking raids, which severely disturbed life in the creative surroundings of a monastic workshop. However, it soon began to follow Europe in developing Romanesque art with the re-creation of older glory in the form of stone High Crosses and beautiful metal-work, such as the Cross of Cong of c. 1123, but with a particular kind of animal ornament which makes Irish Romanesque artistry so different from that anywhere else in Europe. While Irish Romanesque artistry was still at its peak, the new continental monastic orders – and particularly the Cistercians – came to Ireland and, by introducing Ireland to international Gothic, sounded the

first death knell of the older Irish monasteries and the independent world of artistic fantasy which they stood for. But it was the Normans who, arriving in 1169, gradually drained Irish art of its insular originality, and made it a mere provincial and sometimes retardatory reflection of recent developments in France and England. Shortly after 1200, Ireland's most significant contribution to the arts of Europe had already been made.

Although these achievements are now many centuries past, they have not been forgotten by the Irish. The recent definitive series of postage stamps showed motifs from Irish metalwork, while new series feature some of the finest Irish buildings, including the Oratory at Gallarus in the shape of an upturned boat and the twelfth-century Cormac's chapel on the Rock of Cashel. But commemoration of the Irish past has also begun to penetrate even the commercial world. Medhbh, the mythical goddess, adorns the Irish £1 note, while the £5 note is devoted to the ninth century Irish philosopher Johannes Scotus Eriugena, who raised Ireland's intellectual stock in Europe so high that he has been considered perhaps the greatest medieval philosopher preceding Aquinas. The nation's stamps and legal tender remind everyone, both native and visitor, that Ireland is indeed an old and cultured nation which can hold its head high in the cultural achievements of Europe's past.

Art

Máire de Paor

Máire de Paor, writer and broadcaster, is an archaeologist and historian by profession.

When we look at Ireland's heritage from the point of view of material culture, two periods in a long history are outstanding. These are, first of all, the Bronze Age, between 2000 and 500 B.C., when Irish metalworkers in bronze and gold produced works of superb craftsmanship and elegant design, and, secondly, the period between about A.D. 600 and A.D. 1200, when the virtuosity and skills of jewellers, miniaturists and sculptors were at the service of the early Irish Church. Both of these periods have been termed 'Golden Ages', the first because of the wealth of gold ornaments known from Ireland at the time; the second in the wider sense of a time of flowering and excellence in all the arts.

But the long history of Irish art and craft goes further back than the Bronze Age. The beginnings of Irish sculpture, stylized and abstract, can be seen on the great carved stones of kerb and passage in the megalithic tombs built in the Neolithic perod – before 3000 B.C. – by Ireland's first farmers. The most spectacular examples of these burial places, the largest and most impressive in Europe, are in the Boyne valley, and the carvings on the tombs are complemented by miniature pendants, bone pins and pottery, which accompanied the burials. A recent find is an elegantly fashioned stone macehead with spiral ornament from the passage-grave at Knowth.

With the coming of metal the Irish artist seems to have found his most attractive medium, and most of what still survives is fairly small-scale work for utility and ornament. Abstract designs similar to those of the Neolithic sculptors – chevrons, triangles, zig-zags – are found on the earliest bronze objects – axes and daggers – as well as on ornaments of sheet gold. The most characteristic of these is the

lunula, so-called from its crescent shape. Gold was plentiful at the time, and throughout this period personal ornaments of great elegance and simplicity were fashioned. Neck-rings and bracelets of twisted gold (known as torques), earrings, hair ornaments, dress-fasteners of cuff-link type and massive collars are amongst the types which survive. The Bronze-Age craftsmen also made weapons and tools of elegant design, and huge cauldrons and buckets of sheet bronze fastened by rivets. Trade flourished, and Irish gold and bronze were exported in exchange for amber, tin and jet.

We are not certain exactly when Celtic-speaking people, related to those who overran Europe before the Roman conquests, first arrived in Ireland. But from about the third century B.C. their distinctive art style – known as La Tène – can be recognized. The Celts lavished ornament on their weapons, horse-trappings and personal effects, and many examples of fine metalwork in bronze and gold survive. The art is always abstract and highly stylized. This was to remain true of Irish art throughout its history. Curvilinear forms, stylised animal patterns and insets of red enamel characterize this work, and the brilliant insular style can be seen on sword-scabbards, horse-bits and jewellery. The gold collar from Broighter, Co. Derry, and engraved scabbards from Co. Antrim are particularly striking examples. More monumental remains include the remarkable Janus-headed stone idol from Boa Island, Co. Fermanagh, which has close continental affinities, and the phallic pillar from Turoe, Co. Galway, carved with foliate curvilinear designs similar to those on metal.

Ireland was never conquered by Rome, so Irish art and craftsmanship developed independently, although there were borrowings and connections. Techniques of enamelling and the shapes of pins and brooches were the most significant of these. The Christian religion, introduced from Roman Britain in the fifth century, had, however, the most profound and lasting effect on Irish life, art and craft. Because of the Celtic social structure – rural and familial – which existed in Ireland, monasticism flourished rather than the urban-based Roman-style diocesan system. Soon the Irish Church was dominated by a widespread network of monasteries, which for centuries were the most important patrons of art.

Christianity brought with it the Latin language and a knowledge of writing, as well as a repertoire of Christian symbols such as the Chi-Rho, or Monogram of Christ, and the fashion of engraved slabs or pillar-stones to commemorate the dead.

The earliest manuscript artists borrowed patterns and motifs from metalworkers working in a native tradition and combined them with imported motifs. Throughout the sixth, seventh and eighth centuries we see the development in the monastic scriptoria of a remarkable manuscript style, ranging from the simply decorated initials of the *Cathach* of Columcille – the earliest Irish manuscript – through the increasing elaboration of the Book of Durrow, with its decorative carpet-pages and evangelical symbols, and culminating in the extraordinary brilliance and virtuosity of the Book of Kells. The fully developed style of the eighth century in metalwork, manuscript and stone owes much also to influence from Anglo-Saxon and Mediterranean art. Monks, fired with missionary zeal or the spirit of self-sacrifice, travelled to neighbouring lands, and the contacts thus established all helped in the rich flowering of early Christian art.

The accomplishments of the metalworkers can be studied on a series of brooches as well as on altar-plate – chalices and caskets – and reliquaries for bells, books and croziers, many of them peculiarly Irish in form. Ring-pins and brooches were the common dress-fastening (the style of dress was tunic-and-cloak, a Mediterranean fashion) and the decoration of these brooches increased in elaboration until, about A.D. 700, the minute perfection of the Tara brooch was achieved. This is of silver, richly decorated with gold filigree, animal ornament, cast gilt spirals, enamel, glass and amber studs, reliefs of animal and human heads – all in the compass of a few centimetres. The chalice from Ardagh, Co. Limerick, while broadly in the same style and of the same date, is even more accomplished. The plain silver bowl sets off the rich decoration of filigree, multi-coloured enamels, glittering castings and engravings. A hoard of church plate, comprising chalice, paten and strainer, found in 1980 at Derrynavlan, Co. Tipperary, has some craftsmanship equal in quality to the work on the Ardagh chalice. Much of our knowledge of the metalwork of this period comes from Viking graves in Scandinavia, where Irish shrines or parts of shrines, carried off as loot, have been found.

Even more uniquely Irish is the remarkable series of carved stone crosses which can still be found on monastic sites throughout the country. The art of the sculptor developed from simple Christian symbols carved on crude pillar-stones to the intricately carved crosses of the eighth century, whose abstract patterns of frets, spirals and interlace are identical with those of the manuscripts and metal

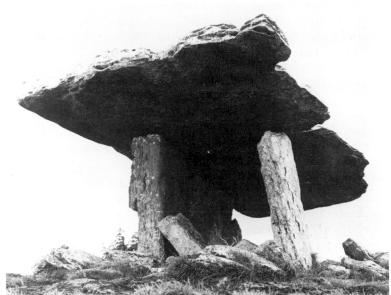

Poulnabrone Dolmen, Co. Clare. A prehistoric tomb which could almost be a piece of modern sculpture (?2000 B.C.). *Bord Fáilte/Irish Tourist Board*

Newgrange, Co. Meath. The carved stone at the entrance (c.3200 B.C.). *Bord Fáilte/Irish Tourist Board*

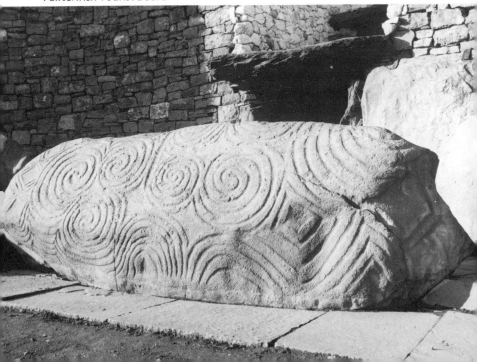

shrines. Later, in the ninth and tenth centuries, when the Viking wars brought change, and perhaps some deterioration, to metalwork and illumination, stone sculpture continued to flourish. Now, however, perhaps due to contact with Carolingian art, the crosses carry figured scenes from the life of Christ and from the Old Testament, side by side with abstract patterns. The elaborate iconography of the great stone crosses of the Midland monasteries, such as Kells, Durrow, Clonmacnoise and Monasterboice, with their extensive repertoire of scriptural subjects, is unique at this period in Europe.

The cross of Muiredach at Monasterboice, Co. Louth, is the best preserved of the series. Carved in sandstone, it stands about eighteen feet high and is dated by an inscription to the early tenth century. There is figure sculpture on both main faces, east and west, and abstract ornament on the narrower sides of the shaft. A Crucifixion scene, with angels and lance- and sponge-bearers, occupies the central position on the east face. Underneath are scenes from the life of Christ. The west face carries an elaborate Judgment scene, showing Christ in majesty with the just being led to paradise on his right and the damned prodded to hell on his left. Below are Old Testament scenes. The interest in biblical scenes may have had a liturgical inspiration to some extent, since a prayer for the dying, known in Ireland at this time, the *Ordo Commendationis Animae*, provides a literary parallel for the scriptural crosses. Later, in the twelfth century, the crosses became more truly crucifixes, carrying the figure of Christ in high relief, as well as animal ornament of Scandinavian inspiration.

After an initial period of pirate raids in the ninth century, Viking traders began to establish trading-posts around the coasts of Ireland. The settlement which developed in Dublin and elsewhere brought new ideas and influence into Irish art. Trial-pieces of bone and stone – the 'sketchbooks' of the artists – from the excavations of Viking Dublin indicate the presence of workshops, and the patterns on these trial-pieces can be paralleled on croziers and shrines of the tenth and eleventh centuries. Scandinavian animal styles were combined with existing patterns to produce a last flowering in metalwork and sculpture in the twelfth century. The most important products came from the west, and the finest example in metal is the large processional cross, known as the cross of Cong, made to the order of the king of Connacht Toirdelbach O Connor to enshrine a relic of the true cross, about A.D. 1123. The cross is made of sheets of bronze

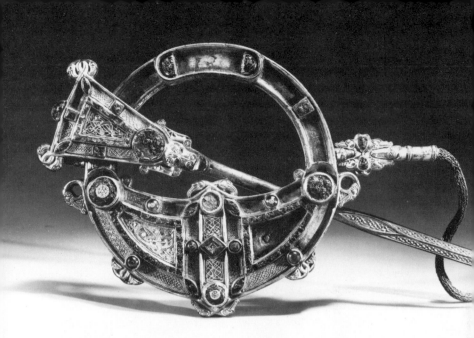

The Tara Brooch, a masterly achievement of Irish metalworker's craft of the eighth century. *National Museum of Ireland*

The Ardagh Chalice, National Museum, Dublin. It shows the brilliance of Early Christian Irish metalwork in the eighth century. *Bord Fáilte/Irish Tourist Board*

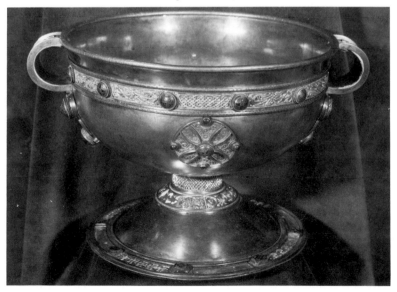

riveted together. Both front and back have decoration of openwork animal interlace – large quadrupeds enmeshed in figure-of-eight serpents. There are also enamel studs and plaques of silver and niello. But changes in the politics of Church and State were bringing an end to the world which had produced this uniquely Irish art. A reform movement in the Irish Church led to the coming of the Cistercians in 1142, and soon the Irish monasteries were superseded by the continental orders. The Anglo-Norman invasion in 1169 brought profound cultural and political change, and Irish art was brought into the mainstream of European culture.

Religion in Ireland

T.P. O'Mahoney

*Before one addresses oneself to any facet of
contemporary Irish culture and its artifacts one
should be aware of the all-pervasive backdrop
of religion, indicated here by T.P. O'Mahoney.*
*Apart from being Religious Correspondent of
the* Irish Press, *T.P. O'Mahoney is the author of a
number of successful novels.*

Writing on the Church in Ireland in 1956, the French jurist Jean
Blanchard observed that the Catholic Bishops appeared to have more
power in practice than those of any other country in the world.

'As a natural outcome of a long historical tradition which has
created exceptionally strong bonds between the nation and its clergy,
their authority is great over the faithful.'

Blanchard was writing, of course, just five years after the famous
controversy over the 'mother and child' health scheme, which was
opposed by the Bishops on the grounds that it meant too great an
intrusion by the State into the rights of the individual. In a letter of
10th October 1950 the Bishops' objections to the scheme were conveyed
to the Taoiseach, Mr John A. Costello. The powers to be given to the
State under the scheme would be, in their view, 'in direct opposition
to the rights of the family and of the individual and are liable to very
great abuse . . . If adopted in law they would constitute a ready-
made instrument for future totalitarian aggression . . .'

The Bishops were also concerned about the proposal in the scheme
that local medical officers should give sex education to Catholic girls
and women, a proposal which might well lead to 'provision for birth
limitation and abortion'. The subsequent controversy dragged on
until May 1951 and effectively brought down the first Coalition
Government (1948–51), and the whole affair has become a *cause
célèbre* in the context of Church–State relations in the Irish Republic.

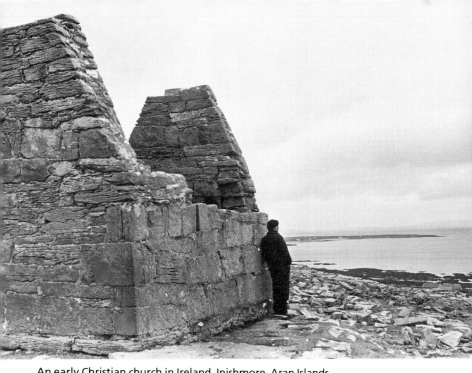

An early Christian church in Ireland, Inishmore, Aran Islands
Gary Grant

Gallarus Oratory, Co. Kerry, erected some time between 800 and 1200. *Bord Fáilte/Irish Tourist Board*

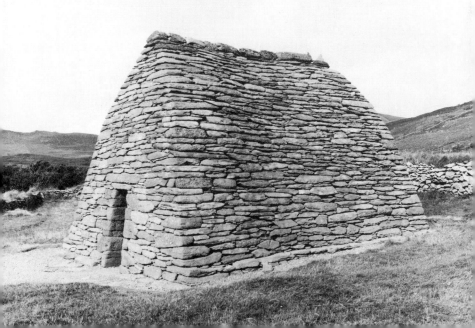

In a notable editorial the *Irish Times* commented: 'This is a sad day for Ireland . . . The most serious revelation is that the Roman Catholic Church would seem to be the effective government of this country . . .'

Today it is possible to argue that a very different situation exists. On 21 December 1982, for instance, when the Cabinet papers for the 1948–51 period became available for inspection under a thirty-year accessibility rule, the *Irish Press*, in an editorial entitled 'Could It Happen Now?' referred to the 'mother and child' controversy, and argued that it was unlikely.

'Both the political and religious establishments have learned wisdom from the traumatic events which brought about the fall of the first Inter-Party Government . . .'

Yet the same editorial also found it necessary to warn that 'the forces of reaction in this country are probably a lot stronger than people suspect'. The validity of this observation is borne out by the circumstances in which a campaign was initiated in Dublin, in April 1981 to add an anti-abortion amendment to the 1937 Constitution.

The Catholic Bishops' role in this campaign has been remarkably discreet and restrained, but even a cursory acquaintance with the exercise of power in Ireland in the 1980s would be sufficient to convince one that that role could change very quickly if circumstances demanded it.

This is not to say that significant alterations in the climate of Church–State relations have not occurred during the interim. Quite apart from the effects of fourteen years of violence and social upheaval in Northern Ireland, the past twenty-five years or so have seen a transformation wrought by such developments as the advent of television, increased international travel, the easing of censorship, EEC membership, Vatican II, and the impact of the feminist movement all cumulatively leading to the breakdown of cultural insularity and intellectual repressiveness.

The implications of this transformation are perhaps not yet fully appreciated, particularly within the Irish Churches. (In the Republic the Catholic Church has 93.9% of the population as members; the Church of Ireland has 3.3%; the Presbyterians 0.5%; the Methodists 0.2%: in Northern Ireland the Catholic Church has 31.44%; the Church of Ireland has 22%; the Presbyterians 26.7% and the Methodists 4.7%.) It is probably otiose therefore to point out that the bulk of artistic expression emanating from the Republic of

Ireland is by, with, or from a powerful Roman Catholic heritage, but the point should always be borne in mind when contemplating the Irish cultural scene.

Among some sectors of the population, in both parts of Ireland, there is evidence of a growing disenchantment with institutionalized religion, a trend which is related to the belief that the Churches have been negative influences in many areas of Irish life, and also to what is perceived as the 'scandal' of division among Christians which has had bloody consequences in the North. The general view among young people in the Republic seems to be that the great influence of the Catholic Church has too often been used in a reactionary way, though some sections are mindful of the potential for reform which lies within the Church.

To appreciate the extent of the influence of the Church, one has to take account of the fact that throughout the nineteenth century (remembering that there had been no domestic parliament in Dublin since the Act of Union of 1800) the Catholic Hierarchy came to represent for many people a kind of 'substitute' native government. Members of the clergy were the buffers between the people and an

Rock of Cashel, Co. Tipperary, with the twelfth century chapel in the centre, and the thirteenth century cathedral looming behind it. *Bord Fáilte/Irish Tourist Board*

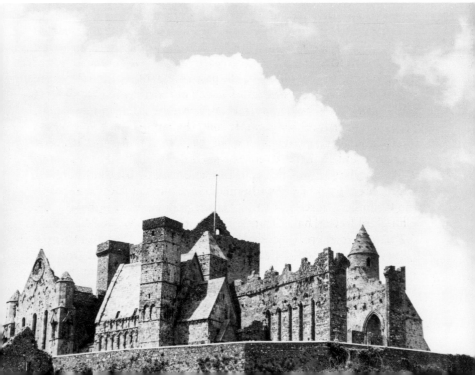

oppressive authority, a combination of Dublin's central administration, local landlords and the police and army. In Northern Ireland where there is no functioning domestic parliament, many Catholics in the ghettos automatically cast sympathetic, individual clergy in the same role.

Even Parnell's Irish Home Rule movement depended greatly on the Church in furthering its popular appeal. The O'Shea divorce case over, Parnell's fall was certain after the Church's withdrawal of support.

Even when constitutional methods gave way to physical force in the early part of the twentieth century, the Bishops as a body worked to safeguard the 'special position' of the Catholic Church, though this process was a painful one. Indeed, it is very much a matter of speculation as to what might have happened if the anti-Treaty forces had won the Civil War of 1922–23.

As things turned out, the power, status and influence of the Catholic Church were safe from threat within the Irish Free State. After all, the revolutionaries themselves had been formed in the womb of Mother Church. And even when in 1937 Eamon de Valera, having come to power as leader of Fianna Fail for the first time in the 1933 General Election, introduced a new Constitution, the power, status and influence of the Church were, if anything, enhanced. So much so, in fact, that today when there is some talk of the need for constitutional reform, it is not uncommon to hear the 1937 document attacked as 'sectarian', and as proof that the Republic is a theocratic or confessional State.

All of this is not without relevance to Northern Ireland, where Catholics and Protestants have been embroiled in bloody conflict since 1969. Much has been made of the 'religious dimension' of this conflict, but that there is such a dimension, no informed person denies. As recently as January of this year (1983), the Catholic Bishop of Derry, Most Rev. Edward Daly, stated in the course of a Radio Telefis Eireann interview that 'the Northern Ireland State was set up on the basis of a sectarian headcount'. Religion was not the sole cause of the conflict there, he added, 'but there is a religious dimension to it – anyone who denies that simply isn't facing the facts . . .'

One might have thought that the quest for Christian unity – powerfully accelerated by Vatican II (1962–65) – would therefore have a special urgency in Ireland. Yet it is one of the paradoxes of the Irish situation that the ecumenical movement is distinguished only

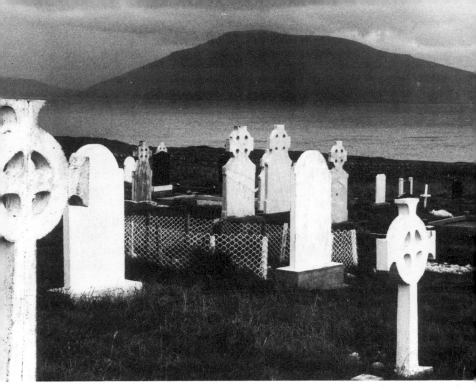

Glave Yard, The Street, Co. Mayo. *Mark Fiennes*

by the tardiness of the support it enjoys.

Any survey of the scene will reveal lukewarm support and even a hardening of attitudes on some fronts, mainly because of what the Protestant Churches regard as the inflexible and unjust policy of the Catholic Church on mixed marriages. Even where there is evidence of ecumenical activity the widening gap between what might be termed 'clerical ecumenism' and 'lay ecumenism' is problematical. 'New links' in Ireland invariably seem to mean clerical links. Yet it is a curious aspect of the Irish situation that while the Churches as institutions are open to criticism, some of the most advanced and enlightened thinking in the socio-moral area and in the sphere of religious and civil liberties comes from its individual clerics.

There is also a long and vibrant missionary tradition of which Irish Christianity can justly be proud. One can at last detect signs of the radicalizing influence on Irish clerics of pastoral experience in the grim socio-political conditions of places like El Salvador and the Philippines where the newly minted 'theology of liberation' has produced a fresh concept of Christian witness.

On the domestic front one is conscious of a burgeoning awareness that to survive as believers young people will need to opt more consciously for faith in the face of new opposing currents of unbelief, and be prepared to live out the social and prophetic aspects of that faith. On the surface, however – and one is compelled to say this bluntly – nothing much has changed since the visit of Pope John Paul II in 1979. Life appears to be going on very much as before.

Yet the visit, like all other visits by the Polish Pope, has struck chords in human hearts and does point to a thirst for something which great numbers of people perceive to be absent from modern life. That 'something' may be termed the experience of religious faith. With that in mind, it is possible to appreciate the comment from Bishop Cahal Daly of the Diocese of Down and Connor – which includes Belfast – when he pointed out that Protestants and Catholics were partners in the battle against unbelief: 'When the bells toll for others' half-empty churches, they toll also for ours . . .'

SHAW. WILDE. O'CASEY. BEHAN. SWIFT. YEATS. SYNGE. JOYCE. BECKETT. GOLDSMITH. SHERIDAN.

These are just a few of our tourist attractions.

No wonder the Irish are the world's supreme conversationalists. They have a literary heritage far longer and richer than many of the major nations of the world could dream of.

That's why, for the lover of language and immortal literature, there's no place like Ireland.

Dublin, for example, is a city steeped in literary legend. Well, of course, you've read "Ulysses".

Apart from Joyce–Swift, Sheridan, Wilde, Shaw, Synge, O'Casey and Behan are some of the famous writers whose birthplace it was.

And wherever you go in Ireland, you're likely to find strong literary associations from the past. County Sligo, for instance, is for the Yeats lover what Stratford is for the Shakespearean.

And in the people you meet–in pubs and restaurants, in shops and on the streets–the tradition endures. Language and literature are alive and well, and living in Ireland.

Come on over and see it all for yourself.

For information on holidays in Ireland, contact the Irish Tourist Board at the address below.

The most interesting people go to

Irish Tourist Board, 150 New Bond Street, London W1Y 0AQ. Telephone: 01-493 3201.

A Glorious Manuscript

Dr G. O. Simms

One of the gifts to civilization of the peculiarly Irish intertwining of the Christian tradition and of the artistic vision, have been some remarkable, illustrated manuscript editions of the Gospels, handcrafted with incredible skill, piety and diligence by monks whose identities were swallowed up in the anonymity of time many centuries ago. Outstanding amongst these manuscripts is the Book of Kells, examined here by George Otto Simms.

The Book of Kells is one of Ireland's special treasures. This manuscript is some twelve hundred years old. It is finely written in clear, bold, well-rounded script; it is also profusely decorated with colourful ornament on almost every page. The designs and decoration are fascinating for their intricacy, their constant variety, and the imaginativeness displayed by the artists and scribes. The four gospels of the New Testament are presented here in lavish style. We are fortunate to have 340 leaves of durable calf-skin, measuring thirteen inches by nine and a half, on which to feast our eyes. These leaves or folios are written on both sides and colourfully ornamented. Every page is a picture.

The Book is now bound in four separate parts; one volume for each of the gospels of Matthew, Mark, Luke, and John. As a result it is possible for visitors to view a number of pages as the several sections of the manuscript lie open in their glass cases at Trinity College Dublin. The spacious Long Room of the library there makes an impressive setting for the Book of Kells as well as for some other famous manuscripts of that golden period of early Irish Christian art and learning. There is thus an opportunity for visitors to compare

and contrast the Book of Kells with its 'elder sister' the Book of Durrow; there are also smaller gospel books, 'pocket-size', such as the Book of Dimma, from Roscrea in Co. Tipperary, and the Book of Moling, from Co. Carlow. In a nearby showcase the Book of Armagh may also be seen; this contains the whole of the New Testament in Latin and important documents dealing with St Patrick, but in appearance it is much smaller and far less colourful than the Book of Kells.

While the home of the Book of Kells has been in Dublin since the year 1661, when Bishop Henry Jones of Meath lodged it in the library of Trinity College, nevertheless it has been possible in recent years for part of the manuscript to be exhibited abroad. It was shown in London side by side with one of that city's great treasures, the Book of Lindisfarne; the Book of Kells has also been exhibited in the United States and currently is being shown in several of the European countries. Those who look into the Book find not merely a Latin text but a whole civilization mirrored in its pages. The architect, the historian, the antiquarian, the archaeologist, as well as the artist and the craftsman all draw inspiration from this workmanship. The overall design, the wealth of colourful detail, the atmosphere of the bizarre and the grotesque, the solemn and the mysterious, the eccentric and the humorous fill one with delighted wonder and baffled amazement.

The spirit of St Columba (Colmcille) hovers over the book. The saint himself, who died in the year 597 A.D., was not responsible for its production. While in Iona, he founded a tradition of bible-study and bible-copying, which is deservedly named 'Columban'. Adamnan, St Columba's biographer, wrote of the high standard of accuracy which the master sought from the members of the community; the scribes were bidden, after carefully copying the texts to 'compare them with the exemplar from which they have written, and amend them with the utmost care'.

It is thought likely that the Book of Kells may have been planned and worked on at first in this island of Iona, off Scotland's west coast, where Columba's monastery was founded. Then as a result of pillage and plunder and worse still, murderous attacks upon the community by invaders, the surviving monks fled to Ireland. In the year 806 A.D. it is recorded that Cellach, abbot of Iona, took refuge in Kells, Co. Meath, some forty miles north-west of Dublin, and repaired or rebuilt the Abbey there. So the link between Iona and Kells was

close; the Book in an unfinished state may well have been worked on further in Kells, although its decoration has never been fully finished. One of Columba's expressed wishes concerned the provision of a gospel *de luxe* for each of his monastic foundations. The Book of Kells appears to have been used in the worship of the community. The Book has had many adventures, but none more exciting and terrifying than the incident described in the Annals of Ulster at the year 1006–7 A.D. Here we read that 'the great Gospel of Colum Cille, the chief treasure of the western world on account of its ornamented cover, was stolen by night from the western sacristy of the great stone church of Cenannus [Kells]. That Gospel was found after twenty nights and two months with its gold stolen from it, buried in the ground.' The golden cover (*cumtach*) was never retrieved, but mercifully the thieves showed no interest in the precious parchment leaves which were ultimately rescued after this rough handling.

While a single mastermind may have been responsible for the design which presents the four narratives of the gospels as a single life of Christ, it seems clear that a team of artists, displaying different styles and much individuality worked on the details. No one knows how long the work could have been in progress. The scholar, Dr Françoise Henry, who devoted a lifetime to the study of the art of this period, recognizes that up to thirty years might have been spent upon the work. She saw several classes of artist in the team; she named them the 'portrait painter', the 'illustrator', the 'geometrician', and the 'goldsmith'. Full-page paintings are devoted to portraits of Christ, and two evangelists, probably St Matthew and St John. Illustrations of significant scenes in the life of Christ are among the great pages of the Book; these include the Nativity painted in solemn colours of mauves and emerald green, in which the Mother of the Christ has a distinctly oriental look. Another full page portrays the Temptation of Jesus, showing Him as a young man, scarcely bearded, facing from the roof of the temple the dark, sinister, skeleton-like figure of the tempter. Christ is clearly in control; He is surrounded by a crowd of witnesses skilfully grouped, and the temple is a copy of an early Celtic stone church or oratory, not very unlike the House of Colmcille which still stands in Kells today, near the old round tower and the carved crosses of the famous monastery.

The opening page of each gospel is intricately designed. At first the reader is baffled by the obscurity of these monograms, so elaborate is

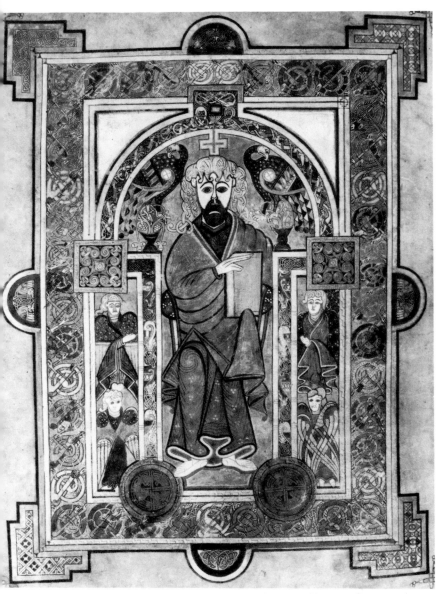

Bord Fáilte/Irish Tourist Board

the interlace, the trumpet pattern, and the detailed ornament which embellish the initial letters. While the writing on the subsequent pages is generally clear and bold, amply spaced and mostly free from abbreviations, the very first words of each gospel are designedly puzzling.

The manuscript was written in the days before chapters and verses, as we know them, were numbered for reference. Paragraphs and sections, however, are clearly defined with the aid of artist as well as scribe. Throughout the book, each paragraph is introduced by a capital letter, ingeniously ornamented, now in the shape of an animal or a pair of beasts, now with a plant design, or again by the twists and turns of a distorted human figure, leaping and writhing with vigour and fun. In other places, precise geometric patterns shape the letters with grace and dignity. Never is the design of this myriad number of capital letters repeated; this contrived variety has contributed to the Book's reputation for eccentricity; there is a uniqueness about these crazy miniatures. This was the scribe's way of transforming the dead formality of the print-like letters into living truth and startling beauty. The artist working in partnership provided the script with colourful comment.

So these gospels were seen to be full of life, joyful and sorrowful. Between the lines of scripture and in the spaces originally blank at paragraph-ends, we find some spirited scenes from the countryside and the farmyard: cats chasing mice, dogs after hares, birds with gay plumage, streamlined fish, peacocks, eagles, doves, all delicately and sensitively drawn with a litheness and a natural agility which reveal the considerable powers of observation possessed by members of the community.

A much-loved page, for many a favourite, shows the *Chi Rho* symbol (XPI) of Christ. This golden picture proclaims the birth of the Saviour in a special way. The X-like initial of Christ (X in Greek signifies Ch) bestrides the whole surface of the parchment. Although there is no gold-leaf in the Book of Kells, the pigment 'orpiment' here and in other places produces a golden sheen of great beauty. Packed closely round the dominant letter 'X' are samples of every kind of creation; animals, both domestic and wild, birds, fishes, human beings, can be found in the maze of mysterious decoration which fills the whole page. All creation might be said to be represented; and the message of a new creation comes with the announcement of Christ's birth. A butterfly, an otter, a pair of cats, sporting with their kittens

capture the atmosphere of new life and joy.

There is a wide range of colour in the manuscript. In addition to the golden 'orpiment', a tomato-coloured red lead is frequently found; the emerald green of copper verdigris is a lasting, shining colour, unfading; the purples and mauves are from a vegetable Mediterranean leaf; while the brilliant blue of lapis lazuli may have been imported from Asia Minor.

The beginning and the ending of this great work have perished. There is no final sentence, no colophon, no prayer, and no signature to indicate to us the name of the author. Much of the fine detail of ornament and decoration cannot be deciphered by the naked eye. Recent reproductions magnified many times have disclosed the spirit of dedication and humility which pervades the whole manuscript. Anonymous writers and artists have clearly shunned personal fame. Their sole concern seems to have been the giving of glory to God. If the ordinary eye cannot perceive this work, faithfully carried out without the aid of spectacles or magnifying-glass, it is certain that the Almighty would have seen it in every detail. Such was the spirit of dedication that shaped the Columban tradition.

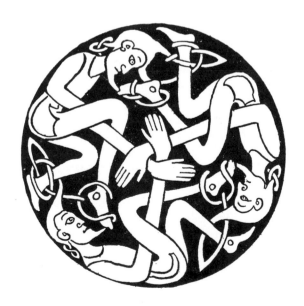

The Artist and the Troubles

Seamus Deane

*Given the long-drawn nature of the troubles in
Northern Ireland, the age-old problem of the
role of the artist in politics has a special
relevance to contemporary Irish writers. Here in
two remarkable pieces of writing Seamus Deane
and Carlo Gébler examine facets of the Irish
artistic conscience, Deane against the backdrop
of the continuing troubles, Gébler using the
experience of a famous Irish novelist in Nazi
Germany.*

*Poet and critic, Dr Seamus Deane, Professor of
Anglo-Irish Literature and Drama at University
College, Dublin, apart from contributing to
many Irish and International journals, is also
editor of the quarterly* Atlantis.

Artists can often be more troubled by the idea that they should be
troubled by a crisis than they are by the crisis itself. The nervous
collapse of the Northern Irish statelet has been uneven in its speed
but relentless in its direction. Yet the recognition that it was a crisis of
real proportions, that it was something other than a squalid little
sectarian war or anachronistic battle between outmoded nationalisms
has only been slowly borne in upon artists, and upon people in
general, and they have accepted it reluctantly and sullenly. It is not
surprising that this should be so. The thought of what the present
state of affairs might become is not attractive. To imagine what it is
like to live in Divis Flats, in Turf Lodge or in Andersonstown is to
imagine what the whole society could become – poor, oppressed,
debased, insanitary, numbed into the acceptance of violence as part
of the daily round. The infernal region in which so many people are

now seen to live seems to extend day by day, as the political hopes recede, as the crack in the industrial base widens, as the distinction between 'security' forces and 'terrorists' fades. In the midst of all this breakdown and internecine strife, the artist is looked to for some kind of 'comment', 'vision', 'attitude', as though the audience still believed, to an extent that few artists do, in the civilizing or clarifying influence of art. Yet the feeling persists that the artist who avoids or evades a confrontation with the crisis is in some sense irresponsible or cowardly or insufficiently an artist to merit the name. The notion that they bear such a responsibility is often repudiated by the artists themselves on the good ground that it can lead to a distortion of the work into a propaganda exercise, an exploitation of easy and ephemeral political feelings which would be better left to sleep. On the other hand, the depth of feeling in the political arena, the savagery of the matching violence in the military arena, are reminders that art and politics are rooted in the same deep atavistic darkness. Their interest in structuring and in destroying structures is a common bond; in modern Ireland, especially, politics and art have gone through what seem to be matching phases of revolution and consolidation. The long and critical years between the fall of Parnell and the rise of De Valera to power (1890–1932) saw the formation of a new state and a new literature, both of which had features exemplary of the general world crisis, defined and articulated on the small Irish stage to an unequalled degree. The relationship between modern romantic nationalism and authoritarian politics can be seen more clearly in Yeats than in anyone else; the transformation of the middle-class English novel into the modern novel in English is more fully achieved in Joyce's work than anywhere else; the relationship between these ostensibly literary subjects and the role of Ireland in the transformation of British imperial and national policies throughout this period would suggest that the intimacy between art and politics was so close, so intimate, that their energies had become interchangeable. A new Ireland or a new idea of Ireland was created by artists and politicians, military leaders and poets. As in the outstanding case of Pearse, these functions were often combined in the same individual. Even afterwards, in the hungry thirties and the lean forties, the provincialism of the new Free State found its artistic voice in the poetry of Patrick Kavanagh who, although an adversary voice in many obvious respects, also realized in literature an aspect of the community's sense of self which the Revival had obscured. In

general terms, whether as sponsors, participants or as opponents, the impression has literally gone abroad that Ireland has traditionally been a culture in which the relationship between art and politics, and especially the politics of trouble, (since there has been little else), has been a close and mutually enforcing one. But, equally, there is at present a conviction that the new crisis in the North has seen the fading of that relationship, and that in the inertia and squalor of the situation there is a symptom of, or the product of the artistic imagination's failure to confront the issues which have been raised.

My own belief is that this is not a true reading of the situation, although it is understandable that it should have been made. One of the reasons for the current interpretation is the disappearance of the heroicizing impulse which Irish art and Irish politics discovered as a principle of liberation and energy in the earlier part of the century. The Northern troubles have developed in a world in which the anti-imperialist ethos has weakened and been replaced by an anxiety to preserve established institutions and systems, precisely because they appeared to have reached a point of exhaustion which it was terrifying to contemplate. In the sixties, when the troubles first began, the political attacks on the ruling establishments in the USA, France, Italy, Germany and the United Kingdom had become so serious that they seemed to be capable of offering an alternative (if much more dishevelled) cultural form and ideology to those then prevailing. The fall of de Gaulle, the end of the Vietnam War, the failure of the new technocrat socialism in England, all seemed to herald the end of an era. But these changes were almost immediately followed by a period of economic gloom in which the need for authority was rediscovered, and the law-and-order theory came into play, with the international terrorist or paramilitary regarded as the primary enemy, the distilled product of a decade's adversarial politics and of authority's invertebrate liberalism. Against this background, the Northern Irish crisis developed. From the outset it contained within itself the seeds of a civil war, as well as having many of the features of a colonial struggle against oppression. Inevitably, therefore, it lent itself to a variety of competing interpretations. Many of them were determined by the 'revisionism' in Irish historical writing (itself a product of the sixties) which had chosen the constitutional nationalist movements in Ireland as its paradigm for the true tradition in Irish history, thereby anticipating and to some extent creating the hostility towards the more militant republican

tradition. Out of all the welter of reportage, interpretation, propaganda and debate, one salient issue emerged – the role of violence, as a moral, as a political, as a social issue. Its relationship to religious belief, to political stability, to social oppression was debated over and over again. Since all sides availed themselves of it and, indeed, made it central to their various policies, the element of hypocrisy and double-think in these debates was possibly higher than normal. But that apart, it had clearly become for Ireland a focus, an obsession, a daily threat. It was here, on this issue, that Irish art, particularly Irish writing, became most profoundly engaged.

The beginning of the Northern troubles coincided with the emergence of the Northern poets as a clearly identifiable group. Although in retrospect it would seem to be one of those apparent coincidences which are really part of a recognizable pattern of related events, it is too easy and dangerous to stress this aspect. For, secreted within this attitude, is the view that there is an inevitable and even welcome connection between violence and art. The release of one and the efflorescence of the other are assumed to be simultaneous. The facts of Northern experience do not bear this out. Violence has often disfigured the society there, but art has not consistently flourished in its shadow. The twenties and thirties were particularly barren in the North as far as artistic productions were concerned. But violence, especially of the politically-directed, official kind, was frequent. Similarly, during the fifties, when tensions in the North began to ease, a group of painters, graduates of the Belfast College of Art, appeared – Basil Blackshaw, Terence Flanagan, Wilfred Stewart, Martin MacKeown and others. Again in retrospect, this emergence seems to have been encouraged by the relatively peaceful, more generously open spirit of those days. Other things stirred: Mary O'Malley's Lyric Players' Theatre, 1951, and its associated magazine *Threshold*, 1957, both of which still survive; the appearance of Brian Moore's first novel, *The Lonely Passion of Judith Hearne* (1955) and preceding it, in 1951, Sam Hanna Bell's *December Bride* and Michael MacLaverty's *Truth in the Night*; the Ulster Group Theatre's production of Gerald McLarnon's *The Bonefire* (1958) and the independent production of Sam Thompson's *Over the Bridge* (1960). Nevertheless, despite such cultural awakenings, the desolation of the province's indelible divisions and injustices also kept coming through – in paintings, in buildings, in novels and poems. Ulster's peculiar fate – to be neither Irish nor British while

also being both – gave to its regional art a characteristic blend of stridency and indecision which ominously prefigured the regional politics of later decades. If one were to compare the peculiar peacefulness of the paintings of William Conor (1881–1968), or of an early novel like Michael MacLaverty's *Call My Brother Back* (1939) with the disturbing silence of Tom Carr's paintings, with their stifled atmospheres, or the sensation of a cramped intellect which we find in Colin Middleton's paintings, Brian Moore's novels, John Montague's early poetry, we can sense the drift from sensibilities secured by local experience to sensibilities dislocated by it. This process was to become more pronounced after 1960. There is hardly a memorable painting, play, novel or poem of that decade that is not both disturbed and disturbing in its implications. Maurice Leitch's novel *Poor Lazarus* (1969), although crudely written, is full of that savage turning back on polluted origins which is by now such an integral part of the Northern sensibility, both political, and artistic.

It is this search, or re-search into the roots of a society so impregnated by violence and division which has marked much contemporary Irish art, both in the North and in the South. Since the early sixties, the new history and the new art shared a repudiation of the idea of violent origin and its extension and ratification into the present. But whereas the writing of history could manage for the most part to rationalize this new version of disengagement from the violent beginnings of both the Republic and the North, art could do so only at the risk of becoming disengaged from its own farouche nature. In the Republic, Thomas Kinsella's poetry underwent a profound sea change in the early seventies, with the publication of *Notes from the Land of the Dead*. In that volume he gave a kind of dreadful pre-eminence to the creative will, that it should structure as a blind force, forging shape out of mess, crystalline order out of inchoate experience in an endless, implacable struggle.

In a similar way, in the year 1972, which brought the first phase of the troubles to a bloody climax, John Montague published *The Rough Field*, a mosaic of discourses, lyric and pleb, which he differentiated from Patrick Kavanagh's *The Great Hunger* by saying that: 'The historical dimension didn't exist for him.' Montague, who more than most believes that the artist must bear witness in a time of historical crisis, has, in a strange way, been energized as an artist by the Northern troubles. The dead Ulster of his childhood has become imaginatively repossessed as a place of value for him, largely because

its occluding political system has broken under the impact of the violence. But this is not to say that he glamourizes violence. The reverse is true. He offers art as the only substantial alternative to it, potentially effective because it draws its energies from the same ancestral and psychic roots.

The engagement with violence or the disengagement from it was, however, an immediate choice which faced those writers who began their careers in the late sixties. Seamus Heaney, Derek Mahon, James Simmons, Michael Longley, and a little later, Ciaran Carson, Frank Ormsby, Paul Muldoon and Tom Paulin all became publicly known as Northern poets and their work received more exposure than usual because of the ongoing crisis. Older poets like John Hewitt and Padraic Fiacc were also subjected to a new pressure, public and private, which had seismic effects on their work. One noticeable feature in these lists is the emergence of Catholic names. Since the 1944 Education Act the role of Catholics in the Northern political and cultural scene, previously so subdued, had promised to become a new reality. Exactly one generation later, the effects were felt. This liberalizing legislation, which helped to undermine the State which passed it, also helped to confirm the presence of two traditions and the close but endlessly difficult relationship which had been soldered between them over a long period. Seamus Heaney's work, which began in a regionalism of the kind which had seemed to have passed with Conor and MacLaverty, suddenly expanded into the historical dimension with *Wintering Out* (1972) and *North* (1975) with such incandescent energy and force that it was immediately clear that here, in this work, the Northern imagination had finally lost its natural stridency (replaced by patience) and had confronted its violent origins. Heaney's best work is a contemplation of root and origin – of words, names, stories, practices, of violence itself. In him, Ulster regionalism realizes itself most fully and, in doing so, transcends itself. On the other hand, Derek Mahon, a natural cosmopolitan, adopted a pose of such mandarin disengagement in his work that it seemed to some he had deliberately chosen stylishness as a defence against the risks of commitment. But Mahon's work has refuted this notion. In his poetry we hear the note of rather weary disaffection which had been so prominent in the work of one of his mentors, Louis MacNeice, blended with grief at the prospect of the wasteland of lost causes which the North and so much else had become. Mahon transposes the customary inspection of the roots of the past into an

inspection of the debris of the future – which is itself the past in its completed form. Between them, these two poets dominate their generations with work which is saturated with a sense of the doom of history expressing itself as violence, made possible by the attrition of feeling, the cauterisation of sensibility. Again it can be seen that in itself, this is a position that accords with the Irish turn against the apotheosis of violence, as a stimulator of consciousness, as a release of and from oppression. But the poets are not simply rehearsing a party line. In their attempt to come to grips with destructive energies, they attempt to demonstrate a way of turning them towards creativity. Their sponsorship is not simply for the sake of art; it is for the energies embodied in art which have been diminished or destroyed elsewhere. This is not a form of political commitment. It is not a form of evasion, either. It is that species of humanism which knows that the demonic and the diabolic have the same origin. In remaining true to the first, they concede to the power of the second.

In a similar fashion, the work of Brian Friel in the drama has revealed an ever-increasing obsession with the linkage between the violent roots of history and the sources of creativity, especially when both of these are tested in a language which is itself a testimony to the presence of these forces. The shadowing of the English language by the Irish language is a metaphor of the contemporary consciousness in its contemplation of history. The great expansion in Friel's work dates from *The Freedom of the City* (1973, although written in that crucial year 1972). As in Montague's and Heaney's, it takes place when the troubles finally force him to include the historical dimension in such a way that his drama of closed communities, with the characteristic ingredients of a hidden story, a gifted outsider with an antic intelligence, a drastic revelation leading to violence is transformed into a meditation on a problem at once political and artistic – that of authority. Yet, none of these writers – Heaney, Mahon, Friel, Montague, Kinsella – or any other artist in other fields – John Behan, F.E. McWilliams, Louis le Brocquy, or even a painter like Joe McWilliams who has asked, 'Why is it that the political and sectarian violence of the past decade is so seldom reflected in Ulster art?' – can be called a political imagination. It is this fact which has been generally recognized, although it has been exaggerated into the claim that Irish artists are in some sense politically disengaged, indifferent, or immobilized.

A preoccupation with history does not necessarily involve a politicization of the artist. In Ireland, the reverse is often true. The core of Irish nationalist feeling, orange or green, has been a moral, not a political passion. No political ideology is bound up with it by necessity; many are linked with it ephemerally or by opportunism. It might even be argued that the separation of Irish nationalisms from socialism left them ideologically lamed to such a degree that they became little more than exercises in introversion once the two States had been formed. The introversion helped to sustain the intensity of feeling; the sense of insecurity, especially in the North, further inflamed it; but the political world was, as a result, dominated by fidelities, loyalties, feelings which had little or nothing to control them. Everything went to heighten them. No idea of society, no idea of the future, no ideology save that of frustration, incompleteness, endless blind struggle, existed to discipline, channel, direct the energies of the community. In such a world, which was very different from that of the earlier part of the century, when programmes of national revival and rehabilitation gave form to political passion, it was almost inevitable that, for the artist, the only available resource was the construction of ideologies of art itself. A preoccupation with history was contributory towards this, especially when, as in the case of writers as diverse as Joyce, Beckett, Flann O'Brien, Francis Stuart, Patrick Kavanagh, history was understood as something to escape from, as an emptiness which only the activity of the artist could, in compensation, fill.

Thus the demands made by a dramatically broken history on artists who are caught between identities, Irish and British, Irish and Anglo-Irish, Catholic and Protestant, are well nigh irresistible. In the period of the Revival, the response to history was heroic and astounding. It cradled figures of great stature: Yeats, Synge, Fayers and O'Casey among them. They produced work which was definitively Irish but which, at the same time, could not be defined by that term. In that respect, they transcended without ignoring the insistent demands of their regional culture. Since them, and especially since Patrick Kavanagh deflected the Yeatsian influence by replacing the notion of the region, Ireland, with the notion of the parish, Monaghan, it has seemed that the pressures of history were becoming more tolerable and amenable. But the transformation of the Republic achieved in the sixties by the new economic policies of the Lemass governments, and the disintegration of the North, unwittingly

brought about by socialist educational policies and by the erosion of unionist economic privilege in the aftermath of the Second World War, heightened the pressures once again. We can look back now, with some nostalgia, at Patrick Kavanagh, the Free State poet, the man who blended the traditional languages of regional loyalty, Catholicism and the adversary language of the artist in a body of work which, finally, bears witness to the spectacle of the ordinary, but still miraculous world. Again, it is the feature of Conor's paintings and MacLaverty's stories. There is a sense of belonging, a sense of at-homeness in these works which is never overborne by the difficulties or disputes they explore. When we think of these in relation to the writing and painting, the sculpture and the performance arts of the present day, we realize with some sense of shock (perhaps) how far the troubles have taken us from the assumptions and pieties of one generation ago. In his realization of an essential homelessness, a political as well as a psychological feature of the Northern crisis (especially in this period of its abandonment), the artist has committed himself to the exploration of a central, if forbidding, feature of the community's experience. Although it is clearly different from the heroic commitments of the past, it is none the less a dedication to the idea that art has a function in society even though it may not be as consolatory as the society would like it to be.

Robert Kee's
THE GREEN FLAG

The most authoritative and revealing history of
Irish nationalism written to date, a book which
replaces the myths and misconceptions of Irish
history with a new evaluation and goes a long
way to explaining the events which make the
headlines today.

Volume One
THE MOST DISTRESSFUL COUNTRY
. . . begins with the question 'who were the
Irish?' and ends in the early 1860s.

Volume Two
THE BOLD FENIAN MEN
. . . covers the events from the foundation
of the Fenian movement to the 1916
Dublin Rising.

Volume Three
OURSELVES ALONE
. . . concentrates on the eventful years
1916-1923, from the Dublin Rising to the
creation of the Irish Free State.

'This is an important book and should start
a timely revaluation of Irish history'
Conor Cruise O'Brien, *Observer*
'*The Green Flag* manages to be not only quite
different but also quite excellent' *Guardian*

Price: £2.95 each
Available from all good bookshops

Quartet Books Limited
A member of the Namara Group
27/29 Goodge Street London W1 Tel: 01-636 3992

'Francis Stuart and St Peter: A Dialogue'

Carlo Gébler

In my *World Dictionary of Writers*, Francis Stuart is described as 'Irish' and 'having cult status'. The entry continues – 'Stuart is best known for his association with Nazism. Spent Second World War in Germany and, for a while, broadcast propaganda.' Sadly, he is no longer with us.

Rummaging recently in the archives of the Vatican – I am researching a thesis on 'Aquinas and Sexuality' – I came across the following dialogue between Francis Stuart and St Peter. How this remarkable document fell from the Heavenly Archives and found its way into the safety of the Vatican Library is a mystery. Unfortunately the document is incomplete. I reproduce it in full.

ST PETER . . . I accept that what you broadcast for the Nazis was not important militarily and that as the citizen of a neutral country – Ireland – you were entitled to do so. Our conversations have passed that stage. The point I want to make to you is that *you* in your own small way are responsible for what happened in Nazi Germany.

STUART I have already accepted that!

ST PETER Well don't you feel sorry? Don't you feel any remorse?

STUART Yes. And better my remorse and guilt than your complacent certainties, the cloying, sickly sensation that comes, not only from being the victor but believing one is in the 'right'. If I was in your shoes and I sat down to write, what I would produce would be garbage.

ST PETER You always return to your work Mr Stuart to justify your behaviour. Do you seriously believe you can exonerate yourself by saying 'I did it for my writing – my art'!

STUART Was my crime so serious? Was it really so serious? I

spent the war in Germany and for a year I broadcast to my own country – Ireland – literary talks, not military or political ones mind you. At the end of the war the Nazis were revealed as a cancer of evil without parallel in history. But did I kill in their cause? No! Or did I harm anyone? No! Yet I was treated as if I had. When the war ended I was incarcerated in a prison and separated from the person I loved. After release my punishment went on. I found it hard to get published – indeed there was a period on earth when I couldn't get published – and whenever I was written about or reviewed, it was never favourable. I was always vilified. Yet my crime was really the relatively mild one of association. Now as I have tried to explain, I wanted the ignominy I experienced. So please don't think I am whining about it. Nor must you think I am protesting 'innocence'. I couldn't have got myself into the kind of position where I ended up 'innocently' – that's impossible. One seeks these things out. But to have achieved this ignominy in peacetime, I would have had to have been a rapist or a mass murderer or a swindler. By nature I am none of these things, so it had to be in the war, where I could do much less yet achieve the same results as if I had committed these crimes, that I at last found I suppose, what I had been groping towards all my life.

ST PETER And what was that?

STUART To be an outcast like the Jews yet even more despised than they were. When I was interned by the French, unlike the Jews in even their worst period, I had no champions whatsoever, with the exception of my beloved Madeleine.

ST PETER You fascinate me Mr Stuart. Your ideas are so well thought out. So articulately put. But I am not convinced you haven't just invented it all to justify the unjustifiable!

STUART I might have – yes. But let me tell you something which I remembered the other day and which I haven't thought about for years. In 1920 I was living in Dublin, studying for my university entrance. The Irish and the British were at war and it was a time of street fighting, reprisals, and so forth. One day, when I was in City Centre, I came across two naked girls who had been chained to the railings of a church; they'd been tarred and feathered . . .

ST PETER They were being punished much as the women collaborators were in France at the end of the Second World War?

STUART Yes. These girls were hated by the Irish because they slept with British soldiers and were probably dismissed by the soldiers as nothing more than cheap, common whores. I gave them

milk and stood by them. I did it without thinking. There was a large hostile crowd and I could have got into terrible trouble but I didn't know what I was doing. When I lie in my cell here and reflect I often think about those girls and I look back on that moment as being the point when I took my first, faltering steps towards where I am now. When I stood by those girls I dimly knew that the only proper associates for the likes of me, are those whose position is indefensible. Now I can put it into words: Dishonour becomes a poet, not titles or acclaim. The dishonour that comes from the associations of which I speak, guarantees that one is not a spokesman for society; on the contrary, society casts the dishonoured out. Isolated, alone and possibly hated – these are the circumstances then in which one is free to write – for you are free of what society expects you to say. Do you understand me?

ST PETER Mr Stuart I understand you perfectly. As a writer you feel your proper place is with the victims not the victors. Yes – I understand this – but the problem is that for a while you did not associate with the victims – you associated with the victors!

STUART I know that.

ST PETER What would you have done if Germany had won the war?

STUART It didn't!

ST PETER You're not answering my question!

STUART As things turned out, 'destiny' served me well. Germany came out at the bottom of the heap and I, in my own small way, along with it.

ST PETER You are still not answering my question!

STUART It's an impossible question! 'What would you have done?' I don't know. Somehow I know I would have found dishonour amongst them – God knows how! – but I would have found it!

ST PETER Are you an anarchist Mr Stuart?

STUART No!

ST PETER Such a pity. It would be easier to say you're an anarchist in my report, than to describe your views. I don't suppose you approve of anarchism?

STUART I don't disapprove.

ST PETER But you're not an anarchist?

STUART Any point of view held in common by a group of people, large or small, whatever the nature of that view, will eventu-

ally become oppressive and damaging.

ST PETER So how does a writer go through life? From what you're suggesting his position is not very far away from cynicism?

STUART No. Not cynicism. To be a writer or whatever, requires a flexibility of attitude that's got nothing to do with cynicism, and an avoidance of all moralizing so that one is free to associate with the losers at any given moment, they who for the poet are the only suitable companions. This means never holding to any political, social or moral beliefs which put one on the right or justified side, for there one is cut off from the true sources of inspiration. As I have said, dishonour is what becomes a poet, not titles or acclaim.

ST PETER Your favourite phrase Mr Stuart. Perhaps on your tombstone, it'll be your epitaph, assuming you have a tombstone of course . . .

At this point the dialogue unfortunately breaks off. Reliable informants tell me that in the end, St Peter declined to admit Francis Stuart to Heaven, dispatching him downwards to Lucifer in Hell. Here however, Francis Stuart was again refused entry. Since neither 'After World' would have him – and perhaps he did not want them either – he dwells today, I gather, in the Limbo between the two, with a small band of like-minded delinquents and dissidents.

(*Editor's note:* Since going to press it has come to light that the dialogue above is a fraud. It now appears that during his heavenly interrogation by St Peter, Francis Stuart refused to speak a word. The document before you, it has been suggested, was counterfeited by the angels in order to have something to put in their records. Apparently they cobbled it together from his novels. The vexed question of how this document came to earth has still not been answered.)

Francis Stuart is in fact alive and well and living in Dublin. In November last year, *Black List, Section H* was issued as a King Penguin.

Extracts from a Sporadic Diary

Brian Friel

RACE AND A SENSE OF PLACE

Artistic struggle of another kind is chronicled by Brian Friel in extracts from a diary he compiled while working on one of the most important plays to appear in contemporary Ireland, Translations *– the difficulty of dealing with Race and Place. He, John Banville, and in differing degrees, Anthony Cronin and Tom Coogan address themselves to the problem, using as their points of departure insights sparked off either from their own work or that of others.*

Apart from Translations, *the plays of Brien Friel, one of Ireland's greatest living playwrights, include,* The Loves of Cass Maguire, Murder at the Guildhall, The Mundy Scheme *and* Philadelphia Here I Come. He is also a noted short-story writer.

(I do not keep a diary. But occasionally, usually when the work has hit a bad patch, I make sporadic notes, partly as a discipline to keep me at the desk, partly in the wan hope that the casual jottings will induce something better. These notes were made throughout 1979. I was working on a play that came to be called *Translations. Translations* is set in a hedge-school in Ballybeg, County Donegal. The year is 1833. The British army is engaged in mapping the whole of Ireland, a process which involves the renaming of every place name in the country. It is a time of great upheaval for the people of Ballybeg: their hedge-school is to be replaced by one of the new national

schools; there is recurring potato blight; they have to acquire a new language (English); and because their townland is being renamed, everything that was familiar is becoming strange.

The play opened in the Guildhall, Derry, on 23 September, 1980. It was the first venture of the Field Day Theatre Company.)

1979

1 MAY. Mayday. Snowing. Still circling around the notion of the hedge-school – ordnance survey play. Reluctant to touch down, to make the commitment of beginning.

11 MAY. Bits and pieces of the new play are coming together. Characters are acquiring form and voice. Attitudes are finding shape and tongue. But only on this very basic level are there the first stirrings. The bigger issues – what the image of map-making evokes, what the play was born of and where it hopes to go to – none of these is acquiring definition. But at this point one still hopes for the numinous.

14 MAY. Went to Urris today, the setting of the hedge-school in the play-in-the-head. No response to the place apart from some sense of how the ordinary British sappers might have reacted to this remote, bleak, desolate strip of land attenuated between mountain and sea. And perhaps in an attempt to commit myself to the material I bought a first edition of Colonel Colby's *Memoir of the City and North Western Liberties of Londonderry.*

The people from Urris/Ballybeg would have been Irish-speaking in 1833. So a theatrical conceit will have to be devised by which – even though the actors speak English – the audience will assume or accept that they are speaking Irish. Could that work?

15 MAY. I keep returning to the same texts: the letters of John O'Donovan, Colby's *Memoir, A Paper Landscape* by John Andrews, *The Hedge-Schools of Ireland* by Dowling, Steiner's *After Babel.* And at each rereading I get interested in some trivial detail or

subside beneath the tedium of the whole idea. For some reason the material resists the intense and necessary fusion of its disparate parts into one whole, and the intense and necessary mental heat that accomplishes that. One aspect that keeps eluding me: the wholeness, the integrity, of that Gaelic past. Maybe because I don't believe in it.

16 MAY. I can envisage a few scenes: the hedge-school classroom; the love scene between lovers who have no common language; the actual task of places being named. Nothing more. The play is not extending its influence into unrealized territories. Stopping short at what it says and shows only.

22 MAY. The thought occurred to me that what I was circling around was a political play and that thought panicked me. But it is a political play – how can that be avoided? If it is not political, what is it? Inaccurate history? Social drama?

23 MAY. I believe that I am reluctant even to name the characters, maybe because the naming-taming process is what the play is about.

29 MAY. Reading and rereading Colby and Andrews and O'Donovan and Steiner and Dowling. Over the same territories again and again and again. I am now at the point when the play *must* be begun and yet all I know about it is this:
I don't want to write a play about Irish peasants being suppressed by English sappers.
I don't want to write a threnody on the death of the Irish language.
I don't want to write a play about land-surveying.
Indeed I don't want to write a play about naming places.
And yet portions of all these are relevant. Each is part of the atmosphere in which the real play lurks.

1 JUNE. What worries me about the play – if there is a play – are the necessary peculiarities, especially the political elements. Because the play has to do with language and only language. And if it becomes

overwhelmed by that political element, it is lost.

18 JUNE. In Ballybeg, at the point when the play begins, the cultural climate is a dying climate – no longer quickened by its past, about to be plunged almost overnight into an alien future. The victims in this situation are the transitional generation. The old can retreat into and find immunity in the past. The young acquire some facility with the new cultural implements. The in-between ages become lost, wandering around in a strange land. Strays.

22 JUNE. Something finally on paper. But what is on paper is far removed from what I thought the play would deal with. For some time there will be this duality – the actual thing and the ideal thing, neither acknowledging the other. Then at some point they must converge. Or one is lost – and then the play is lost.

25 JUNE. Work on the play at a standstill. A complete power-failure. This is always accompanied by a lethargy so total that it seeps into everyday things: all activity collapses. And it is also accompanied by a complete loss of faith in the whole *idea* of the play.

I have never found an antidote to this lethargy. Just drive the work on, mechanically, without belief, vaguely trusting in an instinctive automatic pilot.

2 JULY. A busy week. The first thirteen pages rewritten a dozen times. To create the appropriate atmosphere. To create each voice and endow it with its appropriate pitch. To indicate the themes that will be inhabited and cultivated and to guide the play carefully towards them. Sheep-dog trials.

And now standstill again. Because now that so much is on paper – the characters introduced, their voices distinctive, the direction of the play indicated – everything is so subtly wrong, just so slightly off-key, just so slightly out of focus, that the whole play is flawed. And the difficulty at this stage is to identify those small distortions. Because what the play and the characters and their voices and the themes ought to be – the ideal, the play-in-the-head, the model –

can't be known until it is made real. The catch-22 situation. So you rework, go back over notes. And try to keep faith with that instinct. And at the same time you are aware that each day, as each page is forged, faith is being transferred from that nebulous concept in the head to that permanent and imperfect word on the page.

3 JULY. Complete stop. Are the characters only mouthpieces for certain predetermined concepts? Is the play only an ideas play? And indeed are those ideas amenable to dramatic presentation?

4 JULY. A persistent sense – the logic of the emotions? – that the character Manus is physically maimed.

6 JULY. One of the mistakes of the direction in which the play is presently pulling is the almost wholly *public* concern of the theme: how does the eradication of the Irish language and the substitution of English affect this particular *society*? How long can a *society* live without its tongue? Public questions; issues for politicians; and that's what is wrong with the play now. The play must concern itself only with the exploration of the dark and private places of individual souls.

11 SEPTEMBER. What is so deceptive and so distressing is that the terrain looks so firm and that I think I know it intimately. But the moment I begin to move across it, the ground gives under me. There are a few solid stepping-stones – some characters fully realized – some scenes complete and efficient – but they exist without relationship to one another.

9 OCTOBER. Persistent, nose-to-the-desk, 9.30a.m.–5.30p.m., grinding work. Two acts completed. About to begin Act 3. Final acts are always less taxing because they are predetermined by what has already happened and at this point each character only completes himself, fulfils himself.

I'm not sure what has been achieved. I am more acutely aware of

what has been lost, diluted, confused, perverted than of what has been caught and revealed. A sense, too, that on occasion I have lost faith in the fiction and shouted what should have been overheard. But there is still time.

5 NOVEMBER. The play, named *Translations*, completed.

The task of writing the play, the actual job of putting the pattern together, itself generates belief in the pattern. The act and the artifact sustain one another. And now that the play is finished the value of the pattern and belief in the pattern diminish and lethargy sets in: the life process. But only after the play is produced will I be completely cleansed of my subscription to this particular pattern, this ordering of things. Then a vigour will be summoned. Then a new pattern will have to be forged.

The process seems trivial and transient because the patterns are so impermanent. But is there another way? It is a kind of vigilance – keeping the bush from encroaching into the yard. All art is a diary of evolution; markings that seemed true of and for their time; adjustments in stance and disposition; opening to what seemed the persistence of the moment. Map-makings.

Place Names: The Place

John Banville

John Banville was born in Wexford in 1945 and educated there. His first book was published in 1970. Since then he has produced five novels, including Birchwood *(1974), which won the American-Irish Foundation award,* Doctor Copernicus *(1976), which was awarded the James Tait Black fiction prize, and* Kepler *(1981), which won the* Guardian *prize. Married with two children, he is chief sub-editor of the Irish Press.*

In Ealing Broadway, London Town
I name their several names

Until a world comes to life –
Morning, the silent bog,
And the God of imagination waking
In a Mucker fog.

The nominative is the case of art. The poet wields the name as a wizard his wand and the statues stir and speak. To name is to cast a spell. And in the spelling out, worlds ramify. The proper name, says Roland Barthes, is 'a precious object, compressed, embalmed, which must be opened like a flower', it is 'a sign always pregnant with a dense texture of meaning'. In the lines from Patrick Kavanagh quoted above, it is not only an area of London that we see, nor even that city itself, nor even indeed a mythic Monaghan: but also morning, fog and silence, and Apollo among the potato fields, and, all over, a particular louse-grey shade of longing and of loss.

Further, to name is to lay claim: to assert the community of things. It is our task. Are we here, asks Rilke, just for the saying of names?

> . . . but for *saying*, remember,
> oh, for such saying as never the things themselves
> hoped so intensely to be.

Mute things have a challenging yet somehow poignant thereness; we have the gift of speech. Wallace Stevens:

> From this the poem springs: that we live in a place
> That is not our own and, much more, not ourselves
> And hard it is in spite of blazoned days.

So we say out the names, attempting thus hieratically to assimilate to ourselves all that which is not us.

But *Mucker*?

In the essay* from which I have already quoted, Barthes remarks that Proustian names – *Laumes, Villeparisis, Combray* – whether or not they exist, have none the less what he calls a 'Francophonic plausibility':

> their phonetism, and at least to an equal degree their graphism, are elaborated in conformity with certain sounds and groups of letters specifically attached to French toponymy: it is culture (that of the French) which imposes upon the [Proustian] Name a natural motivation: what is imitated is of course not in Nature but in history, yet a history so old that it constitutes the language which has resulted from it as a veritable nature, the source of models and reasons. The proper name, and singularly the Proustian Name, therefore, has a common signification: it signifies at least the nationality and all the images which can be associated with it.

If a poet, or perhaps more to the point (let us come clean) a novelist, tries to find or invent – the distinction hardly matters – place names which shall have a 'Hibernophonic plausibility', conforming

*'Proust and Names' in *New Critical Essays*, trans. Richard Howard (Hill & Wang, New York, 1980)

to Irish, or at least Anglo-Irish, toponymy, he will find himself tending always, helplessly, toward the comic and the infantile, thanks to decisions made 150 years ago by the British Ordnance Survey. Sometimes, considering all those *Kills* and *Mucks* and *Ballys*, one suspects the Master-General of the Ordnance of a secret sense of humour.

Of course, of course, Mucker may be the loveliest spot imaginable. What's in a name? Lissadell is an extremely ugly house.

And yet.

Nor are we the only country thus disfavoured. What about England's own *Middle Wallop* and *Wookey Hole*?

And yet.

'. . . a history so old that it constitutes the language which has resulted from it as a veritable nature, the source of models and reasons'. The language in which *we* work is a source of models and reasons that are not ours. Speech for us is always, at one level, an act of mimicry: behind the cadences, someone else's history reverberates. The rhythms of our rhetoric were laid down by an imperium not our own. We seem to hear always a not unfond paternalistic laughter greeting our best efforts. Imagine a poet apostrophizing in heroic couplets his hometown of Ballykillmuck.

There are ways. Think of Beckett's scabrous towns: Bally, Ballyba, Ballybaba, and, appallingly, Turdy and Hole. Or, at the other end of the scale of decency, consider Kavanagh's rueful honesty, as above. Or Kinsella's reverberant river Camacamacamacamac . . .

There are ways.

Yet artistic modes, like language itself, carry with them certain ghostly injunctions, idiosyncrasies, limitations. The novel still looks like one of those ingenious yet faintly absurd domestic contraptions so beloved of the Victorians: Mrs Eliot's Patented Self-Loading Moral Measuring Appliance, Mr Dickens's Famous and Ever-Popular Heart-Warmer. Somehow, Irish-English is not a fuel on which such gadgets can be run. The high tone of Tory rectitude or Whig good sense does not convince in the rain-sodden environs of Ballykillmuck. But perhaps the Ballykillmuckers have other aims, other tasks.

The notion of the novel as an art form is relatively new. It was, I would contend, put forward, or at least put firmly into practice, not

by *English* novelists, but by colonials such as Henry James, or out-and-out foreigners like Conrad. Then Joyce. Now the Americans. As Salman Rushdie has it: the Empire strikes back. This is no cause for nationalistic gloating. If something new, or newish, has been achieved, it was made possible by the existence of a solid model of paternalistic rectitude against which to rail and rebel. Artistic adventurousness is the purest form of insurrection. The English language, its 'models and reasons', forced us into subversion and subterfuge, elaborations of defence and attack. It is all a kind of shadow-boxing, of course: the white officers left long ago. The laughter we seem to hear is an echo of the dead.

It is time for us to realize these things.

To grow up is to learn how to take oneself seriously. Which means, I suppose, learning to laugh at oneself, not out of despair, but with forbearance. We have not quite managed yet that kind of laughter. Our saying of the names still will not quite confer plausibility. The God of our imagination stumbles groggily, rubbing his eyes, in a Mucker fog.

The lines quoted are from the poem 'Kerr's Ass', by Patrick Kavanagh, *Collected Poems*, Martin Brian & O'Keeffe, London 1972.

Ned McKeown's Two Doors: A Prefatory Note on the Novel in Ireland

Benedict Kiely

Author, raconteur, broadcaster, former Irish
Press *columnist, Benedict Kiely is one of Ireland's
most distinguished novelists. His writings
include the novels* The Captain with the
Whiskers, Proxopera, *collections of short stories,
works of non-fiction and countless newspaper
and magazine articles.*

If you are Irish you need not, necessarily, come into the parlour: but if you are Irish and you have ever tried to write a novel and then if, long afterwards, you sit down to meditate on the nature of the Irish novel, you may be driven to look back, with sad affection, on your first faltering effort or efforts. Everything, even the great globe itself has to begin and end somewhere (see Shakespeare and Aristotle). Although there once was a legend about Something or Somebody that did not have a beginning and would never have an end.

Reared as I was in a provincial town in a river valley (to which I was particularly devoted) is it not surprising that when I first made an effort to write a novel it should also be an attempt to celebrate that river valley.

In a public park on the Camowen river before it reaches the town, a park called the Lovers' Retreat but known by a grosser name to the liberal soldiers in the barracks, I met, one evening in 1936, a young soldier. We became friendly over the next few months, then he disappeared for a while and I next met him being escorted from the railway station by two RUC men. In the relaxed atmosphere of those days it was possible to stop and ask them what it was all about: when

it appeared that my pal had deserted from the army and, while heading for the border at Strabane, had made love to some bits of property that did not belong to him: like a bicycle, a suit of clothes, and so on. He was very cheerful about it all and was on the best of terms with his captors.

I never saw him again but I did not forget him and, even if I have forgotten his name, I can see him still laughing his way to jail: and about the Christmas of 1939 I started to write a novel about him under the title 'King's Shilling'. I suppose I could say very grandly that my runaway soldier was the symbol of the pilgrim soul and that I was trying to express something very deep about the plight of man on earth. But then I wasn't trying to make him seem to be anything of the sort: I was merely trying to write down the joy I felt in the Strule valley when the grassmeadows were going down in late June or July, according to the weather in any year. So I set my soldier running away along that valley. There naturally had to be people in the story or it wouldn't be a story at all, and I really did like the original of the soldier and the effort of trying to get him down on paper was well worthwhile. The other people came to mind as easily as the grass grew. They also had grown in that valley. It never occurred to me that the people were any different from myself. Why should it have? But grass, and the river and Bessy Bell mountain above it were different: people passed, they remained.

The only publisher's reader I ever showed the thing to told me that he thought it couldn't succeed because I couldn't make a hero out of a man who was really running away from his duty. He was either being very righteous about the story or very polite to me. He was a quiet polite sort of man. Then I showed the script to Francis MacManus, a fine novelist who was to become a great friend. He read it, handed it back to me, said brusquely: 'It's a long short story. Cut it to eighteen thousand words.' In its original state it was about fifty thousand words. So I swallowed my indignation as best I could, and the pathetic thing lay gathering dust while I worked on what became my first novel and on a quasi-political book about, God help us all, the Six Counties. Then when the late J.J. Campbell was editing the *Irish Bookman*, he encouraged me to follow up on the advice of MacManus and reduce the story to publishable length, which I did: and it came down almost exactly to eighteen thousand words. MacManus had an exact eye. What happened to the other thirty two thousand words or what under God they were about I do not recall.

I have written down that triviality at some length because it represents my first close encounter with the Irish novel. For to read a novel is one sort of experience and at times a tolerable one: to try to write it is, obviously, something else and the effort may cast a new illumination on the novels that other men and women have provided for you to read.

For instance: as to where they began and, in so far as we can guess, why. Not where they first took pen in hand and sat down: Flann O'Brien argued very cogently that those two actions were the essential preliminaries to all good writing. But what place first set the imagination on fire and/or made the novelist to think that he or she was looking at a life that cried out for expression, and that he or she felt capable of expressing, felt an urgent need to express.

To take two easy examples from the novels of other countries.

Ireland was, by accident, good to Anthony Trollope both as human being and as novelist but, for obvious reasons, his Irish novels are peripheral to the vast and unified body of his work: which work has two upholding pillars, the soaring spire of Salisbury, the clocktower of Westminster. He has written into his autobiography the revelation that came to him in Salisbury. Much later on an Irish novelist is to talk about epiphanies. Not being Irish, nor Jesuit-educated, Trollope's waking moments were never harried by epiphanies: or, at any rate, he would not have thought about them under that name. Also, failing in his one attempt to become a Member of Parliament, although he claimed that his effort had a good side-effect for the cause of reform, Trollope yet created a parliament that seems more real than the real thing.

Crossing yet another water: is it not high time that we stopped making so much of Proust's tea and biscuits? Every one of us has a dozen similar, slight, evanescent memories. But we do need more and more discussion on those twin steeples of Martinville: 'In noticing and registering the shape of their spires, their shifting lines, the sunny warmth of their surfaces, I felt that I was not penetrating to the core of my impression, that something more lay behind that mobility, that luminosity, something which they seemed at once to contain and to conceal.'

So: the Irish novel begins in Ned McKeown's cottage at the crossroads of Kilrudden. There is today a cottage which I, and others, have actually entered, on the exact site. Not so much with Maria Edgeworth in the great house in the Midlands: no, with

William Carleton in a crossroads cottage in Ulster: 'Ned McKeown's house stood exactly in an angle formed by the crossroads of Kilrudden. It was a long, whitewashed building, well thatched and furnished with the usual appurtenances of yard and offices. Like most Irish houses of the better sort it had two doors, one opening into a garden . . .' At which point beginneth the almost 2,000 pages of my 1836 edition of *The Traits and Stories of the Irish Peasantry*. At which point, also, it may now be objected to me that we are talking, if we are talking, about the novel. Not about a long series of stories, sketches, novellae. Recently it has been argued that Carleton did not make much of a success of the novel although I find it hard to see how such an argument could be upheld against the weight of *Fardorougha the Miser*, *The Black Prophet*, *Valentine McChetchy*, and above all *The Emigrants of Ahadarra*. But *The Traits* I can accept as one long irregular novel in which the author has done what few Irish novelists have done: given us a vast Balzacian world and brought us into it by way of Ned McKeown's crossroads cottage and, be it noted, the folktale that begins with Jack Magennis of the Routing Burn. 'He caught his types,' Shane Leslie wrote, 'before Ireland made the greatest plunge in her history and the Famine had cleaned her to the bone.' The types are valid enough to this day.

As for Maria Edgeworth she became an Irish novelist, a great novelist, almost, you might say by a curious sort of accident. Those improving tales she wrote under guidance of her great and most admirable father are perfect in their European kind. They have entitled her to be forgotten in the company of other impeccable female authors. The happy accident that made her forever memorable was that down there at Edgeworthstown she listened a lot to her father's land steward, John Langan, she borrowed his turn of phrase, transmogrified him into Thadey McQuirke or Quirk and set him to work to tell the story of Castle Rackrent. Discovering, thus, a diction, an idiom, revealing a society. Otherwise she might never have met the Irish people. Even if in *The Absentee*, she did send the young Lord Colambre to visit Mrs Rafferty, the merchant's wife, Lilith to all Castle Catholics forever, in her seaside villa, called Tusculum, near Bray, where the drawing-room was 'fine with bad pictures and gaudy gildings', and the windows all shut, and the company, like their betters, playing cards. She looked out of the window of her coach and saw their looped and windowed ragged-nesses begging on the roadside, and was genuinely concerned about

their welfare, their lack of education and the thrifty virtues. But that was not really to know them, certainly not as a novelist should know his or her subject.

In Limerick city a little later a sensitive young man sat in on a murder trial, was deeply impressed by it and the sad story that led up to it: and by some ominous, superstitious circumstances surrounding the execution of the murderer. From all of which we had Gerald Griffin's novel *The Collegians* which in many ways, and because of the morbid sensibility of the man who wrote it, is the most contemporary of the early Irish novels. We cannot say, 'of the novels to which the Irish novel owes its origin'. We are part of something larger and cannot lay claim to our own Great Tradition: which may be just as well. Our nineteenth century Gothic, Maturin and Le Fanu, is as the Gothic was elsewhere. The first few fumbling collectors of folktales, Lover, Crofton, Croker and, on a much higher level, Patrick Kennedy, did gather something very old and new, from the lips of the people. Maxwell and Lever went soldiering and galloping and singing of the girls they left behind them.

Like the nation itself, or whatever we please to call ourselves, the Irish novel sank low in the doldrums or death that followed the middle of the nineteenth century: bravely sustained perhaps, by a national piety and a most Dickensian national piety that began for Charles Kickham and others, with the beat of the Knockmagow drum on a Christmas morning. The most interesting novel to look back on that particular period was written by a parliamentarian and most eloquent agitator, William O'Brien: *When We Were Boys*. It is of amazing interest: one point being that it was written in twelve months or in two periods of six months, each spent at different times in prison: so that when he worked on the second portion he had not the first portion available for consultation. On that occasion, at any rate, Irish art was not the cracked mirror of the serving maid.

The novel in modern Ireland, if Ireland is modern, begins, as does the short story, with George Moore. Who also, in *Hail and Farewell* and *A Storyteller's Holiday*, patented a style as old as Apuleius, certainly as old as Cellini, which style some contemporary writers have debased under the name of faction, a name itself of debased coinage. And Moore begins perhaps in a Paris studio, perhaps in the smoke on the platform of Stafford railway station, but most certainly by a glimmering lake, haunted by history, in the wilds of Mayo: the lake that he maintained every man has in his heart. Except that, for

myself, I go with Edmund Blunden:

Some love the mountains, some the sea,
But a river-god is the god for me.

It is of interest that a contemporary scholar who is doing a lot to
rehabilitate Moore should pick on *The Lake*, as the central novel. I
would balance against it, *A Drama in Muslin*, with Moore using
Dublin Castle and the Shelboure as Trollope used the clocktower of
the Palace of Westminster now, like Pisa, leaning: and in which novel
Alice Barton looks out meditatively over the falling snow in a passage
which Joyce in 'The Dead' honoured by imitating.

Then a mile or two from Dublin Castle and in a northside side-
street, the great Irish novel begins. No, I'm not thinking of Eccles
Street but of one of the short stories, those curtain-raisers for *Ulysses*,
a story that begins in dullness and reaches out, vainly and tragically,
towards Sabian odours and the spicy shores of Araby the Blessed:

North Richmond Street, being blind, was a quiet street except at
the hour when the Christian Brothers' School set the boys free.
An uninhabited house of two storeys stood at the blind end,
detached from its neighbours in a square ground. The other
houses of the street, conscious of decent lives within them, gazed
at one another with brown imperturbable faces.

Now that was also the street along which a refined Quaker lady had
walked to pay a visit to a Christian Brother who had once been a
novelist, a poet and a playwright, and who had had a gentle platonic
fluttering with the Quaker lady: and who, in a fit of flight from the
world, had destroyed what remained of his manuscripts and taken to
unalloyed religion. When he was told that the Quaker lady, who was
also blamelessly wedded, was in the parlour to pay him a visit, he
gave the matter prayerful thought, sent her a message that he could
not see her, and went on being unalloyed.

That crisis of conscience of Gerald Griffin, the author of *The
Collegians*, found no place in *Dubliners*, but it is at least of casual
interest that it should have taken place in the same street in which the
quest for love and Araby began and ended in a boy's disillusion.
Those brown imperturbable faces, behind them the consciousness of
decent lives, looked out on that darkness of agony in which man

knows himself as 'a creature driven and derided by vanity'.

One door opened on the garden and one on the road and the crowded world. Obscurely in that quiet side street the Ireland we live in had one of its sources.

The Ones that Got Away

Frank Delaney on Today's Irish Novelists

Frank Delaney presents the Radio Four weekly magazine programme Bookshelf, *and the BBC2 TV series 'Frank Delaney'. His book* James Joyce's Odyssey *was published in 1981, and his new book,* Betjeman Country, *will be published in the autumn. A native of Tipperary in Southern Ireland, he has lived in London since 1978.*

Heritage is all in Ireland – ranging from the ancient High Kings right down to 'I knew that fella when he hadn't a backside to his trousers'. In the matter of writing, too, the descent is gloriously important. Was Maria Edgeworth's *Castle Rackrent* the first truly regional novel? Did George Moore write the first realistic novel? Does the stream of consciousness, the *monologue intérieur*, first come to maturity in *Ulysses*? 'Who cares?' I hear you cry – quite right too, except that it is useful to establish the conscious tradition in which Irish writers must work today.

In all these 'firsts', if such they really may be called, there is a vital element of distance. Maria Edgeworth was Protestant, and well-off, therefore, at the time of the Act of Union, above and outside her peasant subject-matter. George Moore had had his perceptions sharpened in Paris. Not a line of *Ulysses* was written in Ireland. Distance, at least, if not downright expatriation, has always been fundamental to the Irish novel. And pursuing the risk of generalization – dangerously greater in any Hibernian context – I believe I can therefore identify three kinds of contemporary Irish novelist and novel. These are – in ascending order of importance – the unexpected, the expected and the ones that got away.

'Unexpected' consists in the novel that has not yet been written, therefore it is not to be expected. It has been talked through, though, nightly, at the bar counter – heft and squirted down the length of the conversation. Thus displayed, it is a big, glorious bog-brown epic of a thing, marbled and veined with melancholy and Celtic self-doubt. Does it ever get beyond that? If it does, it is double 'unexpected'.

'Expected' novels are the kind which are as inevitable as undergraduates, bright, vulnerable and experimental. They appear gallantly and full of wonder in David Marcus's *New Irish Writing*: they emerge, paperbacked and uncertain within the catalogue pages of such vigorous publishers as the Poolbeg Press. Soon, the shadows cast by giants like Joyce, O'Casey, Yeats, will have moved on far enough for these other plants to flourish truly. The novels you 'expect' to find in Ireland would furnish an entire underground movement in an Iron Curtain country. Thematically and innovatively they are vital: waiting for the authors to grow – or disappear – is easy (alas! for them) in a country which has always had such an embarrassment of literary riches.

The third category is the most interesting and successful. The ones that got away fall naturally into two divisions: those who still live on the island of Ireland but have escaped claustrophobia, and those who departed. If there are major differences between them in matters of style and preoccupation these may be natural rather than nationalistic. Tone and shade, I suspect, are more relevant than discussions of relative excellence; different grapes different growths.

Of the Irish novelists who live in Ireland many are powerful and possess important local voices, as mayors, or priests: a few become known abroad, as with cabinet ministers or bishops – one or two are, truly, ambassadors and cardinals. Lists are useless here. Mollie Keane, Tom Kilroy, Clare Boylan, John Broderick, Neil Jordan, Bryan MacMahon, any roll-call will stretch and stretch, without even getting around to travelling giants such as Aidan Higgins and John McGahern. Proliferation dissipates. But there are two novelists, John Banville and Jennifer Johnston who have much in their work to satisfy the Janus requirement now endemic in all realistic literature coming from Ireland.

In May of last year Secker and Warburg published *The Newton Letter* by John Banville, his fifth novel. Technically its length calls down the word 'novella' – but the sound and shape of such a description undermine the pace of the book. It moves forward the cause of

Irish fiction at exactly the right speed – in two previous works the author had been delving about in philosophies and sciences with Kepler and Copernicus and even Banville with all his talent could not avoid the impression that he was a pilgrim monk in unfamiliar territories. With *The Newton Letter* he came back to his monastery and brought with him the depth of perception which ascesis is typically believed to supply.

An historian preoccupied with Isaac Newton rents the lodge on a peeling estate in County Wexford. 'There was an avenue of sycamores and then the road falling away down the hill to the village. In the distance I could see the smoke of the town, and beyond that again a sliver of sea.' Time, he discovers, is different in the country. It affects thinking and loving and madness, too. The family is called Lawless: Charlotte, her big blonde niece, Ottilie, a tow-haired small boy and Edward Lawless, tweedy, distant-across-fields, mysterious. 'It all has the air of a pastoral mime, with the shepherd's wife and the shepherd, and Cupid and the maid, and scribbling within a crystal cave, myself, a haggard-eyed Damon.'

If this were music it would be a quintet for oboe and strings, an unsettling, unsatisfying but important piece. The theme and its resolution are close enough to the banal to make them almost too sensational for literature. Where John Banville's brilliance lies – and he is surely a fierce new force – is that he understands the necessity of the other half of an idea. 'A good short story,' Frank O'Connor told a friend of mine, 'is a female idea which rises off the ground in an arc. Somewhere at the top of the curve it meets and mates with a male idea and they fall, united, to the ground.' *The Newton Letter* is longer than a long short story – but it fulfils O'Connor's principle. Further, with its vibrations of violence, hopeless sexuality, incest and madness it summons up the ambivalence of the dejected, desolate Anglo-Irish Protestantry who elected to survive in the new Post-Treaty Ireland. Had Banville extended the comparison between the sixteenth-century allegations involving Newton and the twentieth-century frenetic loving of the narrator, O'Connor's thought would have grown to include the novel.

Jennifer Johnston knows the same terrain. Like John Banville she not so much looks back over her shoulder as she walks down the avenue away from the Great House; it is more that she stumbles through the ruins, finding cut-stone memories, ivy-clad, or hidden in the long grass. But she has taken one important and risky leap

forward in that almost alone of her prose breed she has written about Northern Ireland and conveyed the quiet desperation of a society disquieted on all sides, like an anguished theatre-in-the-round, by disaffection.

Her early novels, *The Captains and the Kings* and *The Gates* were placed deep in the crumbling Anglo-Irish countryside. Stables had fallen, rooms were closed off, natives, previously servile, now owned land themselves and therefore answered back. *How Many Miles to Babylon* further emphasized the gulf which appeared when landlord became tenant. *The Old Jest* was inscribed with the confusion which dismayed the minor, merchant ascendency who actually liked their Republican neighbours. *Shadows on Our Skin* went straight into the problem which Northern Ireland lobs upon its new generations. Small boy, growing up in Derry, attentive delicately to his young schoolteacher has the relationship betrayed by his IRA older brother. Hurtful, hard – and so true you can smell the gun-oil.

In her most recent novel *The Christmas Tree* Jennifer Johnston is still in pain. Constance Keating lies dying of leukaemia and is writing to Jacob Weinberg, of loving memory, to come and fetch her from death. 'I am frightened now. There is no rhythm now. I get no warning. It is like being eaten by some animal that tears at me until its hunger is temporarily satisfied and then it sleeps uneasily until the hunger starts again.' Unless you choose to make it so this is not necessarily a metaphor for an Ireland which is festering with lawlessness – but the new disease has taken over. Hope is in the baby which Constance has had: death is Joycean and wintry, only the Christmas tree lights up the room. 'It has been snowing and the east wind finds its pernicious way through every window. I will go back to bed then and wait for the daylight. They come and bring me fruit and little dishes they have made for me . . . and flowers, I have a lot of flowers.'

Anthony Burgess has argued: 'Sociability is dangerous to the writer. Go into a pub in Dublin and they'll ask you what you're writing these days. You start telling them the story and realize it's no good, or, having told it orally, you decide there's no point in telling it scriptually as well. That's why the writers leave Ireland.' I do not know whether Jennifer Johnston or John Banville ever go down among the pubs – I seriously doubt it, both would find their instensity leavened. But they have found ways of escape somewhere,

somehow – inner space, perhaps, silence, domicile and cunning?

As distinct from Joyce's weapons of 'silence, exile and cunning', the most-dissected phrase in the academic groves of the American Mid-West? And did not Stephen Dedalus also think: '. . . the black arms of tall ships that stand against the moon, their tale of distant nations. They are held out to say: we are alone – come.'

And the leave was even more glamorous than the leave-taking. Think of Yeats in Antibes, fulminating against the grocers' republic, a white-hot flowing mane of lyrical moral retribution. Think of Wilde, shattered, in a dilatory hotel in Paris, dying of silence, exile and shame. (Although a later correspondence between George Bernard Shaw and Lord Alfred Douglas suggests that Wilde may have died of indignation because Frank Harris, entrepreneur, cheated him out of a new play's proceeds.)

Think again of Joyce, stumbling physically, prancing intellectually, about Europe saying: 'Dublin is a detestable city and the people there are most repulsive to me.' I love–hate: you love–hate: he loves–hates: we love–hate: you love–hate: they love–hate: the declension of an Irish literary exile.

There is a third side to the coin (if you will forgive me) and it is exemplified by two writers who live on the island of England–Scotland–Wales. They are Edna O'Brien and William Trevor. Both Miss O'Brien and Mr Trevor have extended themselves energetically within their discipline – each has written novels, short stories, plays, with – all hail to them – more critical than commercial success. And – to their even greater credit – neither writer has vulgarly emphasized the double-bind of the Irish writer living in England – the ambivalence of being kept comfortably by one alert and civil woman, while lusting after the other, older lady who has agitated you, aggravated you and made you sad before, during and after *coitus interruptus*.

Edna O'Brien is still writing about melancholy, that draped stone urn which ornaments every Irish gate. For a time she became so fashionable on the media that her work became unfashionable. (The London literary establishment uses fashion as if it were a deportation order.) It was her own fault, though. There she was in the pages of the *Sunday Times,* doing pliés and yoga in a day in her life, and looking soulful because the photographer wanted her to be so.

But I will not derogate Miss O'Brien. Last year I spent some time in the company of Dame Rebecca West, who sat like a ruined castle,

deaf, cataracted and dauntless, in her Kensington flat. In a stream of enquiry as to whom she admired in the contemporary canon, the only name she plumped for was Miss O'Brien's. Perhaps it was the Irish affinity – Dame Rebecca, despite a London birth, claims direct descendancy from Daniel O'Connell the Liberator (and Libertine, and perhaps it is a sign that Dame Rebecca is not truly Irish; if she were, she would be more careful as to whom she claimed as ancestor!).

Dame Rebecca West is right. Edna O'Brien is a fine and glistening writer who has explored serious themes seriously, and whose grasp on life as it must be reported – and that is no more and no less than the task of any writer, exile or not – is thoughtful, intelligent and committedly interpretative. Her understanding of predicament in this case, her perceptions of love and loneliness – make her almost as good in her novels as certain of the French: her pithiness in the inner space of that extraordinary parish, the short story, make her as Irish as rain. By Sean O'Faolain, out of Colette, a horse-racing man might say.

Her stance in all her work has been, for an exile, near-perfect. Looking back, as she did in her early trilogy, *The Country Girls, The Lonely Girl* (now called, less theatrically, *The Girl with Green Eyes*), and *Girls in Their Married Bliss,* she explored the gap between nostalgia and reality, between remembrance of things past and the hard pavements of the new land. Emigration was a metaphor for growing up: the homeland was the slowest and saddest of quicksands.

When her books looked forward, to the new frontiers – as with the splendid *Mrs Reinhardt,* or the earlier collection, *The Love Object,* or the unsettling novel, *Casualties of Peace* – the true uncertainty of the immigrant was there; shall I speak up, shall I hold my peace, shall I integrate, shall I ne'er see you more, gentle mother? Mrs Reinhardt, for example, has begun to sleepwalk. 'Then she saw pictures such as she had not seen in life. Her husband owned an art gallery and Mrs Reinhardt had the opportunity to see many pictures, yet the ones she saw at night were much more satisfying. For one thing she was inside them. She was not an outsider looking in, making idiotic remarks, she was part of the picture: an arm or a lily on the grey mane of a horse.' Always, and by choice excluded from the centre: exile personified – the pun is intentional.

William Trevor's breeding is a different matter. Not wistful Catholic, not melancholic by primary instinct, he was born William

Trevor Cox, not of small lands in Clare, as Miss O'Brien was, but of a peripatetic Bank of Ireland family and, therefore, by definition, parochially rootless and Protestant. What would my racing friend say? Out of Virginia Woolf, or Elizabeth Bowen or Jane Austen, by William Plomer, Graham Greene, Evelyn Waugh?

By qualitative or quantitative analysis his output is substantial. Novels, plays in trilogy, small cultivated territories of short story – all bearing the stamp of the fact that his earliest creative discipline was sculpture. Everything is carved and plinthed: within there is quiet chaos. In 'Sunday Drinks' (from the 1981 collection *Beyond the Pale*), Malcolm and Jessica have a secret, a damaged, shuffling, drug-addicted ghost of a son. 'The quiet descent of the stairs, the shuffling through the hall. He would be there in the kitchen, patiently sitting, when they returned. He would smile at them and during lunch a kind of conversation might develop, or it might not.' William Trevor, more than any of his contemporaries, mirrors life's implosions: suddenly, out of the sun, brilliantly and quietly, his heartrending small tragedies dive like missiles. Everything is changed while everything remains the same – each story is a metaphor, each metaphor a story.

In the same collection another story, 'The Blue Dress', claws at itself like a middle-class madman. A tired journalist, Terris, falls in love with twenty-two-year-old Dorothea. He proposes marriage, visits her family, takes tea in the garden. As he uncovers hypocrisy-turned-fantasy within the news stories he writes, so he lays bare and lays waste the family he visits. 'In the sunny room, while marmalade was passed and the flowered china had all the prettiness of a cottage garden, the horror was nonsensical. Mrs Lysarth's elegance, her perfect features and her burnished hair, would surely not be as they were. No wrinkles creased her face; the Doctor's eyes were honestly untroubled, forget-me-not blue, a darker shade than Dorothea's. And Dorothea's hands would surely be less beautiful.' Simple, and as penetrating and resonant as a fugue.

Both Mr Trevor and Edna O'Brien are literal exiles, if not in feeling, then certainly in tone – their voices distinguish them as such. The heightened perceptions of that great Irish national pastime, the double standard, the observation of both the worm and the bud, the twin senses of infinity and the affairs of the parish, the ability to use both watercolours and oils – all gifts which came with release from the white man's burden of daily, claustrophobic Irishry.

Where both are outstanding, though, is in the way in which neither remorse nor foolish dreams enter their works. No silence, no cunning – neither writer takes too much time to contemplate something which might be called 'the emigrant novel'. Their works, along with those of John Banville and Jennifer Johnston are distinguished by the true hallmarks of Irish objectivity – sentiment and maudlin patriotism are utterly absent. As for the Janus factor – all look back and inward as any Irish writer must, all look forward and outward as every Irish writer should. There are post-Parnellite Nationalists and *nouveau* Republicans in Ireland (whose prison is the past) who would reject out of hand any suggestion that all or any of the four novelists is truly Irish. The lack of insularity in their novels makes life at the Gaelic grass-roots uneasy. But it is that looking up, moving away, which adds depth to the insight of the four novelists, and whose objectivity truly makes them the ones that got away. Of course, the phrase is ambivalent, depending on whether you are the gaoler or the gaoled.

The Irish Short Story's Last Hurrah?

David Marcus

David Marcus, Literary Editor of the Irish Press, *has done more to encourage young Irish writers than anyone else in the country through his editorship of the 'New Irish Writing' page in the* Irish Press *for over fifteen years. Currently working on a novel, he has translated* The Midnight Court *from Irish into English and apart from editing the* Sphere Book of Modern Irish Short Stories, *has contributed to several Irish, British and American publications.*

Last hurrah?

But, it may be pointed out, surely the Irish short story has in the past fifteen years flourished so luxuriantly as to evoke memories of its heyday in the twenties and thirties. Has not the *Irish Press*, one of the leading national dailies, devoted a whole page to it every week since 1968; has it not been consistently encouraged with awards and competitions founded by sponsors such as Hennessy brandy and Maxwell House coffee and prestigious festivals such as Writers' Week in Listowel; have not Irish publishers 'discovered' it and rushed to bring out collections by new writers; have not London publishers continued to sprinkle their lists with the contemporary big names, writers like Sean O'Faolain, William Trevor, Benedict Kiely, Edna O'Brien, Julia O'Faolain, Bernard MacLaverty; and have not such writers, and others, maintained its world-wide, illustrious reputation? When has the Irish short story ever had it so good?

And yet its future faces perhaps insurmountable obstacles, chief of

which is the weight of economic conditions which has effectively nipped the Irish short story's growth prospects in the bud. To use such terms is almost to suggest that the short story in Ireland is an industry. Which is exactly what it is – if of the cottage variety – and like any other industry it needs packaging and projection if it is to maintain even its minimal appeal to a public whose taste is being bludgeoned into submission to fifty-seven varieties of yahoo culture. But the finance required for such packaging and projection in competition with the high-powered publicity other mass-entertainment forms can command is just not available, and if it was, its use would probably be self-defeating in that it would make its product even more expensive than it presently is. The only other way of stealing a march on fortune is to offer one's goods to the public for nothing.

Market – smallness of: one can see immediately that that exacerbates the problem of the publisher who happens to be dealing in Irish short stories, but what about the effect on the writers? From the ground floor up the effect has been disastrous – the ground floor being the literary periodical, which has been virtually obliterated in Ireland. Even before the present economic recession, Irish periodicals – of which in the forties and fifties there were anything up to half a dozen nationally viable and of a high standard – had withered away and so there was no spur for young, potential writers to try their hand at the short story and no testing-ground for them if they did. Ever since the rise of the modern short story at the turn of the century, it is the literary periodical, not short-story collections, that has been the acknowledged stimulus for new short-story writers, thus such a deprivation could have had catastrophic results. Of course recent methods of cheap reproduction have made it possible for many coteries and individuals to bring out their own short-lived and self-serving magazines, but cheap printing only makes for cheapened literature. Fortunately, the gaping hole in the Irish situation was plugged by the 'New Irish Writing' page (which since its inception has published over 200 new short-story writers of whom almost forty have gone on either to be published in other periodicals abroad or to have collections or novels brought out). But even such a resuscitant has not been without its adverse side-effects. One is that the variety of approach which half a dozen, or even three or four different eriodicals would provide is lost. The other significant drawback is that though the *Irish Press* has a national

six-figure circulation, it is largely unread by Northern Protestants and so, with the voice of a highly individual group, who constitute nearly twenty-five per cent of the island's population, unheard, the Irish short story is currently, so to speak, firing on only three of its four cylinders.

Then there is the question of reputation. No matter how often a new writer has been published, it is abroad – and, for obvious reasons, initially in Britain – that he has to gain recognition if he is to make his name. Yet what is happening in this area of operation is thoroughly frustrating for the majority of the new Irish short-story writers and thoroughly inimical to the development of the form in Ireland. First, apart from the women's glossies (which are a special case with special requirements) there are very few British periodicals of standing which devote adequate space to the quality short story – adequate meaning more than one story per issue. Consequently, the chances for a new Irish short-story writer to break into these periodicals are reduced to a minimum.

So what's left? Only book publication. Well, understandably British publishing houses don't often bring out story collections by new Irish writers – and perhaps this is a good thing, for when they do their marked preference is for the kind of short story they think Irish writers should write, i.e. a 1980s version of the-mist-that-does-be-on-the-bog, green-foolery that appeals to the patronizing fleck which has always coloured the British attitude to the Irish; and British reviewers are of the same cast, generally swallowing with chortles of admiration the most pretentious, neo-Celtic mystification and semi-poetic effusions. Unpublished Irish writers might conclude that such a style is the easy path to recognition and try to emulate it, a danger which is compounded by the virtual absence from Irish bookstalls of the few British periodicals which publish good short stories and the total absence of similar US and Commonwealth magazines. As a result, the new or aspiring Irish short-story writer writes in blinkers, lacking easy access to the rising short-story writers of other countries whose work exploits the flexibility of the form without bending it into such shapes as make it generally uninspiring, often uninteresting, and sometimes downright unintelligible.

Which brings me to the raw material itself, the sea of current experience which forms our young writers' element and out of which their stories must, in the main, surface. Here there have been two

significant developments over the past few decades, one clearly beneficial, the other only partly so.

The first has been the emergence of almost a score of excellent new women writers. Slowly, if sometimes unsurely, the women of Ireland are liberating themselves and in doing so they are transforming Irish society. As far as the writing of short stories is concerned their impact has been marked, for it has meant that a whole new thematic field is being explored and exposed. 'Exploited' is the sour epithet employed by some critics (overwhelmingly male, of course) since the experience, for example, of motherhood – which before had received only the most predictable, staid and inoffensive treatment – is now being dealt with in all its aspects, not only with frankness and a complete absence of embarrassment, but with what is for many male Irish readers uncomfortably factual. Inevitably, along with this preparedness to demystify, even desanctify, the function of womanhood has come the concomitant exposé of the hitherto subvervient role of women in Irish society. Not unexpectedly, the thrust of this new theme has been against the machismo of the Irish male, the note it strikes varying from cool to satirical to pitying, often showing (showing up?) their hard-drinking, belligerent exclusiveness as a consequence of generations of Mariolatric mammy-fixation, a cover for fundamental gaucherie and a retreat from the realities of life.

It would, however, be incorrect to give the impression that the contemporary Irish women writers are preoccupied with themes and concerns which directly result from their sexuality and are unable to achieve the necessary detachment to allow them to adopt the broad range of human activity as their spectrum. Far from it; in fact the scope of their subject-matter is probably wider than that of the new Irish male story writers, many of whom only with difficulty and discomfort tear themselves away from the *mise-en-scène* of the pub and whose work is consequently more dependent on nostalgia, anecdote and a degenerative heartiness fostered by the illusion that a story is the shortest distance between any two pints.

The other significant development to have a vital bearing on the content of the contemporary Irish short story is, of course, the sea change which life and mores in Ireland are currently undergoing. The staples of the Irish short story in its heyday – the staples, indeed, which contributed to the formation of the Irish character and psyche – were the thee tyrannous S's of the Irish countryside, Sin, Soil, and

Sex; they are no longer its daemons.

Time was when the sense of sin was a formidable moral force in Irish life. Belief and faith were the muscle and flesh of the body politic and social, religion was its binding, piety and devotion its observable manifestations. In the short stories of those times blackthorn-wielding priests belabouring the bushes like squads of beaters God-appointed to flush out sinners were a widely recognized symbol of a life-denying Church militant. Today the priest as 'heavy' or even as 'goody' has virtually disappeared from the Irish short story and those few cassocks which do make an appearance are more often than not in the process of being discarded in favour of mufti and its concomitant attraction. Piety is still prominent in Irish life (recent surveys suggest that church-going and Mass-attendance are anything but in decline) but only the most myopic observer would deny that within the integument the traditional core is being eaten away.

Then there was Soil, that is land-hunger both agricultural and political. The political strain, as far as the short story was concerned, fathered whole volumes, varying from the nakedly jingoistic and bloodthirsty to the sublimely inspired and humanitarian, in which Southern Ireland was the war theatre and Britain the enemy; Britain is still the adversary but the theatre of operations has moved to Northern Ireland and the chroniclers from that area and that conflict have almost exclusively reached for the high utterance of poetry rather than the more bruising collisions of prose. The agricultural strain of the Irish dependence on land inspired a veritable short-story calendar of rural themes paralleled by a powerful and harrowing literature of exile and emigration. The rural themes are now in decline as the haemorrhage from the countryside has continued – for the first time in Ireland's history less than 200,000 people now work on the land – but whereas Britain and the US were in the past the settings for our stories of emigration and exile, this is no longer the case. Today Irish exile is internal, from the land and the countryside homes to the larger cities – Dublin, whose population now comprises about one-third of the Republic. However, as yet twentieth century urbanization is not a theme which has taken the imagination of our new short-story writers, possibly because the majority of the better ones are women.

There remains only the last of those sinister S's – Sex. Here, as has already been remarked, the incursion of the women writers has imposed its own altered emphasis on sexual themes. The balance has

been further tilted by the decay of sexual guilt, which has effectively deprived the short story in general, and the Irish short story in particular, of one of its most dynamic and energising motifs.

The catalogue of obstacles, pressures and deprivations I have outlined suggests that the Irish short story may be facing a period of stagnation or suspended animation during which the gap between it and the European and American short story will grow even wider. Come such a time, then the reception accorded the recent resurgence of the Irish short story will surely prove to have been the last hurrah.

Women, Writing, and Ireland Now

Nuala O'Failain

Despite David Marcus's assessment of the
changes wrought by women writers in Irish
fiction, at least one female critic disagrees.
Nuala O'Failain says that women don't count in
fiction – or Ireland!
 Critic and commentator, Nuala O'Failain, a
former TV producer and lecturer in
communications at the National Institute for
Higher Education in Dublin is currently working
with RTE.

Women don't count for much in contemporary Ireland, and neither does woman's writing. Woman writers there are, of course, and good ones. Mary Lavin, internationally known from her *New Yorker* stories, is in the very first rank of the second-rate. Elegant, shrewd, small. Younger than Mary Lavin and better known, Edna O'Brien was a serious and daring writer before she lapsed into nostalgia. Behind the barrier of the Irish language there are one or two very fine women poets, and Eavan Boland is a good poet in English. These names would be widely known in Ireland: you have to be more of an aficianado to know and name the absolute successes in the glow of short-story collections, once-off novels, autobiographies in full or partial dress which a vigorous domestic publishing industry has made available to the Irish public. Recently an autobiography – *Sisters*, by June Levine – which includes the first memoir of the Irish woman's movement, has been the first work by a woman, since Edna O'Brien nearly thirty years ago, to stimulate censorship, scandal, acrimony and delight. The rest of the time woman's writing has been socially

inconsequential. It exudes an air of furtiveness both in itself, in the work of, say, Maura Treacy and Emma Cooke, and in its position, at the very periphery of Irish literary and social concerns. It's not important.

And it's strange that this is so. The last two decades have been marvellously hospitable to woman writers and womanly themes. Books, a public medium privately apprehended, have been the carriers of women's movement messages, books started and encapsulated modern feminism, books reflect its multiple effects. The very first books, like *The Second Sex, The Female Eunuch, Sexual Politics, The Captive Housewife* had their origin in some accepted field of discipline: sociology, literary criticism, cultural anthropology. But they extended the fields, subverted the disciplines, ignored the man-made rules of the respectability of form. Especially in America, their authors could afford to be post-academic, knowing that there was a growing constituency of jobs, money and influence, an equal-opportunities era in which the feminist specialist was going to be ahead of the pack. In Ireland, only a handful of young women have any academic status. They have nowhere to go if they publish non-objective, irresponsible – *popular* books. No one, for example, has exploited the Irish woman's sexuality. There are no Nancy Fridays or Shere Hites. From the most vulgar to the most scholarly, an Irish woman has no more information now than she had in 1883.

Or, at least, what she has she has from literature. In indirect and oblique ways certain voices have broken the silence. Kate O'Brien, for instance, and Elizabeth Bowen, both only recently dead. Their books can be found on the same shelf as American sexual surveys in a big Dublin bookshop. In the circumstances, they can hardly be heard. One of the effects of the upfront vigour of American women is to make Irish women seem literary, wilfully obscure, so that no woman writer, in the long and honourable tradition from Maria Edgeworth to the present day, is any kind of precursor or elder stateswoman for Irish women now. The influence is all from America, and all of a sudden. Books that would never have been imported or distributed twenty-five years ago can be found in little country towns. Like lounge bars and soap opera they have changed our references. Only much more to our confusion than the bars or the Dallases. The unqualified message of contemporary American women is don't put up with it. Get up and go. And all this raining down on the heads of Irish women, who have no way of going,

89

nowhere to go to, and no local imprimatur for the message at all.

The second generation of American feminist writing was fiction. When *The Women's Room* arrived in Ireland it was passed from woman to woman: so was *Fear of Flying*, so was *Small Changes*. Any sentence from these and many other fictions could be momentous for the Irish woman as she read. These books carried the thinking that surrounds personal liberation. That thinking was unavailable elsewhere. There was and is an Irish woman's movement, most active in the early 1970s, which never had time for the luxury of the personal. It was and is issue-based, as was necessary in a country with no contraception (never mind divorce), and is necessary while the country remains dismissive of women, especially in private life. Women do know their place in Ireland: there's no ambiguity about where that place is. And they can survive. But they cannot hope for freedom. The immense geography, the wealth of population involved in *The Women's Room* is almost beyond our imagination. Yet it is on those that the plots to escape are predicated. Here, there is no distant city, no commune of ideal-sharing strangers, no dropping out. There is no anonymity. The whole notion of striking out on your own is a social and economic absurdity.

What someone needs to do is to write about internal migration for the woman for whom liberation has primarily meant alienation from the Irish status quo. One of the aids in a rough-and-ready migration is the third generation of American woman's writing, the novelettes. These have been far more influential than the first- or second-stage books, if only because they are essentially capitalist assimilations of feminism, old-fashioned, escapist and non-threatening and are therefore readily available. Novelettes like *Singles, Special Effects, Princess Daisy, Scruples*. The heroines of these books are independent, as well as beautiful. They're clever, as well as beautiful. They're not necessarily or always heterosexual. They are not passive. They smell and bleed as well as smile and kiss. Its not much of a victory for feminism, but it's something, that the stereotype of the desirable female has widened her attributes. But even more than the serious books, like Marilyn French's, these light books are no help to the emerging Irish woman. The world of entrepreneurial business, the new arena of glamour, is unknown to most Irish women. They are more likely to become almost anything other than, by their own youthful efforts, rich.

Almost all contemporary writing of interest to women has been

simple and descriptive, realistic. Formal experimentation in the English language is too elitist for this kind of democratic communal literature. This must seem obvious in America, at the heart of the empire. But by the time you get to the empire's edges, to small English-writing countries like Ireland or New Zealand, the imperial energy and directness seem almost surreal. There isn't any way to write a large, action-packed, or a happy novel about a young woman in Ireland today. Or so the non-writer says. To the non-writer, it simply isn't true, it isn't possible that there is an Irish woman alive whose most pressing problem is, say, the acquisition of a zipless fuck. Which is why there is almost a spoken yearning for the writer who might be out there somewhere, an Irish woman who can define us to ourselves, express us, reveal us to each other, make a milestone in our unmarked history. Edna O'Brien was such a one in the 1960s, but then her world was a relatively simple one, uncomplicated by all that women have since absorbed from American feminism. Irish women aren't just Irish any more; they're part of an international insurrection, even if they never asked to be enrolled.

The topic of women and writing is interesting not for what there is around, but for what there isn't. There is no sign yet of a literary response to the profound change brought about in the status and the expectations of women by contraception and by the feminist movement. There's journalism, there's female demagoguery, but there isn't yet that most potent of resources, a book with people in it and a plot, that feels like a true document of change. If one comes, more will come. Meanwhile, it's all quiet on this most western front.

A Ballad

John McGahern

John McGahern is one of the most honoured of contemporary Irish writers, having received several international awards and fellowships. His novels include The Barracks, The Dark *and* The Pornographer.

'Do you think it will be late when Cronin gets in?' Ryan asked sleepily.

'It won't be early. He went to some dance with O'Reilly and the two women.'

Pale light from the streetlamp just outside the window shone on the varnished ceiling boards of the room. Cronin would have to cross the room to get to his bed by the window.

'I don't mind if he comes in late. It's when you've just got to sleep and get woke up . . .' Ryan yawned.

'You can be sure he'll wake us up. He's bound to have some story to get off his chest.'

Ryan was large and gentle and worked as an inseminator from the AI station in the town, as did Cronin. The three of us shared this small room in the roof of the Bridge Restaurant. O'Reilly was the only other lodger Mrs McKinney kept, but he had a room of his own downstairs. He was the civil engineer in charge of the town's new sewage scheme.

'What do you think will happen between O'Reilly and Rachael when the scheme finishes?'

I was startled when Ryan spoke. These intervals of silence before we fell asleep seemed always deeper than sleep. 'I don't know. They've been going out a good while together. She's beautiful. Maybe they'll be married . . . What do you think?'

'I think he'll just clear out. He's had a good few other women here and there even since he started going out with her. I think he'd have

ditched her before now only that she works in the County Council. And he knows he's getting out of town soon anyhow.'

'She'd have no trouble finding someone else.' She'd been the queen of one beauty competition the summer before and runner-up in another. She was fair-haired and tall.

'She mightn't want that,' Ryan replied succinctly enough. 'Anyhow, the Bachelors' Ball will be interesting on Friday night. Why don't you change your mind and come? The dress suits are arriving on the bus Friday evening. All we'd have to do is ring in your measurements.'

'No. I'll not go. You know I'd go but I want to have the money when I go home at Christmas.'

An old bicycle went rattling down the hill and across the bridge, a voice shouting out, *'Fag a' bealach.'*

'That's Paddy Mick on his way home. He has no bell. It means the last of the after-hour houses are shut.'

'It's time to try to get to sleep – Cronin or no Cronin.'

'Good night.'

It was very late when Cronin woke us but daylight hadn't yet started to thin the yellow light from the streetlamp. We would have pretended to have gone on sleeping but he repeated, 'Are yous awake?'

'We are now.'

'That O'Reilly should be run out of town,' he said.

'What's wrong now?' I had always suspected that he might be extremely stupid behind the facade of lean, intense good looks.

'What he made that girl do tonight no poor girl should have to do, and in front of people too.'

'What was it?' Ryan raised himself on an elbow in the bed while Cronin slipped out of his clothes.

'It was horrible.'

'You can't just wake us up like this and not tell us.'

'It was just too foul.'

'Why didn't you blow the whistle if you felt so badly about it?'

'What could you say once it was done. Once he made her do it. My woman was so upset that she didn't talk for the rest of the night.'

Cronin had been going out for a month or so with a hairdresser, some years older than he was, who owned her own business in the town. None of us thought it very serious, but he was taking her to the ball on Friday.

'Are you going to tell us what happened or are you going to let us get back to sleep?'

'I wouldn't disgrace myself by telling it,' he turned his back to us in the bed.

'I hope you have nightmares,' Ryan swore before pulling the clothes and pillow violently over his head.

The four of us had breakfast together the next morning. There was no one else in the big dining-room except some night-shift workers from the mill across the road in their white caps and overalls and the pale dusting of flour still on their arms and faces. I'd always envied their high spirits in the morning. Breakfast was for them a celebration. Cronin was gloomily taciturn until near the end of the meal when he said, 'You're an awful effin so and so, O'Reilly, to do what you did last night.'

'I haven't even a notion what you're talking about,' O'Reilly bloomed. He was a small barrel of a man with a fine handsome head. He had played cornerback for Cavan in two All Irelands.

'No girl should have to do what you made that girl do last night.'

'You know nothing about women, Cronin,' O'Reilly said loudly,

hoping to get the ear of the mill workers, but they were having too good a time of their own. 'Women like to do that. Only they have to pretend that they don't. Let me tell you that they'd take a poor view of any man who took everything at its face value.'

'It was a disgrace,' Cronin said doggedly.

'You're a one to talk,' O'Reilly rose from the table in high good humour. 'Whatever yourself and the hairdresser were up to in the back of the car, I thought several times it was about to turn over.'

'It was a pure disgrace,' Cronin said to his plate.

Ryan and myself stayed cautiously neutral. I had clashed with O'Reilly from the beginning when I'd refused to become involved with the town football team which he seemed to run with fanaticism now that his own career had been cut short by knee injury. We were all the more cautious because usually Cronin seemed to hero-worship O'Reilly. In the long evenings they could be seen kicking a ball round for hours in the park after training matches. Lately, they'd taken to throwing shoes and pieces of cutlery at the ceiling while I was trying to read upstairs or just correcting school exercises. I was looking forward with relish to O'Reilly's departure.

Ryan's unwashed Beetle was waiting outside the school gate when it finished at three that evening.

'I've calls in the Gaeltacht. Maybe you'll come in case there's need of a bit of translating.'

It was an excuse. There was never need of translation. The tied cow could be always pointed out. The breed of the bulls – Shorthorn, Charolais, Friesian – were the same in Gaelic as on the labels on the straws of semen in the stainless steel container on the floor of the Beetle. He didn't like driving on the empty roads between these silent, alien houses on his own.

'I got the whole business out of Cronin in the office this morning,' a wide grin showed on his face as the VW rocked over the narrow roads between the bare whitethorns.

'What was it, then? It won't shock me.'

'It shocked Cronin. O'Reilly got Rachael to take his lad in her mouth. Then he wouldn't let her spit it out.'

'Spit out what?'

'What's in those straws in the bucket,' he gestured towards the container on the floor of the VW where straws of semen were kept in liquid nitrogen.

'They say it's fattening,' I said ironically to cover my own sense of

shock.

'Not half as fattening as in the other place,' I was unprepared for the huge roar of laughter my poor irony induced.

'What do you mean?'

'O'Reilly's in a white fright. He's got Rachael up the pole.'

'Then he'll marry her.'

'Not unless he has to. Cronin told me that he spent all last week applying for engineering jobs in South Africa.'

'But he has a permanent job to go to in Galway as soon as the sewage finishes. He's been boasting about it long enough anyhow.'

'He could go if he married Rachael but it mightn't be easy if he didn't. News travels.'

We'd come to the first of the ugly cottages the government had built on these thirty-acre farms. They were all alike. A woman met us, showed us to the cow, gave Ryan a basin of hot water, soap, a towel to wash and dry his rubbered arm afterwards. She responded to my few questions with deep suspicion, fearful I was some government official sent out to check on grants or the speaking of Irish.

These people had been transplanted here from the seaboard as part of de Valera's dream, lighthouses put down on the plain from which Gaelic would spread from tongue to tongue throughout the land like pentecostal flame. Used to a little fishing, a potato patch, grass for a cow between the rocks, they were lost in the rich green acres of Meath. A few cattle were kept knee-deep in grass, or the land was put out on conacre to the grain contractors who supplied the mill – and the men went to work in England. It was dark by the time we finished. The last call had to be done by the light of a paraffin lantern.

'What will Rachael do if O'Reilly ditches her?' I asked as we drove back.

'What does any girl do!' He spread his hands upwards underneath the half-circle of the steering wheel. 'It's the same for the knockouts as the plain Janes. You might as well come to the ball. It'll be twice as much fun now that we know what's afoot.'

'You know I'll not go.'

The dress suits came in flat cardboard boxes on the evening bus the Friday of the ball. O'Reilly changed into his suit as soon as he came from work and went to the hotel to have drinks with subcontractors on the scheme. There had plainly been a falling out between himself and Cronin. Ryan and Cronin waited till after tea to change. They'd

never worn dress suits before and were restless with excitement, twisting themselves in mirrors, laughing nervously as they paraded in front of the McKinneys. They found time slow to pass before they'd to go for their girls. Having no steady girl, Ryan was just bringing the girl who took the calls in their office. I went with them to the Midland's Bar, where we had three rounds of hot whiskeys. Still it wasn't late enough to leave when we got back, and they went alone to some other bar, this time taking their cars. O'Reilly had already taken his car with him to the hotel. I'd meant to read, but when left alone found I wasn't able because of the excitement and the whiskey. I was half-tempted to go back up to the Midland's with old Paddy McKinney when he went for his nightly jar, and glad when Mrs McKinney came in soon afterwards to join me at the fire.

'You didn't go to the ball after all?' .

'No. I didn't go.'

'You may be as well off. Old Paddy was a great one for dances and balls in his day, would never miss. And he got me. And I got him. That's all it ever seems to have amounted to,' she said with vigorous incomprehension. Later I tried to ask her if she'd let me have O'Reilly's room when he left, but she'd give no firm answer, knowing it'd be easier to let the room than to fill the bed in the upstairs room, and as if to make up for her evasion she made delicious turkey sandwiches and a big pot of tea instead of the usual house glass of milk.

It was the screeching of a car to a violent stop beneath the window that woke me sometime in the morning, the banging of a door, but no voices. A key turned in the front door. I sat up as footsteps started to come up the stairs. O'Reilly open the door. His oiled hair was dishevelled as was the suit and bow.

'I want you to convey a message for me when they return,' he had to concentrate fiercely to frame the words.

'Where are they?'

'They're still at the ball. I abandoned them there.'

'Is Rachael there, too?' I asked cautiously.

'The last I saw of her she was dancing with Cronin. Cronin made a speech. He got up on the stage for a special request and took the microphone. It was most embarrassing. One should never associate with uncultivated people. I decided that the gentlemanly thing to do was to leave at once on my own. So I'm here.' He stood solid as a stone on the floor, but it was obvious from the effort of

concentration and small hiccoughs that he was extraordinarily drunk.

'Tell them that I'm not to be disturbed. Tell them not to go banging on the door. The door will be locked.'

'I'll tell them.'

'I'm most obliged. I'll recompense you in due course.'

I heard him move about for a little while downstairs. Then his door closed. I wasn't able to be certain whether he turned the lock or not.

The others were so long in coming that I was beginning to think they must have met with some accident. They made much noise. I heard them try O'Reilly's door several times, calling out before Cronin and Ryan came upstairs. Cronin was wild with drink, Ryan just merry and foolish.

'Bloody O'Reilly got home. He's locked the door,' Cronin staggered violently as he spoke.

'He was up here,' I said. 'He asked not to be disturbed when you came home.'

'Not to be disturbed,' Cronin glared.

'I'm just giving the message.'

'That's the notice he has hung on the doorknob,' Ryan giggled.

'I made a speech,' Cronin said. 'A most impressive speech.'

'What sort of speech?' I asked as gently as possible in the hope of diverting the drilling stare.

'That it was the bounden duty of every single man to get married. Of course I was referring to O'Reilly in particular, but it had universal significance as well. To show that I was serious I proposed that I myself be married immediately. This week if possible.'

There was no question of laughing. It would be far too dangerous.

'Of course you make no effort to get married. You just lie here in bed,' he continued. The stare would not be diverted, and then he suddenly jumped on me in the bed, but his movements were so slow and drunken that all I had to do was draw my knees upwards and to the side for him to roll across the bed out on the floor the far side. This was repeated three times. 'Make no effort. Just lie there,' he kept saying and each time the breathing grew heavier. I was afraid the farce could go on for some time, until rising he caught sight of himself in the wardrobe mirror and advanced on the mirror.

'I've never seen myself in a dress suit before. I am most impressed. Instead of giving it back, I think I'll buy it out. I'll wear it in my professional capacity. The farmers will be most impressed.'

I used this unexpected diversion to rise and dress. Then another car drew up outside. Looking out the window, Ryan, who all this time had stood there grinning and smiling, said, 'Rachael's back. She's looking to get O'Reilly to drive her home.'

'How did she get this far?'

'With Johnny from the mill and his girl. She wouldn't come with us. They had to leave Johnny's girl home first. We better go down. They have no key.'

'It is our duty to go down,' Cronin said.

I sat for a long time on the bed's edge before following them down.

A piece of cardboard hung from the doorknob of O'Reilly's room below. I lifted it and read PLEASE DO NOT DISTURB.

Rachael was sitting at the corner of the small table in the kitchen, and with her was Johnny Byrne, the foreman of the mill. She was smoking, plainly upset, but it seemed only to make her the more beautiful. She'd pulled a jacket over her bare shoulders, and silver shoes showed beneath the long yellow dress. Ryan and Cronin had taken Mrs McKinney's cooked turkey from the fridge and placed it on the high wooden table. Cronin was waving a turkey leg about as he inspected himself in Paddy McKinney's shaving-mirror.

'It's no trouble now for me to run you the rest of the way home,' Johnny was saying to Rachael.

'No thanks, Johnny.'

'We'll get him up now. It is our duty,' Cronin suddenly said.

We heard him rattling the doorknob in the hallway. 'Get up, O'Reilly. Rachael's here. You have to run her home.'

After a lot of rattling and a threat to break down the door, a hollow voice sounded within the room as if spoken through a sheet by a man whose life was fast ebbing, 'Please inspect notice and go away,' at which point Rachael went out and ushered Cronin back into the kitchen. He was amazingly docile in her hands. Ryan was peeling the turkey breastbone clean with his fingers.

'You must leave him alone. It's between us,' Rachael moved him gently back towards the turkey on the table.

'Even if you got him up now he'd hardly be fit to drive you home,' Johnny Byrne said.

'We could give him coffee,' and after a time she added, 'I'll try just once more.' She called him, asking him to let her into the room. But all that came in the silence were loud simulated snores.

'It'd only take a minute to run you home,' Johnny said when she

came back into the kitchen.

'No, Johnny. I'll wait. You should go home now. You haven't much time till you have to go to work,' and reluctantly, pausing a number of times, he rose and left. Having stripped the turkey clean, Cronin and Ryan fell asleep in chairs. In the garishly lit kitchen, I sat in Byrne's place at the table. A foolish, sentimental idle longing grew: to leave her home, to marry her, to bring up O'Reilly's child with her in some vague, long vista of happiness; and after an hour I said, 'I could get one of their car keys,' indicating the sleeping inseminators, 'and drive you home.'

'No,' she said firmly. 'I'll wait now till morning.'

She was there when Mrs McKinney came down to get the breakfasts in the morning, there to face her bustling annoyance at the disturbances of the rowdy night turn to outrage at the sight of the pillaged turkey on the table.

'I'm sorry to be here. I'm waiting for Peter to get up. He was drunk and locked the door. He took me to the dance and he has to take me home,' she explained with a quiet firmness.

'Was it him did for the turkey too?' The old woman made no effort to conceal her anger.

'No, I don't think so.'

'It must be those other bowsies, then.'

In her long yellow dress and silver shoes Rachael helped tidy the kitchen and prepare for the breakfasts until the old woman was completely pacified, and the two sat down like ancient allies to scalding tea and thickly buttered toast. Through the thin wall they heard O'Reilly's alarm clock go off.

'They're not worth half the trouble they put us to,' the old woman grumbled.

They heard him rise, unlock the door, go upstairs to the bathroom, and as he came down Rachael went out to meet him in the hallway. It was several minutes before she returned to the kitchen, and then it was to borrow a kettle of boiling water. Outside on the street it was a white world. The windscreen of O'Reilly's car was frosted over, the doorhandles stuck.

'You were right to make him leave you home. They should be all learned a bit of manners,' Mrs McKinney said approvingly as she took the empty kettle back, the noise of the car warming up coming from outside.

O'Reilly was a long time leaving Rachael home, and when he came

100

back he checked that no one had been looking for him down at the sewage plant, reported sick, and went to bed. He did not get up till the following morning.

When Mrs McKinney saw the state of Cronin and Ryan later that morning she decided to postpone the business of the turkey for a day or two. They tried to drink a glass of Bols eggnog in the Midland's as a cure before work, but it made them violently ill, and they had to go back to bed.

The town had not had such a juicy piece of scandal since some members of the Pioneer excursion to Knock had to be taken from the bus in Longford for disorderly conduct three years before. Circling the Virgin's Shrine in a solid downpour while responding with Hail Marys to the electronic Our Fathers had proved too severe a trial for a number of recent recruits.

Now I was stopped on my way to school, was stopped again on my way back, to see if I could add anything to news of the night, but everything down to the devastated turkey seemed to be already known.

Rachael and O'Reilly were married in early January. Only Cronin was invited to the wedding from the restaurant, he and O'Reilly having become great pals again. He told us it was quiet and very pleasant, just a few people, the way weddings should be – those big splashes were just a waste of money. We made a collection in the restaurant and with the money Mrs McKinney bought a mantel clock in a mahogany frame and had all our names inscribed on a bright metal scroll. After a brief honeymoon in London, the new couple went together to Galway, where he took up his position with the County Council. Though it was made permanent, he did not hold it long. He started his own construction company and had soon the name of a very wealthy man. 'A pure millionaire.'

I did not see Rachael and O'Reilly till years later. They were walking up Henry Street, a Saturday morning before Christmas. Silver snow glittered in the shop windows. Stars and strings of coloured bulbs winked above the street.

They were both wearing new sheepskin coats. Rachael's coat fell to her ankles, and a beautiful fair-haired child held her hand as she walked. She had lost some of her wild beauty, but was still an extraordinarily handsome woman. O'Reilly looked very well, his black hair beginning to be touched with grey. A small boy rode on his shoulders, pointing excitedly at the jumping monkeys on the pavements and the toy trumpets the sellers blew. Sometimes the mother turned from the street to smile on him. I followed them till they disappeared into Arnott's.

In the hotel lounges, where architects and planners gather for brandies after dinner, I have heard whispered along the vine that they say O'Reilly wouldn't be half – maybe not even half – the man he is if he had not married Rachael.

The Break

A short story by Bernard MacLaverty

Since the recent publication of his novel Cal, *Bernard MacLaverty, who comes from Northern Ireland and now teaches in the Scottish Isle of Islay, has been the most hailed of the younger school of Irish writers. The BBC devoted an 'Omnibus' programme to him.*

The cardinal sat at his large walnut desk speaking slowly and distinctly. When he came to the end of a phrase he pressed the off switch on the microphone he was holding and thought about the next as he stared in front of him. On the wall above the desk was an ikon he had bought in Thessaloniki – he afterwards discovered that he had paid too much for it – and it had been hanging for some months before he noticed, his attention focused by a moment of rare idleness, that Christ had a woodworm hole in the pupil of his left eye. It was inconspicuous by its position and, rather than detracting from the impact, he felt the ikon was enhanced by the authenticity of this small defect. He set the microphone on the desk and sat forward leaning his weight on his elbows, his fingers pushed up into his white hair dishevelling it.

'Lord,' he said, 'this is difficult. Guide me. Help me to say the right thing.' He remained like that for some time. He was tired and could only break the trance he had allowed himself to fall into by pressing his hands into the slack skin of his face and rubbing hard. He picked up the microphone and switched it on with his thumb.

'New paragraph. As I said, Christians are sometimes accused of not being people of compassion – that the Rule is more important than the good which results from it. There is a sad lack of

understanding here but also it must be admitted that it is, for average or even typical Christians, close to the truth.'

The phone rang on the desk making him jump. He switched off the recorder.

'Yes?'

'Eminence, your father's just arrived. Can you see him?'

'Well, can I?'

'You're free until the ecumenical delegation at half four.'

'Have I the papers for that, Father Brennan?'

'Yes, Eminence.'

'I think I need a break. Will you show him up to my sitting-room?' He picked up the microphone again and thought before switching it on.

'We never succeed in being the Christians we know we should and could be. Yours sincerely etcetera.' He made the sign of the cross and prayed, his hands joined, his index fingers pressed to his lips. At the end of his prayer he blessed himself again and stood up, stretching and flexing his aching back. He straightened his tossed hair in the mirror by flattening it with his hands and went into the adjoining room to see if his father had managed the stairs.

The room was empty. He walked to the large bay window and looked down at the film of snow which had fallen the previous night. A black irregular track had been melted up to the front door by people coming and going but the grass of the lawns was still uniformly white. The tree trunks at the far side of the garden were half black, half white where the snow had shadowed them. The wind, he noticed, had been from the north. He shuddered at the scene, felt the cold radiate from the window panes and moved back into the heart of the room to brighten up the fire. With a smile he thought it would be nice to have the old man's glass of stout ready for him. It poured well, almost too well, with a high mushroom-coloured head. He left the bottle still with some in it, beside the glass on the mantelpiece and stood with his back to the fire, his hands extended behind him.

When he heard a one-knuckle knock he knew it was him.

'Come in,' he called. His father pushed the door open and peered round it. Seeing the cardinal alone he smiled.

'And how's his eminence today?'

'Daddy it's good to see you.'

The old man joined him at the fireplace and stood in the same

position. He was much smaller than his son, reaching only to his shoulder. His clothes hung on him, most obviously at the neck where his buttoned shirt and knotted tie were loose as a horse-collar. The waistband of his trousers reached almost to his chest.

The old man said, 'That north wind is cold no matter what direction it's blowing from.' The cardinal smiled. That joke was no longer funny but the old man's persistence in using it was.

'Look, I have your stout already poured for you.'

'Oh that's powerful, powerful altogether.'

'Sit down, take the weight off your legs.'

The old man sat down in the armchair rubbing his hands together to warm them and the cardinal passed him the poured stout.

'Those stairs get worse every time I climb them. Why don't you top-brass clergy live in ordinary houses?'

'It's one of the drawbacks of the job. Have you put on a little weight since the last time?'

'No, no. I'll soon not be able to sink in the bath.'

'Are you taking the stout every day?'

'Just let anyone try and stop me.'

'What about food?'

'As much as ever. But the weight still drops off. I tell you Frank, I'll not be around for too long.'

'Nonsense. You've another ten or twenty years in you.'

The old man looked at him without smiling. There was a considerable pause.

'You know and I know that that's not true. I feel it in my bones. Sit down, son, don't loom.'

'Have you been to see the doctor again?' The cardinal sat opposite him, plucking up the front of his soutane.

'No.' The old man took a drink from his glass and wiped away the slight moustache it left with the back of his hand. 'That's in good order, that stout.'

The cardinal smiled, 'One of the advantages of the job. When I order something from the town, people tend to send me the best.'

The cardinal thought his father seemed jumpy. The old man searched for things in his pockets but brought out nothing. He fidgeted in the chair crossing and recrossing his legs.

'How did you get in today?' asked the cardinal.

'John dropped me off. He had to get some phosphate.'

'What's it like in the hills?'

'Deeper than here, I can tell you that.'

'Did you loose any?'

'It's too soon to tell, but I don't think so. They're hardly boyos, the blackface. I've seen them carrying six inches of snow on their backs all day. It's powerful the way they keep the heat in.' The old man fidgeted and patted his pockets again.

'Why will you not go back to the doctor?'

The old man snorted.

'He'd probably put me off the drink as well.'

'Cigarettes are bad for you, everybody knows that. It's been proved beyond any doubt.'

'I'm off them nearly six months now and I've my nails ate to the elbow. Especially with a bottle of stout. I don't know what to do with my hands.'

'Do you not feel any better for it?'

'Damn the bit. I still cough.' The old man sipped his Guinness and topped up his glass from the remainder in the bottle. The cardinal stared over his head at the fading light of the grey sky. He could well do without this ecumenical delegation. Of late he was not sleeping well with the result that he tended to feel tired during the day. At meetings his eyelids were like lead and he daren't close them because if he did the quiet rise and fall of voices and the unreasonable temperature at which they kept the rooms would lull him to sleep. It had happened twice, only for seconds, when he found himself jerking awake with a kind of snort and looking around to see if anyone had noticed. This afternoon he would much prefer to take to his bed and that was not like him. He should go and see a doctor himself, even though he knew no one could prescribe for weariness. He looked at his father's yellowed face. Several times the old man opened his mouth to speak but said nothing. He was sitting with his fingers threaded through each other, the backs of his hands resting on his thighs. The cardinal was aware that it was exactly how he himself sometimes sat. People said they were the spit of each other. He remembered as a small child the clenched hands of his father as he played a game with him. 'Here is the church, here is the steeple.' The thumbs parted, the hands turned over and the interlaced fingers wagged up at him. 'Open the doors and here are the people.' Now his father's hands lay as if the game was finished but had not the energy to separate from each other. At last the old man broke the silence.

'I'm trying to put everything in order at home. You know – for the

107

big day.' He smiled. 'I was going through all the papers and stuff I'd gathered over the years. And I found this.' He pulled out a pair of glasses from his top pocket with pale flesh-coloured frames. The cardinal knew they were his mother's plundered from her bits and pieces after she died.

'Why don't you get yourself a proper pair of glasses?'

'My sight is perfectly good – it's just that there's not much of it.' His father fumbled into his inside pocket and pulled out two sheets of paper. He hooked the legs of the spectacles behind his ears, briefly inspected the sheets and handed one to his son.

'Do you remember that?'

The cardinal saw his own neat handwriting from some thirty years ago. The letter was addressed to his mother and father from Rome. It was an ordinary letter which tried to describe his new study bedroom – the dark-brightness of the room in the midday sun when the green shutters were closed. The letter turned to nostalgia and expressed a longing to be back on the farm in the hills. The cardinal looked up at his father.

'I don't recall writing this. I remember the room but not the letter.' His father stretched and handed him the second sheet of paper.

'It was in the same envelope as this one.'

The cardinal unfolded the page from its creases.

Dear Daddy,

Don't read this letter out. It is for you alone. I enclose another 'ordinary letter' for you to show Mammy because she will expect to see what I have said.

I write to you because I want you to break it gradually to her that I am not for the priesthood. It would be awful for her if I just arrived through the door and said I wasn't up to it. But that's the truth of it.

This past two months I have prayed my knees numb asking for guidance. I have black rings under my eyes from lack of sleep. To have gone so far – five years of study and prayer – and still to be unsure. I believe now that I can serve God in a better way, a different way from the priesthood.

I know how much it means to her. Please be gentle in preparing her.

The cardinal looked up.

'Yes, I remember this one.'

'I thought you might like to have it.'

'Yes, thank you. I would.' The cardinal let the letter fall back into its original folds and set it on the occasional table beside him. He got up and poked the fire. Using tongs he set a few lumps of coal from the scuttle on to the reddest parts.

'And did you prepare her?'

'Yes. Until I got your next letter.'

'What did she say?'

'She thought it was just me – doubting Thomas she called me.'

'It was a bad time. I still can't smell garlic without remembering it.' He raked the ash away from the bottom bars of the grate to give the fire air and it burst into bright flame. 'Would you like another bottle of stout?'

'It's so good I won't refuse you.' His father finished what was left in the glass. The cardinal poured another and set it by the chair. The old man stared vacantly at the far wall and the cardinal looked out the bay window. The sky was dark and heavy with snow. It was just starting to fall again, large flakes floating down and curving up when they came near the glass.

'You'd better not leave it too late going home,' he said. The old man opened his mouth to speak but stopped.

'What's wrong?'

'Nothing.' His father knuckled his left eye. 'Except . . .'

'Except what?'

'I suppose I showed that letter to you . . . for a purpose. I want to make a confession.'

'Is there no one else . . .'

'Not that kind of confession.' The old man smiled. 'No, a real confession. And it's very hard to say it.' The cardinal, sensing by the tone of his father's voice that something was wrong, sat down.

'Well?'

The old man smiled a smile that stopped in the middle. Then he put his head back to rest it on the white linen chair-back.

'I've lost the faith,' he said. The cardinal was silent. The snow kept up an irregular ticking at the window pane.

'In what way?'

'I don't believe that there is a God.'

'Sorry I'm not with you. Is it that . . .'

'Don't stop me because I've gone over this in my head for months

now.' The cardinal nodded silently. 'I want to say it once and for all – and only to you. I have not believed for twenty-five years. But what could I do? A son who was looked up to by everyone around him – climbing through the ranks of the Church like nobody's business – the youngest-ever cardinal. How could I stop going to mass, to the sacraments? How could I? I never told your mother because it would have killed her long before her time.'

'God rest her.'

'Frank, there is no God. Religion is a marvellous institution, full of great, good people – but it's founded on a lie. Not a deliberate lie – a mistake.'

'You are wrong, Father. I know that God exists. Apart from what I feel in here,' the cardinal pointed to his chest, 'there are convincing proofs.'

'Proofs are no good for God. That's Euclid.' The old man was no longer looking at his son but staring obliquely down at the fire. 'I know in my bones that I'll not be around too long, Frank. I had to tell somebody because I would be a hypocrite if I took it to the grave with me. I am telling you because we're . . . because I . . . admire you.' The cardinal shook his head and looked down at his knees.

'Do you know what the amazing thing is?' said his father. 'I don't miss him. You'd think that somebody who had been reared like me would be lost. You know – the way they taught you to talk to Jesus as a friend – the way you felt you were being looked after – the way you were told it was the be-all and the end-all and for that suddenly to stop and me not even miss it. That was a shock. I'll tell you this Frank, when your mother died I missed her a thousand times more.'

'Yes I'm sure you did.'

'To tell the God's honest truth I miss the cigarettes more.' The cardinal smiled weakly.

'Don't make fun, Father,' he said. 'Are you depressed?

'No.'

'Have the Troubles anything to do with it?'

'Nothing – although when you read of a teacher blown to bits in front of a class with a shotgun, it doesn't help. To destroy the minds of children is a terrible thing.'

The cardinal seemed to sag in his chair. His shoulders went down and his hands lay in his lap, palm upwards. The snow was getting heavier and finer and was hissing at the window. The old man looked over his shoulder at the fading light.

'I'd better think of going. I wonder where John's got to?'

'Did he say he'd pick you up here?'

'Yes.' The old man looked at his son straight in the eye. 'I'm sorry,' he said, 'but I wanted to be honest with you because . . .' He looked into his empty glass, 'because I . . .'

'You can stay the night and we can talk this thing out later.'

'There's not much more to be said.' The old man got up and stood at the window looking down. He looked so frail that his son imagined that he could see through him. He remembered him at the celebration after his ordination in a hotel in Rome banging the table with a soup-spoon for order and then making a speech about having two sons, one who looked after the body's needs and the other who looked after the souls'. When he had finished, as always at functions, he sang 'She Moved thro' the Fair'. The old man looked at his watch.

'Where is he?' He put his hands in his jacket pockets, leaving his thumbs outside, and paced the alcove of the bay window.

'If I may stand Pascal's Wager on its head,' said the cardinal. 'If you do not believe and are as genuinely good a man as you are, then God will accept you. You will have won even though you bet wrongly.' The old man shrugged his shoulders without turning.

'The way I feel that's neither here nor there. But this talk has done me good. I hope it hasn't hurt you too much.'

'It must have been a great burden for you to carry. Now you have just given it to me.' Seeing the concern in his father's face he added, 'But at least I have God to help me bear it. I will pray for you always.'

'It's not as black as I paint it. Over the years there was a kind of contentment. I had lost one thing but gained another. It concentrates the mind wonderfully knowing that this is all we can expect. A glass of stout tastes even better.' The old man took one hand out of his pocket and shaded his eyes peering out into the snow. 'Ah there he is now. It must be bad, he has the headlights on.'

'Does John know all this?'

'No. You are the only one. But please don't worry. I'll continue as I've done up till now. I'll go to mass, receive the sacraments. It's hard to teach an old dog new tricks.'

'That's the farthest thing from my mind.'

The old man turned and came across the room. The cardinal still sat, his hands open. His father took him by the right hand and leaned down and kissed him with his lips on the cheekbone. The hand was light and dry as polystyrene, the lips like paper.

111

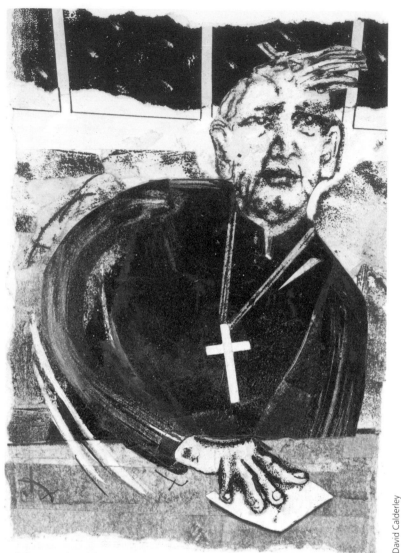

David Calderley

The cardinal had not cried since the death of his mother and even then he had waited until he was alone but now he could not stop the tears rising.

'I will see you again soon,' said his father. Then, noticing his son's brimming eyes, he said, 'Frank if I'd known that I wouldn't have told you.'

'It's not because of that,' said the cardinal. 'Not that at all.'

After he had left his father to the door and had a few words with his brother – mostly about the need for them to get home quickly before the roads became impassable – the cardinal went back to his office. He sat for a long time with his elbows on the desk and his head in his hands. He blessed himself slowly as if there was lead in his right arm and said his prayer-before-work. He picked up the microphone and spoke.

'Add a post-script. The Church has a public and a private face. The Church of Authority and the Church of Compassion, the Church of Rules and the Church of Forgiveness. This was not so with Jesus. We who are within the Church must strive to narrow the gap that exists between them. We know that . . .' His voice trailed away and he switched off the microphone. Then, with an effort that made him groan, he slid from the chair to kneel on the floor. The cushioned Rexene of the chair-seat hissed slowly back to its original shape. He joined his hands in prayer so that his knuckles formed a platform for his chin. When the words would not come he lowered his hands and his interlocked fingers were ready to waggle up at him as in the childish game. A lightning of fear passed through him and he parted his hands and laid them flat on the chair. He raised his eyes to the ikon, his lips moved and he prayed that the Christ of human love would take his father and show him, maybe not the correct way, but a safe way to be united with him in heaven for all eternity.

Poet and critic Kevin T. MacEneaney has also done a great deal to spread an awareness of Irish writing throughout America through his Facsimile Bookshop in New York.

Invocation to the Voodoo Queen

My lovely venomed muse,
What deadly potion are you mixing up now?
And for whom?
Will someone's tongue split down the middle?
A politician's, or perhaps a lawyer's?
Will the landlord's dreams be bloody?
Will the insurance agent strangle his daughter?
Tell me of sprightly suicides in Hollywood,
My half-clothed spiteful cat
Who stalks the moonlit night
And ravages the hypocrisies of the rich,
The proud and the pietistic.
You, my dear, are the Madonna of Hell,
The one-eyed Formorian beauty
Clothed in the mantle of stars,
Born of Night and Eternal Space.
Come closer, take off your fancy lace.

Kevin T. McEneaney

Devotional

It is late at night
and you must remove
your red felt robe.
Lay down
on the double bed
with the silk sheets
and put these blue
Connemara rosary beads
around your navel.

They are made of marble.
They endure.
You must keep still
my dove
as I recite
the rosary of love.

Kevin T. McEneaney

Lenten Love

The clear wax drips.
It is ready.
Remove your red tee-shirt,
my little tom-girl,
so that from this blessed beeswax candle
I may pour
the shapeless molten liquid
into your knotted
belly-button.
This is your penance
for the sins you've committed
against all your bleary lovers,
your soap-opera favourites,
your childhood sweetheart.
Think of all your petty
atrocities and gossip –
let it mingle
with the hot waxed flesh
and let it gently cool
like pale Grecian marble.
The small pollutions of the past
must be purged
so that your body may be
made worthy of Gethsemene.
The legendary Christ of the Cross
hungers for a flesh-scarred paramour.
Some day you will be ready
to climb up on that cross
and become part of the godhead.
Churches will take up the hymn,
'Two on a Cross, they weep and kiss,'
and raw blood-red tonsils
will struggle and strain
to sing your elusive
and ethereal praise.

Kevin T. McEneaney

115

Black Mary

You are the Mary Magdalene
of my dreams.
The way your long dark hair hangs
just as in the Bible.
Repentant you.
Washing my feet
with your hair
because you're sorry
for fucking around.
I should beat you.
But I don't.
Or tie you up in chains.
But I won't.
Terrible things come to my mind but
I love you
and your sins
and your hair.
You are too much.

Kevin T. McEneaney

Complaint to the Goddess
for Martha

When our love was forbidden
we exercised in midnight loft,
executive office sailing in cloud,
or basement nursery with moon
spilling light and shadow over
the red and yellow rocking horse.
Each minute was a sapphire
stolen from the waste of work
or the drudgery of bourgeois time.
No one knew our secret trysts
and I learned to lie and invent,
tutored in the storyteller's art.
Now place and age has ravished
our bodies, the flesh sags.
In the heat of Lake Worth
you are a thousand miles away.
The cares of each day erode
our lives like ogham stones in rain,
water wearing the stone to earth . . .

Kevin T. McEneaney

116

Poet and novelist Brendan Kennelly is Professor of Modern English Literature at Trinity College Dublin and editor of the Penguin Book of Irish Verse.

The Despair of Whales

Back to a time before the sea
Discovered land becoming sea,
They sprawl in colonies of despair.
If they have a home to bull towards
They have forgotten it. If you or I
Could lure them out to sea again
They'd push back here to die.
Unlike the despair of men
This cannot lie to itself
But invades the flopped bodies
Sick of being, eating, loving
The sea's delusive symphonies.

Brendan Kennelly

Folk

The toothless old girl sang 'A Dublin Saunter',
Ignored the sad look of being ignored
In her daughter's eyes.
The old man chirped 'I think I'll join in'
And began to sing
As though the night depended on it.
The new boy worked at his first job,
Conscience beaming from his forehead
Like a miner's lamp in a pretty black pit.
He would be good, really good,
He was ready to sweat blood.
Helen Jones from Tullamore
Pushed back her chair from the table
And walked to the door.
'Not a bad night for love' she said.

Brendan Kennelly

117

When the Game Is Over

The Breeze leads, Bill Holloran follows suit,
My father, smoke-headed, drops the Jack.
Sergeant Langan wins. There's an argument.
My mind, gripped, admiring back,

 adores Miss Vogue
The night before she entered the convent
Tormenting the Breeze,
 'One last kiss, y'oul' rogue';

The kitchen a gambling den;
'The old ticker', my father's heart, flickered, stopped;
Holloran scrapped with cancer, lost;
Sergeant Langan vanished with a young lover,
Went North somewhere, shed the uniform, lived
 apart.
The beauty became a nun who quit to be a mother.

Why do ghosts live so vividly
When the game is over?

 Brendan Kennelly

The Field of Cries

The greyhound tears the hare to pieces
In the field of cries
Nell Hannon says 'tis like a baby
Tortured before it dies

 And the priests and the farmers stand around
 Stand around
 Listening to the cries
 Ascending to the skies
 And buried in the ground

The hare is not yet dead
Is tuggedwrenched from the hound
There's life in the creature still
A man brings on a boy

'Let me teach you how to kill
Slowly kill'

A fair learner, that same boy,
He learns how to kill
Slowly kill
He'll be better in the future
So he will
He's a little crude at first
But this will change to skill

 While the priests and the farmers stand around
 Stand around
 Listening to the cries
 Ascending to the skies
 And buried in the ground

And a hound is not a man
And a hound is born to kill
And helps a boy to learn by heart
The words of a man's will

And we watch where something dies
In the field of cries
Containing man and boy and hound

 While the priests and the farmers stand around
 Stand around
 Still hearing cries
 Ascending to the skies
 And buried in the ground

Brendan Kennelly

TOMÁS MAC SÍOMÓIN

Born in Dublin, 1938. Took PhD in plant pathology at Cornell University, USA. Damhna agus Dánta Eile *(1974);* Codarsnai *(1981);* Cré agus Cláirseach *to be published this year;* Selected Poems, *a bilingual selection, to be published in America.*

Editor's note: the following three poems by Tomás Mac Síomóin are reproduced in the original Irish as well as in translation.

Ar Dhuirling

Fiú nuair a osclaíonn na caisearbháin
(Is iad ag rince sna gorta dubha)
Iomláine mheabhail a gcroíthe
Don ghealach,
Is nuair airítear bó na béaloideasa
Ag smalcadh ceathrú feoile,
Is nuair nach mbíonn i ngad Ariadne
Ach cealgshnáth
In aimhréidh

Fiú
Ansin
Bíonn ruabhéic
Dhochloíte
An chorrlaigh
Timpeallaithe ag
Balla nach ligeann
Aon cheo tríd
A thost
Fiú
Is

Briseann ailgéabair gan oechair
Ar dhúirling cloiche allúraí

Gort An Chriadora

Nó dá mba feasach mé
Praghas na daoirseacht
Don chom sneachta seang slán
Dá dtug mé grá gan chéill!
An tríocha píosa airgid úd,
Tríocha braon fola
Anlactha gan aithrí
In Aicealdáma domhain
Mo chré?

Potter's Field

And had I known then
The price of thraldom
To the perfection of that slender
Shining form
I loved then with a love
Of calculating sense bereft –
Those thirty pieces of silver,
Thirty drops of blood
Buried in this deep Haceldama
Of unrepentant flesh?

Tomás Mac Síomóin

On a Foreshore

Even when the dandelions
Dancing in the black fields
Open the seductive fullness of their hearts
To the moon
And when the great cow of mythology is heard
Chewing on her mess of meat
And when the fabled thread of Ariadne
Is all tangled up
And snarled

Even then
The unconquerable red roar
Of the Laminarians
Is surrounded by a wall
That lets nothing through
Silence
Even

Keyless algebras break
On foreshores of exotic stone

Tomás Mac Síomóin

1845

Lá a raibh
each dubh gan mharcach
ar chosa in airde
ag tóirniú
ar chrúba
ciúine

Lá a raibh
fallaing ag leathadh
a dorchacht
thar learga na gcnoc
lá a dtáinig
spealadóirí
gan súile

Lá dá bhfaca
naomhóga anaithnid
gan duladh ar an bpoll
céaslaí i lámha
marbhán

Lá a ndeachaigh
spealadóir
gan súil ina cheann
ar mhuin eich dhuibh
gur ghluais curracháin
go tamhanda roighin
i dtres mo thíre

1845

The day
a riderless horse
thundered
at full gallop
on hooves
of silence

The day
a cloak spread
its darkness
across the mountain
when the eyeless
reapers
came

The day
strange boats were seen
unmoving on the bay
oars gripped by hands
of deadmen

The day
a reaper
with empty eye sockets
mounted
the black steed
the boats
swung their prows
towards our shores

Thomás Mac Síomóin

Yesterday a great tradition – and today . . . ?
Christopher Fitz-Simon and Fintan O'Toole
present two very different assessments.

Yesterday

Christopher Fitz-Simon

Definitions of 'Irishness' bedevil discussion of the Irish theatre. Can William Congreve be described as Irish? Is Oliver Goldsmith's *She Stoops to Conquer* an Irish play? Does George Bernard Shaw belong to an Irish school of comedy? How Irish is Samuel Beckett?

The short answers to such specific questions are that Congreve is unequivocally classed as Irish in *The Revels History of Drama in English* (1975) and the most recent edition of *Modern Playwrights* (1978). *She Stoops to Conquer* is Irish in so far as it came from the pen of the Club's pet leprechaun and is founded on an autobiographical incident which occurred at Ardagh, Co. Longford. Oscar Wilde wrote to his fellow-Dubliner George Bernard Shaw after the first production of *Widowers' Houses* to welcome him to what he called the 'Celtic school' of play-writing. Samuel Beckett is as clearly Irish as James Joyce, and, as Joyce found it necessary to create a new form – and a new language – for the European novel, thus Beckett for the European play: their dissatisfaction with English is central to both, but this dissatisfaction had been growing among Irish writers in English since the 'Celtic Revival' of the late nineteenth century.

Language, of course, is at the root of the confusion, for all the major Irish dramatists have written in English, or a form of it. The old Gaelic literature, whether epic or lyric, addresses itself to the single hearer or reader – or to a very small attentive group. Furthermore, Ireland lacked urban centres of any great importance

until well after the Anglo–Norman invasion of 1169, and the theatre, being a public act, only flourishes in cities. The Anglo–Normans brought with them a tradition of European liturgical drama, and performances of mystery and morality plays were given sporadically in Dublin and Kilkenny and possibly elsewhere. These plays, and the religious dramas of John Bale who was Bishop of Ossory in the mid-sixteenth century, were performed in the English language, which the vast proportion of the Irish population was unable to understand.

The theatre, therefore, is a latecomer to Ireland; but the Irish, once they had assimilated the English language over a period of time, allied certain Gaelic qualities – the imaginative turns of phrase, the inventive juxtaposition of images, the devious (and rather personal) sense of fun – to the sophisticated structures of European drama which reached Ireland via England. If wheels may ever be appropriately described as turning full circle, then Brian Friel's play of 1976 *Faith Healer* – a very theatrical piece of work – completes this circle, making direct and obvious use of the Gaelic storytelling technique, buttonholing the hearer from the first line, and maintaining the monologue form throughout. Friel revels in words, though not merely for the sake of pleasant sounds; and in this his Gaelic ancestry resonantly manifests itself.

It can, of course, be argued that a high proportion of the Irish dramatists of the seventeenth, eighteenth and nineteenth centuries were the descendants of colonial settlers, and therefore not properly 'Irish' at all; but how many centuries does it take, I wonder, for an immigrant family to identify itself with its indigenous neighbours? 'More Irish than the Irish themselves' is the oft-quoted and apt phrase used to describe the progeny of the Anglo–Norman settlers. The poet Jorge Luis Borges, in his essay 'Argentina: Writer and Tradition', says that 'in the case of the Irish, we have no reason to suppose that the profusion of Irish names in British literature and philosophy is due to any racial pre-eminence, for many of those illustrious Irishmen (Shaw, Berkeley, Swift) were the descendants of Englishmen, were people who had no Celtic blood; however, *it was sufficient to them to feel Irish, to feel different,** in order to be innovators . . .'

Had Borges been writing exclusively of the theatre, he might have mentioned, in this context, Boyle, Southerne, Congreve, Farquhar,

* My italics

Goldsmith, Boucicault and Wilde – most of whom (I hasten to emphasize) *did* possess 'Celtic' blood through intermarriage. But there are other dramatists of the last three centuries who are true Celts (if we are to assume so xenophobic a categorization) – like the members of the Sheridan (Ó Sireadáin) theatrical dynasty, of which Thomas Sheridan, the actor and manager, and his son Richard Brinsley Sheridan the playwright, are the most famous. Obvious surnames proclaim the native Irishry of Arthur Murphy, who, in his day in London, was considered superior to Goldsmith and Sheridan; or Hugh Kelly, Goldsmith's rival; or John O'Keefe, the exuberant author of over two dozen comedies including the delightful *Wild Oats* which enjoyed a two-year run in its RSC revival in the 1970s.

The fact is, the contribution of the island of Ireland to the theatre of the English-speaking world has been out of all proportion to the size of the country or the number of its inhabitants, and it is perfectly realistic to argue that every phase of the British theatre from the post-Restoration period until the present day has been dominated by an Irish figure or figures.

Writers like Farquhar, Goldsmith and Wilde moved their place of domicile from Dublin to London because London was the centre of their literary and artistic universe. (Much has been written on the subject of the Irish literary exile, but it must be stated that not all took the emigrant boat in the Joycean spirit of 'I will not serve'.) What these very different writers had in common was an ability to observe and portray English and, more specially, London society, from the point of view of the outsider. They saw the foibles of this society from quite a different perspective than that of their British counterparts. Generally, they excelled in mannered or satiric comedy, often of a destructive nature, making a mock of the Englishman's proper and serious regard for his own social institutions, particularly for that most sacred of all institutions, the English language.

Congreve's diamond-like observations and ripostes; Sheridan's spiky antipathetic dialogue with its dependence on visual allusion; Wilde's masterly use of epigrammatic inversion; all, in their disparate ways, display a relish in verbal mockery which would have delighted their Gaelic antecedents or the neighbours of their antecedents, had these antecedents been able to understand so strange and unambiguous a foreign language. – 'A character dead at every turn!' exclaims someone in *The School for Scandal,* and, he might have added, 'English institutions murdered! The English language

Oliver Goldsmith

George Bernard Shaw

strained to bursting!'

Not all the playwrights of this Irish school have been so influential or so innovatory, but it is worth mentioning some of the lesser lights in passing, for most of them shared their masters' wit or exuberance to some degree, and all helped to keep the theatres of London (as well as Dublin) busy: Charles Coffey, Charles Molloy, Nicholas Brady, Nahum Tate, Henry Brooke, Isaac Bickerstaffe and Andrew Cherry.

The only considerable Irish playwright of the early nineteenth century was J. Sheridan Knowles, who wrote a large number of showy and extremely popular tragedies in the 'Shakespearian' style for leading British players like Macready and Kemble; he was less successful with his comedies, but *The Love Chase* is not at all unworthy of a kinsman of Richard Brinsley Sheridan, and now seems immensely superior to his tragedies. However, the taste for comedy of manners had passed. Dion Boucicault's early comedies *London Assurance* and *Old Heads and Young Hearts* are in the same tradition, and it is interesting to note that the former was very successfully revived by the RSC in 1970, whereas it is unlikely that one of his later melodramas would have done so well. Boucicault's Irish trilogy, *The Colleen Bawn*, *Arrah-na-Pogue* and *The Shaughran* is still performed to applause in Ireland. Shaw was a Boucicault admirer, and took his courtroom scene for *The Devil's Disciple* almost directly from *Arrah-na-Pogue*. O'Casey, as a boy, acted in Boucicault, and of course saw many Boucicault revivals: his use of alternating scenes of tragedy and farcical comedy is an inherited trait.

Naturally enough, Augusta Gregory, who was O'Casey's chief mentor at the Abbey Theatre, could not abide Boucicault's plays, and in the famous manifesto which she, W.B. Yeats and Edward Martyn issued under the banner of the Irish National Theatre Society in 1898 the words 'we will show that Ireland is not the home of easy buffoonery and sentiment' appear. In identifying these repulsive qualities they failed to appreciate the older playwright's skill as a theatre craftsman.

The National Theatre Society sought to create a theatre where Irish writers could seriously treat Irish themes for an Irish (rather than a largely British or American) public. If, from 1898, we have a recognizably 'Irish' theatre, we also have one which received its chief influences from the continent of Europe. The France–Belgian association was particularly strong. William Fay, the company's first

professional director, had been stirred by André Antoine's Théâtre Libre. Yeats was fascinated by the symbolist theatre, and especially by the plays of Maeterlinck. (Wilde's influential *Salomé* – written in French – can be easily fitted into this scheme.) Synge, who, like Beckett a generation later, studied French in Trinity College, Dublin, spent half of every year in Paris over a decade, drew some of his dramatic material from early French drama, was interested in Maeterlinck, and was fluent enough in the language to write his working notes in it. George Moore, an early supporter, was an inveterate Francophile.

As well as this, the voices of Ibsen and Strindberg were distinctly heard, via J.T. Grein's Independent Theatre in London – the earliest management to produce a play by Shaw. Annie Horniman produced Shaw, Yeats and (the now forgotten) John Todhunter while lessee of the Avenue Theatre. London resumed its position as a meeting-place for serious-minded Irish writers and also as a place where, for practical reasons, their plays could be presented.

Thus it will be seen that the influences affecting the new Irish drama came very much from France and Scandinavia, just as the themes and stories for the plays came from the Irish countryside, provincial towns, and city streets. The jockeying for position between the followers of Ibsen and the realistic drama of everyday life, and the followers of Maeterlinck and the symbolic drama of the interior life, was very much a feature of the early Abbey Theatre. Plays of the local and contemporary world hobnobbed, so to speak, with plays which were other-worldly.

It is hardly a step at all from the world of Synge's grotesques and solitaries – one thinks immediately of Martin and Mary Doul (*dall* = blind) in *The Well of the Saints* , alone, distressed, yet eloquent and inventive, and the 'dreaming back' ghost-ridden and word-abounding characters of the later Yeats – to the world of Beckett's articulate vagrants and lonely voices, passing their time in remote or vague locations, emitting a flow of restless and arresting talk – allusive, recondite, and packed with native wit. Synge, writing in English, developed a language which many Englishmen find difficult to understand; on the surface a transcription of the English spoken by farmers and fisherfolk who were natural Irish-language speakers, or else only a generation removed from the Irish language: English words but Gaelic constructions expressing the Gaelic thought-process.

Many critics have found Synge's language altogether too fanciful, and have failed to understand what was happening: John Millington Synge, descendant of English settlers, very much at one with the Irish landscape and its people, absorbing the speech and the ways of the peasantry, consciously learning the Irish language (he was, we note with hindsight, the first important playwright to do so) yet virtually having to invent a language for the theatre, so inadequate did contemporary standard English seem. Joyce, in the novels, went further, making the English language his own, fracturing it, preparing the road for Beckett and his theatre; Beckett who eschews English totally when it suits his purpose – '*En français, c'est plus facile d'écrire sans style*' (!), or making use of English at other times, English being 'a good theatre language, because of its concreteness, its close relationship between thing and vocable'. Congreve would have said the same, though he would have expressed it differently.

Irish playwrights, situated on the periphery of Europe, inheriting a language which is not their own, removed from the culture of the great commercial nation which has had such a bearing on their own culture and from which many of them descend, now find themselves in a far more commanding (or, manifestly, far less forelock-touching) position than they did in the days of Farquhar or Goldsmith or Boucicault. Yet problems of nationality and national identity still seem to preoccupy them – and nowhere so much in recent times as in Brian Friel's play *Translations* (1980), which at its heart concerns itself with the destruction of one language by another, of one culture by another; with the notion of language as a means of communication and as a barrier to communication at the same time; and about the nature of words themselves.

Christopher Fitz-Simon, lecturer, and producer for both stage and television, is the author of The Irish Theatre *(202 illustrations, 24 in colour) published by Thames & Hudson in July 1983.*

Today: Contemporary Irish Theatre – The Illusion of Tradition

Fintan O'Toole

Fintan O'Toole was born in Dublin in 1958. He is a freelance journalist and theatre critic of In Dublin *magazine. Over the past five years he has also written for a wide variety of other publications in Ireland and has reviewed plays for RTE radio and television.*

Contemporary Irish dramatists are the orphans of the Irish Literary Renaissance. Supposed to be part of a continuous tradition springing from the illustrious loins of the founders of the Abbey, they are in fact working in a country which has no genuine theatrical tradition, which has no system of formal training for actors, which has only a handful of trained directors, and which frequently lacks the resources to realize their plays on stage. For those who attempt to go beyond the dominant naturalism, it is a matter of battling to construct individual solutions in an often unyielding environment. According to the solutions they have adopted, almost all modern Irish playwrights can be regarded as belonging to one of three distinct groups.

The first, and best known of these groups is the one formed by the dramatists who initially managed to by-pass the Irish theatre and find recognition in Britain or America. The three writers who are regarded as being between them responsible for the bulk of Ireland's contribution to contemporary theatre all became international figures in the sixties and for a long period wrote primarily for foreign audiences. Tom Murphy, with *A Whistle in the Dark* staged in London in 1961, Hugh Leonard with the 1963 London production of

132

Stephen D and Brian Friel with the New York success of *Philadelphia Here I Come!* in 1966, each established himself as a playwright without having to confront the narrowness of his native theatre.

All three are now living and working in Ireland and of them, only Hugh Leonard has been able to do so without having to intervene directly and create the conditions in which his own work can be produced on stage. Winning a Tony Award for *Da* in New York in 1978 has placed Leonard in the mainstream of international commercial theatre and his audience in Ireland is in many ways incidental to his work. Like most of the plays that are successful on Broadway or in the West End, Leonard's works are comedies of impotence. The world is shored up with laughter, not confronted. His characters are classless, and they have no nationality or history. Their Irishness is insignificant, their dilemmas universal to the modern middle class.

Significantly, Leonard's most recent play, the first of his plays to reflect on a specifically Irish situation in a way which could hold little interest for foreign audiences, was also his least successful work for many years. *Kill* is a political satire aimed largely at the figure of Charles Haughey, the former Irish Prime Minister. Its complex system of references and analogies would be beyond any audience other than an Irish one and Leonard was perfectly aware of this when he undertook the project. The fact that the play was well below the standard of most of his mature work suggests that, having thoroughly committed himself to an international idiom, Leonard can no longer revert to a voice that is for Irish ears alone.

The other two writers who form this group, Tom Murphy and Brian Friel, are close friends of each other but not of Leonard. The mutual antipathy (Friel regards Leonard as an Irish version of Neil Simon; Leonard sees Friel as a narrow nationalist) mirrors a much less superficial dichotomy of attitudes regarding their personal roles as playwrights in Ireland. In different ways, their perception of those roles has led both Friel and Murphy to attempt the establishment of greater control over the staging of their own work. Without theatrical institutions of sufficient authority and stature to be able to match the creative power of the playwrights, the writers adopt a justified defensiveness in seeking to minimize the risks of theatrical miscarriage when their plays are produced.

'The man who goes to England and who belongs neither to England nor to Ireland lives in a vacuum,' said Tom Murphy when he

lived in London. On his return to work in Ireland at the beginning of the seventies, Murphy found himself to be still in a theatrical vacuum. His work has moved beyond naturalism to a concern with what he calls the 'broad strokes' of theatre, with expressionism and melodrama. In spite of the fact that he wrote, during the seventies, two of the finest plays produced in Ireland since the war, *The Morning After Optimism* (1971) and *The Sanctuary Lamp* (1975), Murphy has become increasingly marginalized in the Irish theatre as his struggle for new forms has progressed. His reputation in Britain seems to have all but disappeared, and his last three plays staged in Dublin, and given productions that never really approached a fulfilment of their theatrical power, failed badly at the box office. Yet *The J. Arthur Maginnis Story*, *The Blue Macushla* and his adaptation of Liam O'Flaherty's novel *The Informer* all provided further support for the belief that he is Ireland's most important living dramatist.

Murphy has attempted to break out of the vacuum into which the underdeveloped state of the Irish theatre has placed him by himself directing his new plays. Brian Friel went much further by forming Field Day Theatre Company with actor Stephen Rea in 1980. Questions of identity and exile, personal, geographical and political, have dominated Friel's plays since *Philadelphia, Here I Come!* and as an Ulsterman the political dimension of that sense of exile has come more and more into focus in recent years. Field Day, which so far has produced only work by Friel, is an attempt to extend the concerns of his plays into an organized theatrical enterprise. As a member of the Northern minority, he himself is aware of a sense of exile. 'If you have a sense of exile,' he says 'that brings with it some kind of alertness, and some kind of eagerness and some kind of hunger . . . those are the kind of qualities that maybe Field Day can express.'

Since its foundation, all three of Field Day's annual productions have been dominated by Friel's sense of the importance of language in the determination of what constitutes Irishness. Friel now emphatically states that he is writing for an Irish audience and that if his discourse is overhead by outsiders, that is no more than a pleasant but insignificant bonus. Field Day's first production *Translations* which had the greatest impact of any new play in Ireland for many years, examined the historical disjunction caused by the forced shift of Irish speech from the Gaelic language to English. In his translation of Chekhov's *Three Sisters* the following year Friel very successfully transposed the play into an Irish idiom with a range of meaning very

different to the standard English versions. His most recent play *The Communication Cord*, a farce, continues the themes of language and heritage in a modern setting which acts both as a parody of *Translations* and marks the impoverishment of Irish culture which he sees as having taken place since 1833 when the action of the latter play occurs.

If questions of exile animate the work of Friel and Field Day, there is a second distinct group of Irish playwrights for whom physical exile is a more or less permanent reality. Writers like David Rudkin, Bill Morrison, Ron Hutchinson, and to a lesser extent Stewart Parker are based in Britain and their relationship to the theatre in Ireland has been either tenuous or non-existent. While their themes have remained Irish, or more specifically Northern Irish, their work has found more of a place on the British stage and television than it ever has in Ireland. Rudkin, however, has become an Associate Director of the Belfast-based New Writers' Theatre and seems set to make a more direct contribution to Irish theatre over the next few years.

The third group of writers, and one which has emerged only over the past four years, is comprised of a number of new dramatists who have gathered around the Peacock Theatre, the small companion theatre of the Abbey. Bernard Farrell, Graham Reid, Neil Donnelly and Frank McGuinness are at times starkly different playwrights but together they form the first group of Irish playwrights since the war to have established themselves professionally through writing primarily for the Dublin stage. They have managed to do so only because of a change of policy with regard to the Peacock brought about by the Abbey's Artistic Director Joe Dowling and particularly its Script Editor Sean McCarthy (who is to leave Ireland for Edinburgh shortly). Under their administration the Peacock has become in some sense an 'alternative' to the Abbey, a forum for new work and above all a platform for expressing in theatre urgent, broadly political notions about the nature and direction of Irish society.

If the Peacock is an 'alternative' theatre, though, it is a rather reluctant one and, as a part of the Abbey, remains 'establishment'. This ambivalence has expressed itself in the fact that although the new writers show a sharp social concern, they have been largely conservative in their choice of theatrical form. Their livelihoods revolve around the Abbey and their work has quickly fallen into line with the robust and cunning naturalism which dominates that insti-

tution. These new writers have produced a number of plays of real value but none that could suggest the rebirth of the once-revolutionary tradition of the Irish theatre.

The Peacock has taken on the role that it has largely because of the lack of any real alternative to the Abbey in Dublin. The Gate, founded by Micheal MacLiammoir and Hilton Edwards with the intention of providing just such an alternative, of bringing international work to Ireland, of discovering new Irish work and experimenting in methods of presentation, has wandered very far from that intention, particularly since the deaths of its founders. Its staple diet has now been reduced to second-hand versions of West End successes and its contribution to the development of Irish theatre is currently barely discernible.

The energies which gathered around Dublin's Project Arts Centre in the seventies as a hub for new and experimental work have also been dispersed. The man around whom most of those energies were consolidated, the playwright and director Jim Sheridan, is now living in New York. His latest play *The Immigrant* was seen at the Project during 1982 Dublin Theatre Festival performed by the Canadian company Theatre Passe Muraille, and it is suggested that when Sheridan returns to Dublin he will have a major role to play. The Project, meanwhile, is attempting to re-establish the level of theatrical activity which it once produced and a full-time company of actors will be set up shortly.

The most exciting evidence of the final emergence of a revivified Irish theatre, however, is coming from Galway, a city with little theatrical tradition, and from a company that is less than eight years old. Under the direction of Garry Hynes, Druid Theatre Company has developed a style which places the emphasis on performance rather than interpretation, which is physically assured and constantly inventive, which has its strength in visual impact as well as in the verbal ingenuity that for too long has been the only boast of the Irish theatre. Their 1982 production of *The Playboy of the Western World* matched at last the richness of Synge's language with the powerful images it created on stage, exorcizing the ghost of the Irish Literary Renaissance which has haunted the vacuous recesses of our contemporary theatre.

There are other signs too. The writer Tom McIntyre has settled permanently in Ireland and has begun a series of plays which will unite the visual and the verbal in a way which, if he finds actors and

directors to suit his enterprise, could be enormously fertile. There is also a new willingness to develop the physical skills necessary for encouraging the dimensions which have so long been undernourished, as evidenced for example by Vincent O'Neill's establishment of Ireland's first ever mime school at the Oscar Theatre. Slowly, disparately, the elements of a new Irish theatre are being assembled.

Irish language

Tim Pat Coogan

The Irish language until recently was one of the most controversial issues in Irish life. Now it is merely one of the most poignant.

The reason that the language has not been restored at least, say, to the pitch of Welsh, though all governments since Independence have been committed to restoration, was explained to me once in an anecdote told by a scholarly west of Ireland schoolteacher, Michael Muldoon, now retired. In the early twenties he was on a bicycle tour of a remote part of Irish-speaking Connemara with another, older, teacher when he was startled by suddenly coming upon a wild-looking crowd of people of all ages and apparently in the grip of some strong emotion. The centrepiece of the crowd's attention was a young fellow aged about eighteen, dressed in homespuns, shockheaded, with a bundle wrapped in newspaper under his arm.

It transpired that the teachers were witnessing the finale of an American wake; the crowd of relations had come to see him to the bus that would bring him on the first stage of his journey to America.

The older teacher said to Muldoon: 'We are lyrical about the glories of the Irish language but that's what will kill it.' He was right, as Michael Muldoon explained to me nearly sixty years later. There were nine or ten children in the wake family, and nearly all of them had to emigrate like all the other families of their type. Their parents wanted them at least to have a knowledge of English when they went abroad having left the 'National' or primary school at an average age of twelve. Until 1965, when the Irish educational system was vastly improved, half of all Irish schoolchildren left school at that age. Obviously something had to give.

'They would come down to the school and say things like "Maistir [Master] don't have them going abroad a fool for the world. Teach them English," ', recalled Muldoon.

Most of those families wouldn't have been living in the impoverished, western seaboard in the first place, had their ancestors

not been dispossessed of their own fertile holdings and driven 'to Hell or Connacht' as the Cromwellian slogan had it.

As travel facilities improved they voted with their feet to try for fresh opportunities in other parts of the world, thereby depleting the wellspring of the language.

No matter what grants or doles the government pumped into those areas to encourage Irish, they were swimming against the forces of the economic stream. Moreover as the twentieth century progressed the State was relying on a wellspring that in many cases preserved a Neolithic culture, which further broke down under the spread of communications.

Other factors complicated this process, the narrow, near fanaticism of some of the language revivalists: which had the effect of repelling many potential sources of sympathy; the fact that language was taught in a purist's, severely grammatical fashion, as a badge of identity, rather than a means of communication, and that music, song, the sheer enjoyment of life was banished from its purview. All this daubed the revivalists' movement with an image of puritanism, which alienated it from young Ireland. In fact, the Irish tradition is as earthy and bawdy as any other, as for instance the lengthy comic poem the 'Midnight Court' testifies. In the 'Court' the women of Ireland protest in graphic detail at the lack of sexuality in Ireland's menfolk.

However, in the past twenty years or so more affluent parents who were also language enthusiasts began to organize the setting up of schools in which Irish was the medium of instruction. Something approaching a 'second front' built up. As this development spread charges of elitism came to be levelled at the Irish schools by opponents of the revival but this 'second front' does seem to hold out real promise, several hundred schools being established in recent years many of them, increasingly, in working-class Dublin suburbs.

As the early founders of the State were all Gaelic-speakers and wished in the words of Pearse, the executed 1916 leader, that Ireland be 'not free merely but Gaelic as well', the language for a time had powerful friends in court and in De Valera's Constitution is termed the first official language of the State. This, however, generated equally powerful opposition and controversy as one unsuccessful scheme after another was promoted to resuscitate the language – up to recently all schoolchildren, for instance, had to take Irish as a compulsory subject.

Nevertheless while the number of 'native speakers' – those living in the western Gaeltacht areas and using Irish as a daily means of communication – has dwindled inexorably, the sheer consciousness of being Irish mentioned in my introduction had staged something of a comeback, 'the roots syndrome'. A principal force in helping this has been the legacy of Sean O'Riada in Irish music carried on by groups such as the Chieftains and Horslips. This has certainly influenced young people. The growth in popularity of *Seisiuns*, traditional, musical occasions in the west, have played their part. The Irish-speaking Aran Islands where Yeats sent Synge to rediscover Gaelic culture in the great days of the Abbey's youth attract thousands of visitors each year – though more for the 'crack than the culture' – and writers like Daragh O'Conaola have made a conscious effort to return to the islands, birthplace of writers such as Liam O'Flaherty, and the poet Mairtin O Direain, and of the documentary film. Robin Flaherty made *Man of Aran* on Inis Mor, the largest of the three islands. Probably the Northern troubles have something to do with it too. The heightening of a sense of nationality brought on by the troubles resulted in phenomena like that observed during the 'dirty protest', which preceded the Long Kesh hunger-strike, of prisoners learning Irish by cutting a word a day into their own excrement smeared on the cell walls – sometimes with their Rosary beads. A classic example of how love of the language carried to extremes by definition aroused correspondingly strong feelings on the part of its adversaries. In this case the Loyalist prison warders.

The Irish language is one of the most emotive, intractable and significant issues that forms part of the backdrop to the cultural scene. But it is not all backdrop. Writers like Martin O Cadhain or Brendan Behan may have gone to join the majority, but as the translations of some of the better parts of the younger school now working in Irish show, there is plenty stirring in the forefront also. Michael Davitt, one of the most active and prolific of the contemporary young Gaelic intellectuals, takes up the story.

HOLIDAY IRELAND

Ireland is so close, so varied and so friendly that it makes an ideal place for getting away from it all.

And with Aer Lingus, you can fly there in about an hour, pick up a hire car and drive off into beautiful Irish countryside.

Aer Lingus offer a wide choice of flight-inclusive holidays in Ireland, with convenient departures from 8 airports in Britain. Starting from only £88 (per person, based on 2 or more travelling together).

Tara Luxury Touring.

Spend a fabulous week exploring Ireland by car. Prices start from £259. Simply plan your route by choosing from a range of beautiful country houses, castles and luxury hotels. Selected from the finest in the country, each one is set in its own private grounds and offers you a leisurely and relaxed lifestyle.

And between each stop there are miles and miles of magnificent touring country — mountains, rivers, lakes and craggy coastlines.

Farmhouse Holidays.

Live on the farm for a week for as little as £183 per person. You can either stay seven nights at a farm of your choice, or tour around staying in several different farmhouses — seeing Ireland on the way.

Farmhouses are great family holidays — many with beaches nearby, fishing, boating and golfing. And with all that fresh air, you'll be glad of the good country cooking that's just part of the Irish farmhouse lifestyle.

Dublin Weekends.

Fly to Dublin and settle into your first class hotel for a weekend from £97 per person, in this historic and beautiful city.

Dublin has everything — from Georgian buildings, squares and terraces to fashionable shops, a wide choice of restaurants, theatres and cinemas — and of course, the famous bars. And there's all sorts of sports — golf, football, rugby and horse racing.

For full details of these and other superb Irish holidays from Aer Lingus, see your local travel agent and pick up a copy of our 1983 brochure. Then you can hop over to the holiday island with a difference.

The most interesting people go to Ireland.

ATOL 912

Aer Lingus Holidays ☘

London: 01-439 7262

Birmingham: 021-236 6211; Manchester: 061-832 8611; Glasgow: 041-248 4121

A Repossession

Michael Davitt

Michael Davitt, born in Cork in 1950, is the founder/editor of the poetry journal INNTI.

I have always found it hard to discuss the Irish language through the medium of English in an ordered logical way. It can be a bit like referring to an old person as *it* – Irish (Gaeilge) is *she*. The same old arguments for and against *it* tend to be clinical and unenlightened: should it be allowed a peaceful and dignified death . . . why are Irish speakers so snobbish, old-fashioned, narrow-minded, puritanical? . . . the revival can still work if the government pumps a few million pounds into the Gaeltacht . . . if only the West Brits and the Gombeen men were silenced and the real Irish were given back their voice . . . what good will *it* do me when I leave school? . . . etc. etc. The Irish language is a raw nerve on the national funny-bone.

It is even harder to discuss writing in Irish, through English. It is like making the reason you write in Irish seem redundant.

1981 saw the publication of Thomas Kinsella's and Seán Ó Tuama's *Poems of the Dispossessed*, a hundred poems with English translations, from the 1600 to 1900 period, during which an assault by an imperial foreign government on the Gaelic people took place, through armed force, penal repression and famine. This book is an acclaimed popular success at home and abroad, unveiling the richness of the Gaelic heritage to non-Irish speakers, in particular, as Daniel Corkery's *The Hidden Ireland* did in the twenties. But with respect to the 'dispossessed' and to their newly-acquired audience, there are a number of us who don't give in too easily and who continue to be engaged in the ongoing adventure of Repossession.

Many critics would prefer us to be repossessors in a purer sense since the modern writer of Irish is faced with an embarrassment of riches, the unique threads that have gone to make the language tapestry: the oral and written literature – one of the oldest in Europe

– prayers, proverbs, and the extraordinary dynamic of Gaeltacht speech, whether Munster, Connaught or Ulster dialect. Even browsing through Fr Patrick Dineen's Irish–English Dictionary (1927) – the beautifully quirky one-time bible of Modern Irish – you will find the likes of *buarach bháis* (pron. buarax vas') in every second page or so:

> *buarach bháis*, an unbroken hoop of skin cut with incantation from a corpse across the entire body from shoulder to footsole and wrapped in silk of the colours of the rainbow and used as a spancel to tie the legs of a person to produce certain effects by witchcraft. (Connaught folk tales).'

Until recently literature in Irish was judged by this distinctiveness. Criticism was, and still tends to be, a form of inspection, the critic looking for the polished phrase, for the closest proximity to native idiom. But for reasons of artistic honesty the modern writer must create his own idiom. Seán Ó Ríordáin (1917–76) was the great 'door-opener' in this regard and was the first modern poet to suffer the isolation which accompanies the decision to write in Irish – the *first official* language of the State whose 'revival' has been carried out since the 1890s by single-minded enthusiasts while the State nods approvingly in English. Ó Ríordáin also suffered the brunt of critics who saw his innovative and idiosyncratic use of Irish as violence to a tradition. He and his successors are like white-collared Aborigines, and not respected enough to be included in the Penguin, Sphere or Faber Books of *Irish* Verse.

Máire Mhacan Saoi says in her fine essay 'The Role of the Poet in Gaelic Society', one of fifty-five essays in a new book *The Celtic Consciousness* (Ed. Robert O'Driscoll):

> I should now like to hazard my concluding theory. Irish – that is Gaelic – verse is so intensely conservative that at all times it has taken a major cataclysm to cause it to change. The coming of Christianity is such a jolt . . . Today it is possible that yet another crisis, this time the death throes of a language, is producing another last flowering.'

Poetry in Irish since the sixties is remarkably diverse. We see Eastern European poets like Holub influencing Tomás Mac Síomóin. Nuala

Ní Dhomhnaill spent over five years in Turkey. Her cosmopolitanism is tempered by a genuine feeling for Irish folk traditions and many of her poems breathe a new life into rural ways and expressions. Liam Ó Muirthile has been exploring his English-speaking Cork roots through the lens of his chosen medium, Irish. Gabriel Rosenstock's work is full of the whole non-Occidental shebang. And so on. Only the most despondent of us would consider his or her language of choice as another Latin. We must continue to find a language for the condition and not contrive a condition to fit the language (and its embarrassment of riches).

There was a great social, political, cultural and artistic upheaval in Ireland towards the end of the last century. We are now heading towards the end of this century and one senses a major shift in consciousness. Maybe the time is right for a Revival, a Celtic Twilight in reverse. And maybe this time the twilighters will see the dawn; all out, swinging the *buarach bháis*!

Botanic Gds. Belfast

ULSTER MUSEUM

Writing on an Island

Dara O'Conaola

Dara O'Conaola is a native of the middle island of Aran, Inishmaan, and now lives on Inishere, his father's native island.

In his teens he left the islands for the mainland, going first to Galway to attend its technical school, where he began his apprenticeship to the woodwork trade, and later to Gorey, County Wexford, where he trained for two years as a woodwork teacher.

He taught in various parts of Ireland for five years, the last two of which he spent in Dublin where he met his wife, Pacella.

Ten years ago they decided to move back to Inishere where they run a craft shop and rear their family. They have three children, one daughter Lasairfhiona, aged ten, and two sons, Dairmaid aged seven and Mac Dara aged four.

I have often heard it said that island life is conducive to writing. There are long lists of island writers, or writers who were inspired by island life, in the annals of the two literatures. One thinks immediately of J. M. Synge who discovered some subtle spiritual quality in Aran that had previously eluded him. I was born and reared in the Aran Islands. I left, though later returned. They called me back. It wasn't the subtle magic sensed by Synge that drew me back, though I was aware of that too. It was something more. In Irish we call it *dúchas*, the ineluctable native experience, the compound of tradition, place and language. I would like my children to know this *dúchas* and that of Ireland in general. The pounding of storm waves on wintry nights,

the wild sound-effects from the chimney accompanying the wonder-tales that have been handed down through generations of story-tellers; or a lambent spring day when the earth seems to move and the heart leaps in your chest.

When I was growing up in Aran most people hadn't even a radio, so, naturally enough, we relied on traditional forms of entertainment. We were just as happy. Nothing could please us more than sitting around the fire listening to my father telling old stories and sagas. Before long we came to know them ourselves. 'Tell us about the giants!' we'd say. And he'd be off. Any change at all, any attempt at an edited or watered-down version late at night and we'd stop him in his tracks: 'That's not how you told it the last time!' Storytelling thrilled my imagination and as soon as I learned to read I got my hands on books. From reading it was only one more step to writing.

A weekly Irish-language paper, *Amárach*, published a story of mine when I was only twelve. A dog talking about himself! I'm still barking away, not up the wrong tree I hope, and articles, poetry and stories flow from my pen in an even, steady stream. An Gúm,

educational and general publishers, published two books of mine: *An Gaiscíoch Beag*, a retelling of a mock-heroic tale and *Mo Chathair Ghríobháin*, a collection of stories.

Usually I'm reluctant to discuss my own writing since, in my opinion, every piece of writing should speak for itself. However, every author and poet has ideas about his work. I write from my own experiences, people and places I know, and there is nothing I like better than adding my own imagination to a traditional tale and coming up with a new story entirely.

Old cottages inspire me always. They remind me of the people who lived in them long ago. Indeed, I find the environment of my family house a great source of inspiration.

For example, in the following story the house would seem to have a life of its own, and nothing in it, great or small, is without significance.

SPIDER

by Dara O'Conaola

Every morning I smoke a pipeful before getting out of bed. It's an old habit of mine. It does me some kind of good that I can't explain. It may be no more than a peculiarity that has stuck to me, though it may just as likely be a subconscious strategy to acquire the peace of mind I need. Call it my matins, if you will.

I sit up in bed. I put on my bawneen. I take the pipe that's sitting next to me. Then the tobacco. I cut it. I rub it. I redden it at my ease. All thoughts of the world leave my head as I contemplate the night's adventures, sleep – which they say is a brother of Death – my worldly duties, and the day ahead.

During these morning meditations of mine, I sometimes shudder at the thought of being disturbed. It would be calamitous to intrude; not only would my reveries be interrupted, my whole day would be ruined and my plans all in a tumble.

The people of the house have learned not to interfere with me and I usually manage a very restful meditation. And then I get up, full of eagerness to tackle whatever bit of work I have laid out for myself.

That's the way it was one morning recently. My mind was gently drifting as usual, my back to the gable, facing the little cupboard and

the small chimney; it was then I noticed something that got my wind up.

A big slob of a spider it was, dangling from the beam and he measuring up the prospects of crashlanding on the cupboard.

'Well, you big oaf you,' says I, 'what business have you to be disturbing the likes of me?' Basically, you see, I'm a peevish, liverish type, mornings especially. Consequently, my first impulse was to teach this impudent lout a lesson. Ah, wasn't he the lucky fellow I wasn't reclining a bit nearer him.

After a few puffs of the pipe, the evil drained from me and soon I was back enjoying my reveries once more and me boyo, the spider, spinning away like mad in my mind's attic.

For all I know, I thought, the fellow could be my poor deceased grandfather, or even my grandmother, or some other relation sent back to earth to spin more karmic web. There's no knowing, I said to myself.

Whoever he was, he was making precious little progress, oscillating to and fro, this way and that, and coming no nearer the cupboard.

I left him to his fate. Let him spin his own destiny, I said in my own mind, for I am not obliged to help or hinder him.

I spent an eternity watching him. To and fro. This way and that. When he tired of his gyrations, by which stage I was near gaga myself from watching him, up he goes. Up his thread, straight up to the beam. He vanished in the darkness.

Then I thought of the day ahead, the work and the foostering that awaited me. I put aside the pipe and readied myself to get up . . . but I wasn't ready yet with the spider.

Whatever innocent glance escaped the corner of my eye what was it I saw but himself coming down the wall; his gait had the resoluteness of a penitent pilgrim. He was making for the cupboard.

Down he came. He reached the top of the cupboard but he didn't stop there. Down still further. He reached the board under the cupboard. He walked the plank. Where the devil are you off to? He seemed to know well enough.

There was a little hole that had escaped my notice until now on the left side of the cupboard, low down, just between the frame and the wall. In he goes.

It was a great relief to me that he stayed there. I got up. I must admit I was very content with the way the morning reveries had progressed.

Many is the morning since then I have watched his peregrinations, up and down, up and up, until eventually he would end up in his little dust bowl between board and wall. He gave me no further cause for annoyance and in the end I grew attached to him. For all I know, as I have previously mused, he may be one of the dear departed.

Time flies. Things change. Things grow. Things flourish. The world moulds people and things, at no time more conspicuously than in spring. The days stretch. Dark winter memories fade.

This is the time when new resolves to be good burgeon in the heart and one attempts to tackle life with something of the zest of a crusader. My wife had such an attack recently, or so her symptoms would suggest.

'Now,' says she, 'now that spring is here, hadn't I better clean out that room and slap a coat of paint on it – it's an anathema, that's what it is, a holy show altogether.'

I had no objection to this move. Indeed, I'm partial to spruceness myself.

She scoured. She painted. It wasn't long before she reached the cupboard. Then I remembered my eight-legged friend. 'Look,' says she, 'would you look at that confusion of webs!'

I closed my eyes, foreseeing the nemesis. When I opened them again, the boards and joints were wiped clean. The spider's dwelling razed, the tenant evicted.

I said nothing. I accepted it – mistakenly or otherwise, I shall never know – as dharma.

Of late, mornings seldom slip by that I don't say a little prayer for the dead. It's not that I give unequivocal credence to what may have been no more than a fanciful notion crossing my mind when he first crawled into my life; not at all. But just in case, and, as I have ventured to opine, there's no knowing . . .

© Translation by Gabriel Rosenstock for the *Literary Review*

THE REAL CHARLOTTE

A brilliant, bittersweet novel of Victorian Ireland

E. OE. Somerville and Martin Ross

Into the small Irish lakeside town of Lismoyle moves pretty, coquettish Francie Fitzpatrick. She provides a steady subject for gossip in the close community as her attentions waver between Christopher Dysart, the shy, scholarly heir of the Dysarts of Bruff, Roddy Lambert, his raffish land agent, and the dashing English army officer, Gerald Hawkins.

Against the dreamy late Victorian background of boating outings and tennis parties, Francie flirts with her young men, unaware of the darker drama which surrounds her, for her cousin Charlotte, a stiff plain woman of secret passions, has laid schemes which go tragically awry...

'Leaving the huge whale — *Ulysses* — basking off-shore, what better Irish novel is there than *The Real Charlotte*?' Terence de Vere White, *Irish Times*

'The whole thing is delightful' Norman Shrapnel, *Guardian*

'A masterpiece...very funny indeed' *Daily Mail*

Price: £4.95 Paperback Available from all good bookshops

Quartet Books Limited
A member of the Namara Group
27/29 Goodge Street,
London W1
Tel: 01-636 3992

Sweeney Astray

Seamus Heaney

Seamus Heaney, generally regarded as the out-standing contemporary Irish poet, originally came from Northern Ireland, but divides his time now between Dublin and Harvard. He has won several major awards, his considerable volume of published work including Death of a Naturalist, Wintering Out *and* Fieldwork.

The following extracts are from a version of the medieval Irish tale *Buile Shuibhne,* a work already available in the old-fashioned English crib provided by J.G. O'Keeffe in his edition of the work for the Early Irish Texts Society in 1913. It is also available, in hilarious and abbreviated form, as part of the comic apparatus of Flann O'Brien's novel *At Swim-Two-Birds.*

Sweeney is an Ulster King who offends a saint, is cursed by him and turned into a bird. The transformation occurs at the moment when violence breaks out at the Battle of Moira and from then until his death Sweeney is doomed to roam Ireland, a displaced person, full of distrust and resourceful lament, a chastened Lear undergoing purgatorial exile among the branches.

Sweeney is anti-heroic, traumatized, in love with the actual, surviving by keeping close to the minimal nurtures and consolations of the earth. He has also awakened from the nightmare of power politics and is attempting to remake his soul. He is a figure of what the Irish poetic imagination has been through and while my original attraction to his story sprang from a relish of the natural magic in many passages of melancholy sweetness I also recognized in Sweeney himself an 'objective correlative' of the poet. I first began to work on the material in Wicklow in 1972 when my identification with the Ulsterman sheltering in woodlands was at its most immediate. Since

then I have tried to make this work more objective, more in tune with the clean shapes of the original.

from Sweeney Astray

Then Sweeney said, From now on I won't tarry in Dal Araidhe because Lynchseachan would have my life to avenge the hag's. So he proceeded to Roscommon in Connaght, where he alighted on the bank of the well and treated himself to watercress and water. But when a woman came out of the erenach's house, he panicked and fled, and she gathered the watercress from the stream. Sweeney watched her from his tree and greatly lamented the theft of his patch of cress, saying, It is a shame that you are taking my watercress. If only you knew my plight, how I am unpitied by tribesman or kinsman, how I am no longer a guest in any house on the ridge of the world. Watercress is my wealth, water is my wine and hard bare trees and soft tree-bowers are my friends. Even if you left that cress, you would not be left wanting: but if you take it, you are taking the bite from my mouth.

And he made this poem

Woman, picking the watercress
and scooping up my drink of water,
were you to leave them as my due
you would still be none the poorer.

Woman, have consideration,
we two go two different ways:
I perch out among tree-tops,
you lodge here in a friendly house.

Woman, have consideration.
Think of me in the sharp wind,
forgotten, past consideration,
without a cloak to wrap me in.

Woman, you cannot start to know
sorrows Sweeney has forgotten:
how friends were so long denied him
he killed his gift for friendship even.

Fugitive, deserted, mocked
my memories of my days as king,
no longer called to head the troop
when warriors are mustering,

no longer the honoured guest
at tables anywhere in Ireland,
ranging like a mad pilgrim
over rock-peaks on the mountain.

The harper who harped me to rest,
where is his soothing music now?
My people too, my kith and kin,
where did their affection go?

In my heyday, on horseback,
I rode high into my own:
now memory's an unbroken horse
that rears and suddenly throws me down.

Over starlit moors and plains,
woman plucking my watercress,
to his cold and lonely station
the shadow of that Sweeney goes

with watercress for his herds
and cold water for his mead,
bushes for companions,
the bare hillside for his bed.

Hugging these, my cold comforts,
still hungering after cress,
above the bare plain of Emly
I hear cries of the wild geese,

and still bowed to my hard yoke,
still a bag of skin and bone,
I reel as if a blow hit me
and fly off at the cry of a heron

to land maybe in Dairbre
in spring, when days are on the turn,
to scare off again by twilight
westward, into the Mournes.

Gazing down at clean gravel,
to lean out over a cool well,
drink a mouthful of sunlit water
and gather cress by the handful –

even this you would pluck from me,
lean pickings that have thinned my blood
and chilled me on the cold uplands,
hunkering low when winds spring up.

Morning wind is the coldest wind,
it flays me of my rags, it freezes –
the very memory leaves me speechless,
woman, picking the watercress.

One time during his wild career Sweeney left Slieve Lougher and
landed in Feegile. He stayed there for a year among the clear streams
and branches of the wood, eating red holly-berries and dark brown
acorns, and drinking from the River Feegile. At the end of that time,
deep grief and sorrow settled over him because of his terrible life; so
he came out with this short poem:

Look at Sweeney now, alas!
His body mortified and numb,
unconsoled and sleepless
in the rough blast of the storm.

From Slieve Lougher I came
to the border marches of Feegile,
my diet still the usual
ivy-berries and oak-mast.

I spent a year on the mountain
enduring my transformation,
dabbing, dabbing like a bird
at the holly berries' crimson.

My grief is raw and constant.
Tonight my strength is all gone.
Who has more cause to lament
than Mad Sweeney of Glen Bolcain?

One day Sweeney went to Drum Iarann in Connacht where he stole
some watercress and drank from a green-flecked well. A cleric came
out of the church, full of indignation and resentment, calling
Sweeney a well-fed, contented madman, and reproaching him where
he cowered in the yew tree:

Cleric: Aren't you the contented one?
 First you ate my cress.
 Next you're perched in the yew
 beside my little house.

Sweeney: Contented's not the word!
 I am so terrified,
 so panicky and haunted,
 I dare not bat an eyelid.

 The flight of a small wren
 scares me as much, bellman,
 as a great expedition
 out to hunt me down.

 Were you in my place, monk,
 and I in yours, I think
 you would be quick to learn
 madmen are not contented.

Seamus Heaney

The Mirror

Paul Muldoon

Paul Muldoon, born 1951 in County Armagh, now works as a Radio Producer for BBC Northern Ireland. He has published three books of poetry, New Weather *(1973),* Mules *(1977) and* Why Brownlee Left *(1980).*

A fourth collection, Quoof, *is due from Faber and Faber this autumn.*

Paul Muldoon is a Fellow of the Royal Society for Literature, and a member of Aosdana, the recently established Irish academy of artists.

The Mirror *in memory of my father*

I

He was no longer my father
but I was still his son;
I would get to grips with that cold paradox,
the remote figure in his Sunday best
who was buried the next day.

A great day for tears, snifters of sherry,
whiskey, beef sandwiches, tea.
An old mate of his was recounting
their day excursion
to Youghal in the thirties,
how he was his first partner
on the Cork/Skibbereen route
in the late forties.
There was a splay of Mass cards
on the sitting-room mantel-piece
which formed a crescent round a glass vase,
his retirement present from CIE.

II

I didn't realize till two days later
it was the mirror took his breath away.

The monstrous old Victorian mirror
with the ornate gold frame
we had found in the three-storey house
when we moved in from the country.

I was afraid that it would sneak
down from the wall and swallow me up
in one gulp in the middle of the night.

While he was decorating the bedroom
he had taken down the mirror
without asking for help;
soon he turned the colour of terra cotta
and his heart broke that night.

III

There was nothing for it
but to set about finishing the job,
papering over the cracks,
painting the high window,
stripping the door, like the door of a crypt.
When I took hold of the mirror
I had a fright. I imagined him breathing through it.
I heard him say in a reassuring whisper:
I'll give you a hand, here.

And we lifted the mirror back in position
above the fireplace,
my father holding it steady
while I drove home
the two nails.

from the Irish of Michael Davitt

Childhood Portrait I
For Annie Bowen

I felt like the stump of a scaldy turnip
When you had finished shearing me
In a chair planked down in the roadway.
'I'll give you a *clip*,' you said.
I was only a boy; the strange word stuck.
You had a knack of laying out a corpse.
Though I never saw you at the trade
It seemed that no one could be rightly dead
When touched by your bony strength.
That stiffness could not last –
I thought that at your whim
Your hands could knead the soul back in.
But at Dan Brien's wake
When praise, tobacco, drink
Were brimming over, you came out with
'Sure every day of his life
Was a horse-fair; he was as cracked
As a mare in season.'
Mounting the hill one afternoon
With a full string bag
Dangling from your bike
You got off, spread your legs out wide
And said, 'I have to have a leak' –
And so you did;
You pissed as shamelessly as any cow.
I can still hear your gruff voice,
See your cassock, cap and man's boots.
I want it again, that easy space
That yawned between us as we yarned,
Your haltering halfway in the road
As I drew in, bit by bit,
To the rough skirts of your humanity.

Liam Ó Muirthile
translated by Ciaran Carson

Diver

Naked the diver
Those are his glasses on the shore,
Naked the diver
Limbs of the bay opening out ever more,
Naked the diver
Nothing he hears but the roar:
'Naked the diver!'
No shadow behind or before.

 Gabriel Rosenstock
 freely translated by author

Hearts of Oak
for Máirtín Ó Direáin

'*Save your breath,*
Poem-maker.
Keep it under wraps
In the tall tree of yourself.'

When he stood on the hearthstone
His hands would rustle with new poems.
A peal of thunder when he spoke.
His eye was a knot in oak.

A little acorn of light pitched
Into our bald patch
From the red branch above
Might take root there, and thrive.

 Michael Davitt
 translated by Paul Muldoon

161

Third Draft of a Dream
(In Tyrone Guthrie's house, Annaghmakerrig, Co. Monaghan)*

The door, that shadowy door
Closes. And the mind is closed.
A disembodied eye
Roves through the big house . . .

 the great hall's flagstones
 that sent up showers of sparks
 from riding
 boots

 a poster announcing
 The Merchant of Venice
 at Covent Garden
 in 1827

 the relics
 of butter-making
 in a bright back-kitchen

 the family portraits
 of the once-quick
 now dead
 a dream of fair women
 in the first flush of youth
 the lady of the house
 telling her tale
 of a life
 lived behind a veil
 while out
 in the ploughing
 a million other versions
 of life – no fit subjects
 for oil
 on canvas –
 are conspiring
 the lake
 the wood

stealing up
through the darkness
their chorus of voices
murmuring the secrets
of fishermen
and lovers
then making their way back
discreetly
to their proper places

In the morning, a hunter of words
Is snatched from his bed
By a squadron of swallows.
He sits at the table
To begin
The second draft
Of the dream.

Michael Davitt
translated by Paul Muldoon

*The house was bequeathed in his will by Guthrie so that it is today administered by the Arts Councils of the Republic and of Northern Ireland as a haven where writers and artists may live and work.

Biographical Notes

MICHAEL DAVITT
Born in Cork, 1950. Founder/editor of poetry journal INNTI *which has been the focal point of poetry in Irish since 1970. Gleann ar Ghleann (selected poems 1968-81) was published last year.*
LIAM Ó MUIRTHILE
Born in Cork, 1950. Has been on leave from the newsroom in RTÉ this past year, with the aid of an Arts Council bursary, completing his first collection of poetry and a novel.
GABRIEL ROSENSTOCK
Born in Kilfinane, Co. Limerick, 1949. Has published four books of verse for children and two collections of poetry Tuirlingt *(with Cathal Ó Searcaigh) and* Méaram. *Well-known presenter of Irish-language programmes on RTÉ radio and television.*

A Guide to Lesser Iliads

Sean Quinlan

Dr Sean Quinlan teaches Moral Theology at Maynooth College and is a noted scholar, traveller and wit.

Keith Dewhurst, writing in the *Radio Times* (5–11 February 1983) of the tragic death in Munich twenty-five years ago of many of the brilliant Manchester United Busby Babes, invokes first the old glory of the city. Manchester did after all in large part invent the modern world. He continues: 'Then the plane crashed, and thousands of people realized that it was the red shirts in the drizzle that had made somehow the last statement of Manchester's greatness.'

A paradoxical statement; this transformation of a dead football team into the plain man's elegy for the imperial looms, the exchanges, the inventive genius of the city. But I can recognize the imaginative flash in it: something secret and true in a way that remembering Achilles and the funeral games at Troy on the deck of an Onassis yacht could never be.

Sport goes into our deep recesses: less than art of course, but more omnipresent; a free passion, rarely lethal; a front and back garden and armchair for the folk imagination in Rio, Ireland, Bobby Charlton's Northumberland. It enslaves at every level. The Pope was once a soccer goalie in his native place. It makes for odd improvisations. I once saw a boy and his llama act as one of the goalposts – the other was a hat – high in the Andes near Lake Titicaca in Bolivia. And, simply to give old Aristotle a rattle, in an age which levels much to noisy banality, footballers, for instance, are almost the last recognized aristocrats, if you concede selectivity and paucity as conditions for an aristocracy.

If you judge Irish sport by the names that are famous in England, you'll think soccer *is* the Irish game. Not true, but more true north than south of the border. It is the sport of a section of urban Ireland,

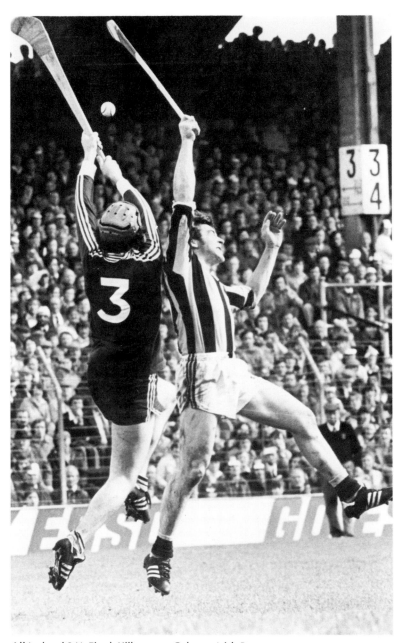

All Ireland S.H. Final, Kilkenny *v.* Galway. *Irish Press*

Galway *v.* Offally. *Irish Press*

something for happy weekends with no lucrative contracts for players. The following is not especially large. In fact, Irish soccer is a nursery for English clubs. But the Irish TV audience for British soccer is huge, and I suspect that most small boys in Ireland see themselves as stars in soccer rather than in any other game. Soccer is now the universe with ball and boots.

Viewed from Twickenham, the Irish game is rugby. Men in green jerseys, a shamrock over the heart, impetuous, unpredictable, inventors of a tornado called the *Garryowen*, who at their irregular best go tearing over the line to score, 'festooned with Saxons'.

In Ireland rugby still has certain snob associations. It's the game of the 'better' schools, a lingering accent of the old Ascendancy hangs about it still. But increasingly it commands a wider national following.

In a peculiar way, the sociology of Irish rugby is, or was, one of the more interesting mirrors of many strands in Irish society. Even when the Ascendancy schools were dispatching from their rugby fields budding young subalterns for Kenya and tea planters for Assam, a young fellow called De Valera got a lifelong passion for the game in

166

schools which were anything but Ascendancy. In the small town of Castleisland in Kerry forty years ago rugby was as universal and democratic as in any Welsh mining valley.

Today's flowering is of course aided by last year's Triple Crown success and the current form of the Irish international rugby team, which interacts with rugby's popularity as a school sport – it not only has the merit in teachers' eyes of keeping thirty spirited adolescents at a time mutually employed in harmlessly blowing off steam, but it also finds favour as a 'character-building' game.

For the vast majority of Irish people, however, hurling and Gaelic football are the national games: they are *the Gaelic* games, although the adjective is never applied to hurling when it's mentioned alone, because, I suppose, it's so uniquely Irish. And to claim to be able to trace its history for 2,000 years is fortunately no silly chauvinism.

Of the two, hurling is *the* Irish game: a mixture of hockey and sudden death, Bernard Shaw called it. That's a pleasant caricature. It hints at the excitement of the game without doing any justice to its speed and brilliance. Hockey is distinctly dowagerish in comparison, and people prone to sudden death are usually advised by elderly relatives not to play it.

Hurling and Gaelic football are the only games I know, or have ever heard of, which by deliberate and idealistic policy were fostered as a means of creating a national identity and as instruments of hostility to 'foreign' games, i.e. rugby in particular, and the general sporting ethos of the British army of occupation, a stance still held in Ulster.

This was expressed negtively by a *ban*. A member of the Gaelic Athletic Association, which was founded a hundred years ago to launch this ideology, could not, for instance, even attend a dance sponsored by a rugby club. Soccer and rugby were the villains: golf and tennis never mattered. The ban disappeared little more than fifteen years ago.

Dewhurst can see the dead Busby Babes in terms of elegy for the great past of a great city. The Gaelic Athletic Association were, so to speak, working inversely in trying to use certain games as selected absolutes among other absolutes to create a distinctly Irish cultural identity. It may have been a unique experiment. One never hears of capitalist versus marxist soccer.

Gaelic football is a hybrid game. Sociologists have observed that British social theorists sometimes rediscover a value or folkway

which had died in Britain, but which they hold should be made to live again, when all the time it's still alive and well in Ireland, but regarded as antediluvian.

In the matter of Gaelic football, I've had the opposite experience. A year or so ago I watched on the BBC a game being played somewhere in the north of England, if I remember rightly. The field was the whole parish; the teams, one half of the parish against t'other. No holds were barred and tussles for the ball in mud or midstream were part and parcel of it all, nor did there seem to be a time-limit. One hundred years ago that was 'Gaelic' football in Ireland. *Caid* they called it.

I knew a priest who tried to revive it. When his sacristan almost lost his life in the Blackwater on the Cork-Kerry border, the priest was carpeted by his Bishop who told him he would hold him personally responsible for all deaths. With that, *Caid* departed to join whiskey at tuppence a glass and other such heroic and miraculous things.

At a latter stage, the game was reduced to a fixed space, fixed numbers in the teams, and it had two sets of goalposts side by side; one for goals, the other for points scored over a crossbar like a conversion in rugby, but with the ration of three points to one goal. This version of the game the Irish took with them to Australia where it is triumphantly alive and known as 'Australian Rules'.

The modern Gaelic game has elements of rugby, soccer and basketball. It's a good game.

For your man in the Irish street a game's a game, ideology a recurrent fever, if it's there at all. He likes skill and daring, *gaisce*. He has his pantheon. Addressing the minor majesty of his pint in the company of King Rodomonte, a visiting monarch from Algeria, your Corkman will say with scientific intensity: 'It's a well-known fact that a German scientist discovered the very idea of the laser beam watching Christy Ring's heavenly accuracy with the *camán*.' And your Kerryman, a modest lot: 'Could, you ask me, Micko Connell jump high for a ball? The most truthful answer I can give is to say he touched Sputnik once, but only barely with a fingertip.'

Gaelic games are now tending to be independent passions like sport anywhere, apolitical, a joyous memesis of our larger life.

The exclusiveness is largely gone in television's vast brotherhood. The followers of Ring and O'Connell understand and feel as well as a Lancastrian the moving requiem spoken for the Busby Babes by

Dewhurst: 'And how we are growing old and they will not: how Roger Byrne is forever elegant and Geoff Bent crouches over the ball.'

Cork *v.* Tipperary. *Irish Press*

The Traditional Music Scene in Ireland

Breandán Breathnach

Breandán Breathnach is one of the greatest living authorities on, and practitioners of Irish music, song and dance.

In 1746 John Geoghegan published his *Compleat Tutor for the Pastoral or New Bagpipe* in London, the first of its kind in Britain or Ireland. It was intended, he declared, for those gentlemen whose inclination urged them to play the bagpipe but were prevented by that instrument's wanting a scale or gamut to learn by. The gentlemen of Paris feeling a similar urge to play these pipes in their modern form have a choice of three Metro stations to reach the headquarters of Na Píobairí, Association des Sonneurs de Uilleann Pipes de France, whose tutor, the eleventh since Geoghegan's, is the most recent to appear. That is, if the tutor of the United Irish Pipers' Club, whose members hail from San Francisco and Seattle and places in between and beyond, has not yet been delivered by the printers. And at the beginning of this century the uilleann or, more correctly, union pipes seemed doomed to follow the harp into oblivion.

Forty years ago the Public Dance Hall Act, introduced to control commercial dance halls, was used to eradicate the country house dance and, declining since the beginning of the century, dancing thereafter ceased to be a part of the social scene in rural Ireland. Musicians laid aside their instruments, fiddle and flute and box, having no further use for them. The youth, finding no encouragement to take up a music now largely rejected by the public, turned their attention to other forms. The traditional music of the countryside and the associated dances began silently to pass from folk memory.

Many causes have been advanced to explain the extraordinary

170

resurgence of this music over the last few years. The regular radio programmes of traditional music and song, the BBC's *As I Roved Out*, the *Job of Journey Work* and *Ceolta Tíre* on Radio Éireann certainly played a part in this resuscitation. Broadcasting gained for this music and song a certain measure of acceptance, and counteracted to an extent the public indifference towards them. More important, an interest in the older musicians was re-awakened and players scarcely known outside their own parish began to achieve a national audience and a reputation.

Comhaltas Ceoltóirí Éirann – the association of the musicians of Ireland – founded in 1951 to foster such music – added a tremendous impetus to this wider interest. Its activities climax in Fleadh Cheoil na hÉireann, the music festival of Ireland, held annually at different venues throughout the country at which musicians in their hundreds engage in competitions and the public are to be counted in their tens of thousands.

And yet the prime cause is not to be found in these islands but rather in the United States. It was a by-product of the new ethnicity, that moved people to look beyond the homogenized American and search out their own roots and culture. The fads and fashions of New York, with a recognizable time lag, had surfaced and the Clancy Brothers, unnoticed in Ireland before they departed to the States, returned in the fifties on the crest of that wave to initiate the ballad craze in this island.

Nothing was traditional in their method of presentation; more often than not the material was non-traditional, even to the ritual Aran sweaters. They did, however, attract a segment of the public to the popular ballad and folksong and thus created a potential audience for the older traditional song and dance music.

It was Seán Ó Riada who introduced this audience to the dance music. Ó Riada at the time was musical director at the Abbey Theatre. During preparations for the production of Brian MacMahon's *The Song of the Anvil* he conceived the idea of replacing the regular music ensemble by a group of traditional musicians. The play was not a success but the music did catch on and out of this emerged Ceoltóirí Chualann. The group embraced fiddle and pipes, flute and accordion as well as the more exotic harpsichord, bones and bodhrán or tambourine. Jigs, reels and hornpipes, diluted with some airs of Carolan, and rendered solo, in duet and other permutations made an immediate impact on audiences drawn largely from the general

public. Its reception in traditional circles was less warm.

At the time, and since, Ó Riada was hailed as a great innovator, one who was seeking to present the traditional music of Ireland in modern sophisticated terms, who was indeed creating a new art form from the native idiom. These claims are exaggerated. Ó Riada's use of traditional players was a gimmick. He did create a new sound but progress beyond the initial stage was not possible. Eventually Ó Riada lost interest in this group activity and Ceoltóirí Chualann passed out of existence.

By the late sixties a huge following had been created for the music; people were willing to pay to listen to it and groups in clubs and music pubs sprang up to meet this new demand. Ceoltóirí Chualann regrouped under the leadership of Paddy Moloney, piper, and, as the Chieftans, was soon attracting huge audiences. Other groups emerged, the Bothy Band, Planxty, the Furey Brothers and the more recent Dé Danainn, Stockton's Wing and Clannad. The music became a tourist attraction; it is now a commonplace backing for commercials on radio and television. Britain, America and Australia were obvious targets for enterprising groups but it was soon discovered that Scandinavia and Germany were no less enthusiastic about it and the Chieftains at present are preparing for an engagement in China.

There has been one unexpected side-effect of this wave of popularity. The music has come to the notice of ethnomusicologists, and already doctorates have been awarded in Amsterdam for treatises on the oral tradition of the 'come-all-ye', and on the socio-economic aspects of the dance music. Collections of dance music and songs intended for popular consumption abound and hundreds of LPs are available. Here the labours of Topic Records of London and the Shanachie and Green Linnet recording companies in the United States must be mentioned for the number and quality of the recordings they have issued.

All the while apart from the popular movement, music was flourishing in traditional circles. The idea of a *fleadh* (feast of music) without a public to get in the way of the music, better still confined to pipers, was voiced and found attractive. The suggested gathering was held in April 1968, and from it came Na Píobairí Uilleann, the association of Irish or uilleann pipers. There had been other pipers' societies around the beginning of the century but they had petered out when the initial enthusiasm that led to their formation waned.

NPU has grown steadily since its inception. Piping is flourishing as never before in Ireland. The position outside Ireland is truly extraordinary. There are over fifty pipers in France; they are not, as one might at first be inclined to think, all or nearly all from Brittany. Continental Europe is represented from Sweden to Italy. Membership in North America stretches from Alaska to San Fancisco; Australia and New Zealand likewise figure on the roll.

When asked what first attracted them to the Irish pipes, foreigners usually reply, their sound. Encountering a living tradition with an incredibly rich repertory – over 3,000 reels (traditional dances) alone – and techniques which although simple to grasp require years of practice to acquire, the initiated become addicted. The skills demanded in making a set of pipes and the materials used have enticed English musical instrument makers to extend their activities to pipe-making.

The impingement of the popular movement on the living tradition has had happy results here. Those groups which followed the Ceoltóirí Chualann pattern of making instrumental music the centre-piece of their performance, usually did so by organizing it around the piper. Audiences abroad were in that way introduced to piping at a very high level. Paddy Moloney of the Chieftains, Liam Ó Floinn of Planxty and Finbar Furey of the Furey Brothers by their perform-ances in concert have gained many overseas members for Na Píobairí Uilleann.

The deep attraction which traditional music holds for its devotees is shown, not by the crowds that throng the annual Fleadh Cheoil but by those who attend the Willie Clancy Summer School held during the first week of July in Miltown Malbay, a small town on the west coast of Ireland. The school commemorates the memory of Willie Clancy, a founder member of Na Píobairí Uilleann, whose role in passing on the living tradition is recorded in Pat Mitchel's *The Dance Music of Willie Clancy*.

Miltown truly becomes an international centre during this week. Australians hail across the street last year's acquaintances from Seattle; French, German and Dutch mingle with Scots, English and Welsh. Hotels and guest houses overflow; caravans and tents are crammed to bursting point. The townspeople good-naturedly put up with this invasion and publicans make hay while the sun shines.

Between 500–600 participate in the school. Every classroom in local schools is occupied, with classes for pipes and fiddle, flute,

whistle and concertina. Many a student from abroad is thrilled to find himself being taught by a musician whose records are a treasured possession at home. All are madly intent on absorbing tunes and techniques; they have a week to acquire a year's store. In the local dance-hall some fifty adults are on the floor, being led through the Kerry Polka or Plain Set, forms of the quadrille said to have been introduced into Ireland by the soldiers returning home in the victorious armies of Wellington after Waterloo.

The popular interest in Irish music which exploded twenty years ago has subsided. Those engaged in music-making for its own sake may not be affected by this change in public taste. There are grounds, however, for concern about the future of this heritage of music and song. Traditional singing in Irish is inextricably bound up with the fortune of the language and who can be sanguine about its future?

Singing in English is for other reasons in quite as perilous a state. Traditional dancing has long ceased being a part of the social life of the countryside. One may fear, then, that the music, detached as it is from its related dance, may not survive in a traditional form. However, when one takes into account the high standard of performance achieved by so many young musicians, one is entitled, between the jigs and the reels, to look on the bright side of things for the future.

Opposite: Bodhran making, Co. Kerry. *Bord Fáilte/Irish Tourist Board*
Joe Brown playing the flute, Dingle, Co. Kerry. *Mark Fiennes*

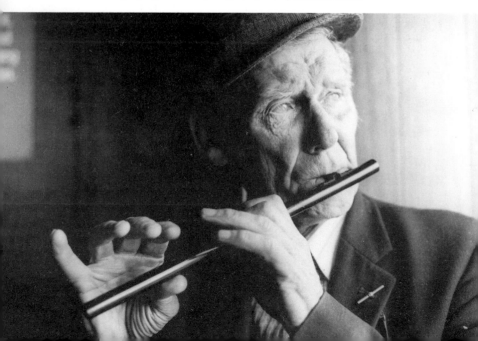

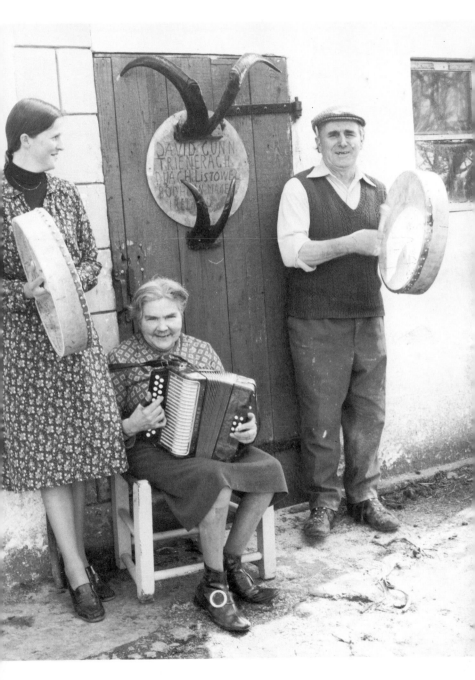

Classical

John O'Donovan

John O'Donovan is a polymath. Author, playwright, and broadcaster, apart from being a script writer for both radio and television, he is recognized as an authority on George Bernard Shaw, vegetarianism, Irish antiquities and on music. A former music critic with the Evening Press, *he is a Vice-President of the Royal Irish Acacemy of Music.*

As the world knows the specific genius of Ireland is verbal not musical. Our Bachs and Beethovens, our Verdis and Puccinis express themselves in words not sounds. Analogies tend to take wing, so that I am tempted to let this one have a short flight in the opposite direction and add that our Dickenses express themselves in sound, for in the late A. J. Potter, a cathedral singer turned composer, we had a first-rate comic fantasist whose Dickensian sense of the absurd enabled him to produce hilarious sets of variations on sentimental ballad tunes, concerning which (the cathedral singer being stronger in him than he or we suspected) he would later have bouts of remorse, swearing to dedicate himself henceforward to solemnities, including a funeral march, which in any event he would presently require for personal use.

Many a true word . . . Poor Archie Potter died untimely, probably as much to his own surprise as to his friends', having indeed composed a De Profundis and other solemnities which, although they are fine in their way, we have not taken to our hearts as eagerly as his Variations on 'The Wild Colonial Boy' and other exuberances.

Archie Potter departed without having fulfilled expectations created by his early manifestation of creative talent. But even had he lived out his full term he would hardly have reached the big league,

providing a musical equipoise to some of our literary giants. The truth is, only one Irish composer so far has achieved true international celebrity, and that was Michael William Balfe, born in 1808, who, starting as a singer, moved into composition and discovered he had a facility for supplying Victorian popular taste with exactly what it wanted. He turned out opera after opera filled with what could be described as 'instant melody' or, if you don't mind the cruelty, musical junk food.

His great achievement was *The Bohemian Girl*, first performed in 1843 at Drury Lane and reaching New York the following year, a speedy journey for an opera at that or any time. *The 'Boh' Girl* had a companion piece, the somewhat less beguiling *Maritana*, composed by another Irishman, Vincent Wallace (1814–65), first produced at Drury Lane two years after the Balfe work, and which the following year got as far as Philadelphia. After a pause to collect its energies, it made it to New York by 1848. For at least two generations *The 'Boh' Girl* was apparently the world's most popular opera and, with *Maritana* hanging on to her petticoats, remained in the repertoire until the 1930s, the combinations being known in the profession as The Irish Ring.

The Irish Ring catered for audiences of the kind which later took to *Oklahoma!* and *My Fair Lady*. But, that conceded, it can be fairly claimed that Balfe's musical substance was of better quality than that of the Rodgers & Hammerstein school, for Balfe had a genuine sense of drama – had he not been born and bred in Dublin where every second male is born with a playwright's pen in his mouth? – and this added strength to his scores much beyond what the rather tawdry librettos deserved. *The Bohemian Girl* made Balfe's name as respected in his time as Meyerbeer's or Gounod's, and the opera could still be revived as a period piece without undue risk of disaster, although its success would depend more than many another score upon the skill and sympathy of the performers. Sir Thomas Beecham revived it at Covent Garden in 1951, but although Sir Thomas was incomparable at turning water into wine (temporarily), the 1950s was not a time propitious to the revival of Victorian sentiment, nor were 1950s ears, just about then getting used to the spicy delights of Stravinsky, willing to take an evening of unadventurous mid-Victorian harmony. Today, now that we have in Nietzschean fashion gone right through harmony and come out at the other side, the current passion for the Baroque suggests that with thirds and sixths

regaining their long-lost novel charm *The 'Boh' Girl*, if not the entire Irish Ring, might stage a comeback.

Balfe's success was of course established abroad and then began to spread as far as his native land, for Ireland reverses the usual procedure by which the creative artist begins with a certain amount of local success which eventually reaches other countries. This makes life hard for all Irish artists, but bears less heavily on Irish musicians than on Irish writers. What's seldom is wonderful and high proficiency in the use of words is too common in Ireland to be much valued. Our less common talent for music tends to be more highly esteemed, a statement Irish musicians may hotly dispute, pointing out that up until the 1950s when the musicians' union managed to make its presence felt, St Cecilia's followers were the most scandalously ill-paid professional class in the country.

I can help to make the musicians' case for them in as much as I have in my possession some accounts relating to the Dublin Symphony Orchestra during the first decade of this century. These reveal that professionals at that time were obliged to play in a full-scale concert, preceded by two rehearsals, for a total fee of half-a-crown (12½ pence in present Irish money, or about 20 US cents).

But one can be highly esteemed without being highly paid, esteem being often deemed an adequate substitute for hard cash not merely by tight-fisted managements but comparatively well-heeled arts councils. Music is widely loved because it is at once the most respectable and, next to ballet, the most sensuous of the arts. In Ireland it certainly found support at all levels of society, even the poorest. One might say *especially* the poorest. There were at least two reasons. One was that singing and piping involved no unavoidable production costs when the performers were the people themselves. The other was that music provided a living for the blind.

In the eighteenth and early nineteenth centuries eye disease was very common amongst the poor because of malnutrition. When a child began to exhibit signs of blindness it was, if male, taught the harp or flute or fiddle so that it could become an itinerant player, earning a few days' subsistence in one hamlet before moving on to another. It was the poor person's recital tour and, as with other recitalists, there were very popular and successful performers and even stars. Carolan* was one such star, a blind harper who was

Recte Turlough O'Carolan.

treated so hospitably at the houses of the gentry that he became alcoholic and died pickled at sixty-eight. But although he died two and half centuries ago he lives on in our race consciousness, as does Paganini in Europe's, and Carolan's 'Concerto', although an unremarkable little tune, is still venerated as part of the national heritage.

Incidentally, the old-time blind musicians have bequeathed us a curious custom. To this day you will find our folk musicians, although perfectly sighted, playing with their eyes closed, even with their heads averted from their instrument, and usually with expressionless faces. Evidently what had begun as an unthinking or only half-conscious imitation of the blind by sighted players became established as the proper posture for performance.

Ireland's historical circumstances and her geographical position as an island off an island off Europe, cut her off in pre-electronic-communication times from the benefit of cross-fertilization by other musical cultures. As a consequence we could not build up a corpus of worthwhile art music such as other nations did, and it is only recently that a school of native composers has emerged with something individual and interesting to say, and that our capital city has acquired a proper concert hall.

Yet the emergence during our Dark Ages of composers like John Field and Balfe, Wallace and Charles Villiers Stanford proves that we had the human raw material for a fine school of art music composers. The work of Irish musicians who operated chiefly by the light of nature justifies us in claiming that there but for the non-grace of God went, if not exactly an Irish Bach or Handel, at least an Irish Donizetti or Karl Stamitz. As for a supportive public, that we have always had, and still have thanks to our Education Department's neglect to make music a school subject, thereby saving Mozart and Verdi from becoming as loathed by the average person as Shakespeare and Shelley are. In this connection I can cite the testimony of Lecky, Moses-historian of the Ireland of the eighteenth century, who handed down the relevant tablets as follows:

> The taste for music was stronger and more general than the taste for literature. There was a public garden for musical entertainments, after the model of Vauxhall; a music-hall, founded in 1741; a considerable society of amateur musicians, who cultivated the art and sang for charities; a musical academy, established in 1755,

and presided over by Lord Mornington. Foreign artists were always welcomed. Dubourg, the violinist, the favourite pupil of Geminiani, came to Dublin in 1728, and resided there for many years. Handel's *Messiah* was sung for the first time before a Dublin audience.*

Handel, too, writing from Dublin to his English librettist Jennens, gives a good account of the standard of Irish musicianship and the receptiveness of the local audiences. No doubt there was an element of public relations in Handel's compliments to us, he being enough of a businessman to know the value of a success reported from what was then the 'second city of the Empire'. A Dublin newspaper saluted the public rehearsal of *Messiah* as giving 'universal satisfaction' to 'a most grand, polite, and crowded audience' – 'and was allowed, by the greatest judges, to be the finest composition of music that was ever heard'.**

Although there is no shred of evidence that the reporter either heard a note of *Messiah* or was competent to tell the difference between B flat and a bull's foot, we are at least entitled to point out that the Dublin hacks scored a singularly lucky hit with their waffle at first try. It took London hacks several years to grasp that *Messiah* was something special, and it can be added, the Leipsic hacks totally failed to register any recognition of just who and what they had in a local church musician named Johann Sebastian Bach.

We move to firmer ground for self-congratulation in the Lord Mornington mentioned by Lecky. He was the father of the Duke of Wellington and was, besides, a skilled performer on violin and harpsichord, being sufficiently the father of his celebrated son to defy the ridicule of his fellow peers by walking through Dublin with his fiddle case under his arm. He was also adept enough in composition to leave us some charming glees and madrigals, his 'Here in Cool Grot' still being a favourite of chamber choirs. He was, moreover, founder and first occupant of the Chair of Music at Trinity College, Dublin.

Irish music-making suffered a distinct loss when financial troubles forced him to exchange his aristocratic lifestyle in Ireland, where he

*Lecky: *History of Ireland in the Eighteenth Century*, vol. 1, pp. 327–8.
**Faulkner's Journal for 6–10 April 1742.

had one of the most imposing of Dublin's mansions and an elegant seat with Paradisal pleasure grounds in County Meath, for lodgings in a village near London, called Knightsbridge. In comparison with the Iron Duke, Lord Mornington may not seem the most forceful of characters but he had enough energy and drive to keep music in the forefront of Dublin's social life for a decade.

His successor in this task did not emerge for nearly another half-century. This was Joseph Robinson, most remarkable of the four remarkable sons of a Yorkshireman who set up as a merchant in Dublin and founded a musical society called the Sons of Handel. Each of the Robinsons was a naturally gifted singer and instrumentalist. Joseph, born in 1815, was, besides, a dynamic organizer. At nineteen he somehow managed to raise enough money to take over a disused gasworks in the centre of the city and reconstruct it as a concert hall, with a minor hall and a rehearsal room, all with a most satisfying acoustic. The complex was known as the Antient Concert Rooms (a name borrowed from a London body) and was a busy centre of musical activity for so long as Joseph Robinson, with some fraternal assistance, could afford to devote unpaid labour to running it as manager, solo bass-baritone, choirmaster and orchestral conductor.

Robinson's concerts were kept to the highest achievable standards in content and execution, providing Dublin with a succession of classical concerts which in quantity and quality would have been the envy of a larger and richer city. He also took the lead in founding Ireland's first public music teaching institution, the Irish Academy of Music (a Royal College from 1872).* His lieutenant was a violinist, Richard Michael Levey (*né* O'Shaughnessy), musical director of the Theatre Royal for half a century, where he led his gallant little band nightly through anything from pantomime to grand opera and oratorio. As professor at the Academy Levey tutored scores of fiddlers to a degree of skill sufficient for them to get employment in orchestras the world over. One son from his outsize family (twenty children by three wives), enjoyed a vogue as a soloist under the name Paganini Redivivus.

A third man, always associated with Robinson and Levey by their contemporaries, was Robert (eventually Sir Robert) Prescott

*The eighteenth century academy headed by Lord Mornington was a performing not a teaching body.

Stewart. He had a Telemann-like technical facility, being able to do what Handel said Telemann could do: write an eight-part motet as easily as another man could write a letter. In fact Stewart, who was at one period simultaneously the official organist of Dublin's two cathedrals as well as Professor of Composition at the Academy (one pupil being John Millington Synge, who ambitiously tried his hand at a string quartet, a most difficult form), Professor of Music at Trinity College and Kapellmeister to the Viceroy, was reputed to be able to accompany choral evensong at the organ with two feet and a hand, reply to correspondence with the other hand, all the while giving whispered lessons to a pupil. His colleagues remarked that only by working in this way could an Irish musician manage to earn a decent living. (On his death in 1894 he was found to have left a couple of thousand pounds, which certainly made him by local standards a citizen of substance.)

But Stewart had nothing in him of Telemann's ability to turn out an unending stream of pretty and expressive tunes. Such of his works as escaped a self-critical bonfire at the end of his life sound at best like Dame Ethyl Smyth on a very off day. Nevertheless Stewart did much to raise academic standards both in Irish and English universities, where he was greatly respected. He was one of the earliest genuine admirers of Wagner in these islands, and by fostering the talent of Charles Villiers Stanford and encouraging Stanford *père* to send C.V.S. to study at Cambridge and in Germany, was indirectly responsible for helping to change the course of English music. For it was Stanford who as professor at Cambridge and at the Royal College in London, gave their early training to several later distinguished musicians, rescuing them from the regimen of watered-down Handel, Mozart and Mendelssohn which was then the approved English diet. Since those pupils included Vaughan Williams, Gustav Holst, Frank Bridge and John Ireland, Stanford would have earned a place in musical history even if he hadn't written some of the best Brahms music that Brahms himself didn't write. And since Frank Bridge nurtured Benjamin Britten, Stanford was Britten's musical grandfather.

It is worth mentioning that Stanford was just one of three Dubliners of the same generation who changed British life and art: Bernard Shaw doing so by socialist propaganda and dramatic reform; and Alfred Harmsworth by creating mass-produced newspapers written by office boys for office boys.

In the next generation an Ulsterman, Hamilton Harty, raised the quality of Manchester's Halle Orchestra to international standard and trained English audiences to accept Hector Berlioz (married to an Irish actress who was the inspiration of the Fantastic Symphony) for the astounding genius he was, and John McCormack likewise set out from Ireland to become one of the greatest tenors and most fastidious artistes of his time.

If Stanford's and Harty's combined compositions form only a molehill in comparison with the towering peaks reared by the great German and Italian masters, we have at least one composer who is a fraction above the molehill class: the eighteenth century Dubliner John Field. It was he who, so to speak, placed the nocturne ball at Chopin's feet, enabling the Pole to kick to goal. Field remains our most memorable melodist. Any of a dozen of his piano pieces can still be included in a celebrity recital without causing audiences to stare at each other in wild surmise about the sanity of the recitalist.

We can claim Arthur Sullivan, although London-born, as the son of a Corkman, and fondly recollect that Catherine Hayes from Limerick was one of the best-loved lyric sopranos of her time, and that a Dublin tenor named Michael Kelly sang in the first perform-ance of *The Marriage of Figaro* and in his reminiscences left us a vivid and touching pen sketch of its composer. In short, musical Ireland was not just merely the place Jenny Lind loved coming to because after the show she could swill porter and dance jigs into the small hours with the hotel waiter, and where Liszt on a recital tour stopped at Naas for a cup of tea and, according to legend, was served with a liquid from a cracked teapot which combined the smell of brandy with the taste of pee.

Fortunately music flourishes today in Ireland more than it has ever done. the national broadcasting service, Radio Telefis Eireann, was appointed foster-parent to a symphony orchestra which has been built up, on numbers and in performing ability, to international standards.

The great national lack is, however, a proper concert hall in every large town and city. Even Dublin itself was without one until September 1981 when, after many false starts and not a few blunders, which a little common sense in high places could have averted, the National Concert Hall was at last opened. It is an adapted examination hall in the former headquarters of University College, Dublin, but the examination hall was itself adapted early this century

from a concert hall erected as part of the 1872 Exhibition Buildings. Naturally, this concert hall has drawbacks, but the advantages far outweight them. It is not only the home base of our orchestra, officially the RTE Symphony Orchestra, but an appropriate venue for performances by our ever-increasing body of splendidly talented artists.

The names of Bernadette Greevy and Frank Patterson amongst our singers, Veronica McSwiney, John O'Conor, and Micheal O'Rorke amongst our pianists, and Geraldine O'Grady, Brian MacNamars and the up and coming Daire Fitzgerald amongst our string-players, spring easily to mind.

I have not dealt with any of the many Irish composers who are building up an international reputation for themselves: that would require another article. But it can be justly said that our contemporary musicians as a body are set to achieve not less than thier prececessors and very likely a good deal more. The pleasant task of chronicling their attainments I must leave to some future scribe.

The National Concert Hall

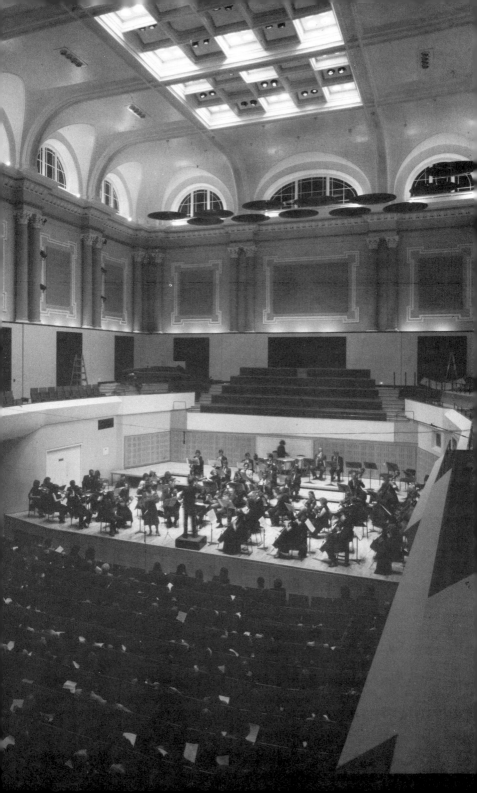

The Irish Rock Scene

Gerry Stevenson

*Gerry Stevenson, a teacher from Dublin, reviews
rock, books and TV for* In Dublin *magazine.*

In some ways the success of Irish performers in the international rock
arenas might be seen as analogous to that of the literary figures of an
earlier era. Yet although silence, exile and cunning have all certainly
played their parts, it is only in a very tenuous fashion that rock music,
whether imported or home-produced, could be said to have forged,
or even to have aspired to forge, the consciousness of the race.

While it must be admitted that virtually all the major musical
successes to emerge from this country in the last decade have pre-
served a considerable Irish element in their music, they have by and
large approximated and conformed to contemporary international
expectations and have launched themselves from London or New
York. The big breakthrough has proved far more difficult for those
who either instrumentally or through their lyrics attempted to
incorporate a Celtic element more directly into their work or who
addressed themselves to more local issues.

It is true that over the years there have been several freak inter-
national successes for Irish groups working in what can broadly be
called the 'commercial' folk idiom. The Clancy Brothers were
enormously popular in the US for many years and, in Britain, the
Dubliners with 'Seven Drunken Nights', the Furey Brothers with
'When You Were Sweet Sixteen' and Foster and Allen with 'The
Bunch of Thyme'; all reached the Top Twenty. Clannad, a more
'traditional' group, recently had the first Irish-language record to
enter the British pop charts with their 'Theme from *Harry's Game* '.
But the various attempts to weld Irish traditional music and Irish
concerns on to rock music have, at least internationally, been less
successful.

In the 1970s, Horslips, who blended fiddle, mandolin and tin

whistle with the more orthodox rock instrumentation, had tremendous support and success throughout Ireland having led an assault on the hitherto out-of-bounds ballroom circuit. Their debut album dominated the Irish charts for over two months. They re-worked traditional jigs, reels and airs into their music and lyrically also plundered Irish culture, from ancient legend to contemporary fiction. They had a considerable cult following in America before breaking up in 1980. Ironically, many saw their failure to capitalize on their initial impact as stemming from their gradual abandonment of the Celtic influences.

There were quite a few Horslips emulators during the seventies but the most enduring international recognition came to the Chieftains, the purest of traditional groups, although their music was initially 'creatively' arranged and later composed by uilleann piper Paddy Moloney. Their work has been admired by people like Eric Clapton and Paul McCartney and during the massive Rolling Stones concert last year in Slane, the Chieftains were the Irish act chosen by Mick Jagger to open the proceedings. When Don Henley of the Eagles recently included a short piece written and played by Moloney (and featuring an uilleann pipe solo on another track) on his debut solo album, Emmylou Harris declared herself aggrieved that Henley had anticipated her own intentions.

A notable Irish attempt to utilize the uilleann pipes in a rock setting has been made by Moving Hearts, a band which while following in the tradition of Horslips, is unique in many ways. They were formed in February 1981 by Christy Moore and Donal Lunny who had worked together in the very popular traditional group Planxty. The charismatic Moore was an unlikely-looking 'star', but capable of drawing huge audiences whether in the context of Planxty or as a solo performer. Lunny was a musical all-rounder and the producer of many Irish rock and traditional records. They gathered together a group of prominent Irish musicians, including Declan Sinnott, Horslips' original lead guitarist; the classically trained Keith Donald who had played in showbands, concert and symphony orchestras and with jazz musicians such as Louis Stewart, Zoot Sims and Barney Kessel; and uillean piper Davy Spillane. But allied and even subservient to their virtuoso musical prowess, which they demonstrated on material ranging from folk to hard rock, Moving Hearts endeavoured to perform songs picked on for their social and political content and awareness. During their first tour, for example, they

recorded a live version of Mick Hanly's song 'On the Blanket', about the H-Block protest, which was given out free with their first single; and their debut album, *Moving Hearts*, included songs ranging from Jackson Browne's anthem 'Before the Deluge' to Jack Warshaw's 'No Time for Love', which included the verse:

> They took away Sacho, Vanzetti, Connolly and Pearse in
> their time
> They came for Newton and Seale, Bobby Sands and some of
> his friends
> In Boston, Chicago, Saigon, Santiago, Warsaw and Belfast
> And places that never make headlines; the list never ends.

The album went straight to the top of the Irish charts and charted also in Italy and Greece. Their second album, *Dark End of the Street*, was better produced and more universal in its subject-matter but made less impact, and shortly after its release Christy Moore left the band, to be replaced by songwriter Mick Hanly. They have been well received in Britain on several short tours, but it remains to be seen if their rapid and dramatic Irish success can be repeated abroad. Past experience suggests it will be very difficult. The earlier generation of Irish acts achieved their success despite, and not because of, their 'Irishness'. Thin Lizzy, at that stage an all-Irish three-piece outfit, moved to London in 1971 and had a Top Thirty single hit with a rocked-up version of 'Whiskey in the Jar', a traditional Irish ballad first popularized by the Clancy Brothers. Their early work, such as the *Vagabonds of the Western World* album, owed much to their Irish background but their chart success was not followed up until in 1976, with an international line-up featuring American Scott Gorman and Scot Brian Robertson on guitars, the single 'The Boys Are Back in Town' and the album *Jailbreak* charted in both Britain and the US, elevating the band to the superstar bracket.

Rory Gallagher broke from the Irish showband scene with his own brand of American blues following in the slipstream of Cream. Van Morrison's origins were in rhythm and blues but his magnificent series of albums, from *Astral Weeks* in 1968 to *Veedon Fleece* in 1974, while on occasions reflecting his Irish background, were very much a part of the singer-songwriter trend in America at that period. Morrison, incidentally, was recently seen in Dublin at a Moving Hearts concert and piper Davy Spillane is to be featured on 'Celtic

Heartbeat', a track on Morrison's current album. Morrison's influence abroad is undeniable and it is worth noting that not only has Kevin Rowland had a hit single with 'Jacky Wilson Says', a song written by his mentor Morrison, but also his use of traditional Irish fiddles has contributed in no small way to the success of Dexy's Midnight Runners' recent album.

Even among the younger generation of Irish rock bands a similar pattern emerges. The Boomtown Rats' achievements were astonishing but their 'Irishness' was again secondary to their talents. 'Rat Trap', their first British Number One, was very much a Dublin song, its location instantly recognizable, but their second big hit, 'I Don't Like Mondays', was inspired by newspaper reports of an incident in San Diego. Their success did not open up the British market, as at one time it was felt it would, for young Irish bands, and none suffered more than the Radiators. Their second album, *Ghostown*, produced by David Bowie's producer, Tony Visconti, was released in 1979, two years after their punk-orientated debut, and was a commercial disaster. Described as a sort of 'James Joyce concept album' on the theme of growing up in Dublin, it contained songs of remarkable quality from Philip Chevron, one of which, 'Faithful Departed', was included on Moving Hearts' first album, by which time the Radiators had broken up.

Equally, the Undertones from Derry were possibly the best pop band Ireland ever produced. Like the Boomtown Rats their progress seems to have hit a mid-career doldrum but their songwriting continues to mature as they do. Belfast band Stiff Little Fingers, however, were as much a product of the Northern troubles as of the new wave, and have this year decided to disband. Their first two albums, *Inflammable Material* and *Nobody's Heroes* entered the British Top Ten. Their single 'Alternative Ulster' also sold extremely well and *Shellshock Rock*, a film featuring the band, had to use subtitles to render the lyrics comprehensible outside Ireland. But the band's later efforts, again more universal in content, were met with more or less indifference and their fall was almost as rapid as their rise.

One band which has uncompromisingly gone its own way, continued to base itself and record in Dublin and enjoy major international acclaim, has been U2. Initially seen as following in the trail of the Boomtown Rats, their progress has been rather different. They never played the Irish pub circuit, but found venues of their own and

established a large young audience; their rise has been steady and level-headed. Their greatest successes so far have been with their albums, *Boy* and *October*, the latter charting in America. The one doubt about them was whether or not they could write hit singles, a doubt they have recently answered with the entry of their last single, 'New Year's Day', into the British Top Ten. This will ensure that their third album, *War* will be received with more than usual interest.

The future also looks bright for two Irish singer-songwriters whose careers should continue to expand in the 1980s. Chris De Burgh's *Best Moves* compilation sold 50,000 copies in Ireland and one million in Europe, and although he has yet to make the big commercial breakthrough in Britain and the US it is probably only a matter of time until he does so. Paul Brady, for many years best known as a folk performer, both as a solo artist and with groups such as the Johnstons and Planxty, will soon release his second rock album. His first, *Hard Stations*, was possibly the best home-produced album of original material ever. One of the songs, 'Night-hunting Time', was covered by American group Chicago on their last album and soul-queen Tina Turner has just recorded one of his new songs which may lead international audiences sooner rather than later back to the excellent originals.

Stiff Little Fingers

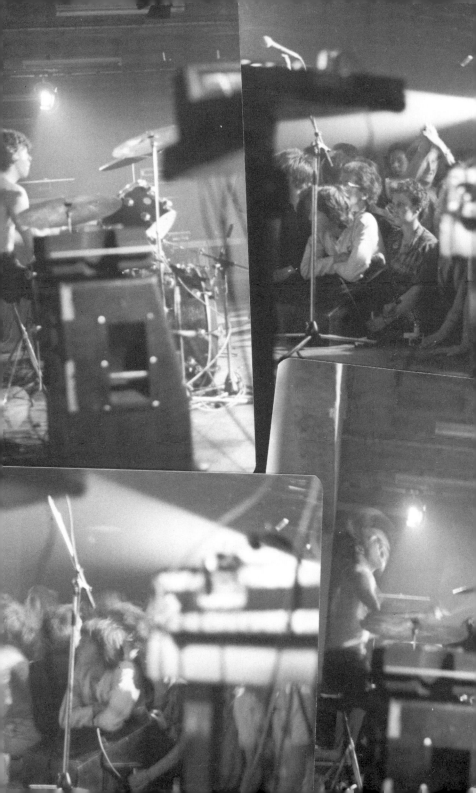

The Irish Renaissance and the Visual Arts

Bruce Arnold

Bruce Arnold, novelist and political correspondent of the Irish Independent, *is an art critic and the author of the definitive biography of the artist William Orpen.*

In the second half of the nineteenth century painting in Ireland took on an increasingly distinctive independence. The style of painting applied to landscape became more directly suited to the nature of the countryside, and the unique qualities of the light. The strictly English, art-school conventions, which had dominated through the first half of the century were steadily replaced from the 1870s by a richness and diversity of vision deriving from continental sources. Similarly, in the painting of people in urban settings, in the treatment of social environment, in portraiture, in genre painting, even in still life, a directness of interpretation in the form of honest realism became an essential feature, widening the gulf between the English and the Irish traditions in art to a point which led to the birth of modern Irish painting.

It was a subtle and complicated transition. The evidence for it taking place at all is mostly visual. There is little or no documentation beyond the hard facts about individual painters going off to art schools on the continent rather than going to London. There is even less firm proof of associations between painters and men and women working in the other arts, whose responses, in their turn, to Irish mythology, Celtic legend, and the tortured and so far abortive struggle for independence, can be traced in the theatre, poetry and drama which was to give birth to the Irish Literary Renaissance. And there is virtually no hint at all that Irish artists, travelling widely in Europe, were influenced by political and social upheavals there.

Consequently, and it is a huge and misleading consequence, there is an instinctive determination to set aside the visual contribution to that movement in thought and artistic inspiration, at the end of the nineteenth century and the beginning of the twentieth, which is so widely credited in Ireland with being a force towards national independence. The visual tradition is dismissed. How could a peasant and 'hedge-school' society produce painting of distinction, when paint itself would have been too expensive to buy? Conveniently, the fact that the literary burden was shouldered largely by the well-to-do is overlooked. W.B. Yeats, George Moore, Lady Gregory, Edward Martyn, John M. Synge, and many others, are given a central role on the stage in the drama in which Ireland discovered her true identity; Jack Yeats, Walter Osborne, Nathaniel Hone, Sarah Purser, have only small parts; and the many other fine artists are lost in the crowd scenes.

This strangely negative phenomenon is further underlined by the fact that Ireland's emergence from an essentially British artistic tradition was echoed in other parts of the world where it is heralded as central. In Canada, Australia, the United States, the same shaking off of shackles took place, the result being recognized quite early, and leading to vibrant movements of modern art. The birth of the renowned Heidelburg School, in and around Melbourne in the 1880s, led directly to modern Australian painting as we know it. Similarly, the genesis of Canadian painting owes a huge debt to the Group of Seven, a debt recognized at an early stage, and one which led to unbroken evolution in Canadian art of a genuinely national kind.

Central to both was the visual quality. What mattered most of all with the Melbourne artists and the Group of Seven was the way in which, physically, they saw their own country. They looked at it and saw it differently. Before their advent, European techniques had largely failed to come to grips with totally different effects of light: in the case of Australia on its sun-baked earth, in the case of Canada on its snowy wildernesses.

Irish artists like Nathaniel Hone, Walter Osborne, Joseph Malachy Kavanagh, came to similar convictions about Ireland, and how it should be depicted. They unyoked themselves from the discipline and the authority of the English art schools, to which their predecessors had been largely confined, and applied instead the teaching of Brussels, Antwerp, Paris, Fontainebleau. Nor was it just

the teaching. That, in turn, would have merely imposed an alternative set of principles, not necessarily any better. What they derived in addition was an increased degree of independence and of challenge. Persuaded and encouraged by the egalitarian atmosphere prevailing in those art centres to look afresh at their surroundings, they did so.

The results there for all to see – during a period when a similar process of national disengagement and self-assertion was taking place elsewhere in the world – did not have a comparable impact. Indeed, it would be fair to say that Irish art of the 1880–1930 period has only been the subject of serious reassessment in recent years, and that even this reassessment is still at a relatively early stage. Apart from general works on Irish art, and detailed research in the form of small monographs, there is still no literature of significance. The two major artists of the period, Nathaniel Hone and Walter Osborne, await their biographers.

The problem, however, is not just one of research, or of the accidents of history. It goes more deeply into the realm of fundamental perception. In respect of the two leading figures there were two distinct misfortunes. In the case of Walter Osborne, his early death in 1903, at the age of forty-four, cut off a talent – the impact of which was already considerable on Irish painting – at a time when it might have had a much wider influence in galvanizing younger artists and giving them greater confidence. In the case of Nathaniel Hone, the fact that he had sufficient private means to paint entirely to suit himself, combined with his much greater age, which set him apart from those with whom he might have formed the equivalent of a *plein air* movement, isolated him; when he should have been the leader of a liberation movement in the visual arts he was the Grand Old Man of the movement instead.

Both men drew their inspiration from quite different sources, Osborne from the Antwerp School, Nathaniel Hone from the Barbizon School. But both men came together in their obedience to the rules of truth to nature, whether in its rural manifestations, or in those faithful and poignant urban scenes which Walter Osborne did in the decrepit older parts of Dublin.

In order to understand fully the fresh simplicity of their artistic vision, it is only necessary to contrast them with the alternative, British-based tradition in Irish art, most forcefully exemplified by William Orpen. Orpen was trained in Dublin, under the English

art-school tradition, and then in London, at the Slade. Opposed to the *plein air* ideals, he never truly came to grips with landscape, and actually had a distaste for it in its pure form. Virtually never did he paint an exterior without the presence of people in it; and it was in keeping with the training he had had that he depended on the drama and tension in art which was increasingly exemplified in his own work. It ran side by side with the Hone-Osborne approach in Irish art, and should not be decried on the grounds of its origins. Notable followers of Orpen, like Sean Keating and Maurice MacGonigal, were later to deploy the tradition of dramatic tension in art in order to deal with issues of character and history. And a far more substantial artist, Jack Yeats, also grew out of this British-based artistic tradition, as opposed to the European one.

In a sense this fundamental dichotomy between different and conflicting traditions has obscured and complicated the actual events and developments in Irish art, and imposed a sequence of reassessments. It is fashionable now to place emphasis on the work of the 'purer' painters, who studied in Europe, and brought back from France, Belgium and Holland a new and stimulating sense of landscape.

But in reality, at the turn of the century, the power-struggles habitual to art – about who controlled art education, the major exhibitions, the Royal Hibernian Academy – tended to be won by the British-based tradition. Money was in portraiture, in genre painting, in the tense rural drama which so attracted Jack Yeats, and in the provocative and haunting canvases of William Orpen.

By the year 1900 a broad revival of interest was taking place, inspiration coming from Paris, Antwerp, Fontainebleau, Brittany, Glasgow, London, and of course Dublin itself. Self-awareness was insufficient to lead to any firm and direct involvement in the literary revival, in spite of the fact that there was a direct relationship between Jack Yeats on the one hand and his brother William Butler Yeats on the other, as well as their father, John Butler Yeats, who seemed open to influences from all sides. And it was only as the literary revival gathered momentum, in the early years of the century, that the visual artist began to respond. Those contributing to this response included George Moore, whose talents as a writer were enormously reinforced by his great knowledge of, and love for painting; Hugh Lane, who was the practical driving force behind what was then the Modern Movement in art; William Orpen, Dermod O'Brien, Patrick

Vincent Duffy, who was keeper and treasurer of the RHA.

It is perhaps indicative of the real atmosphere surrounding the visual arts during the period up to the First World War, that the efforts to get even a modern art gallery established were consistently, and, in some respects, deliberately frustrated, and that the moving spirit, Hugh Lane, went to his death in the sinking of the *Lusitania*, in 1915, in a state of despair and disillusionment about the recognition of art in Ireland. His state of mind reflected reality. It was endorsed, in a way, by the reaction of William Orpen, who identified with Britain around this time, and came home no more to Ireland after 1918, and by George Moore, who, following his experimentation with 'being Irish', returned to London to live there for the rest of his days.

Further names which are now associated with the development of Irish art at this time, like Roderic O'Conor and William Leech, are questionable candidates for the honour. Leech's association was marginal, O'Conor's non-existent.

The truth of the matter is nevertheless positive in this sense: a body of painters of distinction and skill worked in and out of Ireland, moving between their homeland and various continental centres throughout the decades between 1860 and 1920, constantly rejuvenating the body of work and inspiration upon which art depended. The impact they had was tiny by comparison with the written, spoken and acted word. Nevertheless, not entirely unlike the richness of a group of painters in Australia and Canada, these artists left a growing volume of work which increasingly established a cohesion of style and direction.

Like literature, which could produce Yeats, Synge, Joyce, Shaw, Moore, O'Casey and many lesser names in a span of half a century, the visual arts in Ireland must also be commended for the richness of this same era. Their diversity aptly reflects the nature of the people, the country, and the turbulent history through which Ireland was passing.

Nathaniel Hone (1831–1917) was the doyen, magisterial, sensitive, remote, austere and prodigal; he is still not fully recognized for the genius with which he orchestrated colour.

Walter Osborne (1859–1903) had Hone's sense of light and landscape, but added to it that incomparable feeling for people, particularly children and the poor, which endows his work with a unique sensitivity.

William Orpen (1878–1931) loved humour, drama, bravado and the domination of the individual within each of his canvases; yet he was a superb colourist, a master draughtsman, and he instilled into generations of Irish artists these capabilities together with a profound respect for professionalism.

Jack Yeats (1871–1957) also loved humour and drama, but in a subtle and elusive fashion, deploying his draughtsmanship and sense of colour along paths quite different from Orpen. His inspiration had a spiritual quality which enlarged steadily throughout his long life, during which he extended firmly the frontiers of Irish art.

Thomas Moynan, Sarah Purser, Joseph Malachy Kavanagh, Frank O'Meara, Augustus Burke, Henry Allen, Rose Barton, John Lavery, Nathaniel Hill, Aloysius O'Kelly and John Butler Yeats are further names relevant to the tangled process of revival within which each, in his fashion, recognized the essential element of disengagement, of self-confidence leading to self-determination, of new awareness, new perception, a new way of seeing. The extent, if any at all, to which it contributed to the turbulent political events of the period, is hard to define, just as it is hard to reconstruct either the ingredients of art history over a period of more than half a century, or the impact of people and of their paintings. But anyone who looks with sympathetic eyes upon the canvases, watercolours and drawings of these artists will see unfolding before him, more immediately than in any other art form, a sense of place, of time, of a people, and of a unique atmosphere, which provides a rich and complex backcloth to one of the great periods in the country's history.

A Matrix of Contemporary Irish Visual Art

Gordon Lambert

Gordon Lambert, Chairman of W. & R. Jacob Ltd, the huge Irish biscuit company, is, apart from being one of the country's foremost businessmen, and owning one of Ireland's most important private art collections, Chairman of the Contemporary Irish Art Society and a member of a number of cultural and artistic bodies including the International Council of the Museum of Modern Art, New York; the Cultural Relations Committee of the Irish Dept. of Foreign Affairs; and the Art Committee of the Arts Council of Northern Ireland. He is a former member of the Irish Senate.

The visual art scene in Ireland today is exciting, stimulating and burgeoning with creative talent in all the modern forms of painting, sculpture and graphics, including performance and video art. While the trends in contemporary Irish art might appear to follow international movements, the artists, as in the other arts, retain their individuality, exploiting their inherent instincts in the composition of their works and in the use of native materials which more often than not result in uniquely indigenous and imaginative percepts. Unfortunately their work is little known outside Ireland; however, there is a growing affirmation amongst people like myself who are acquainted with the international art scene that much of our contemporary art could hold its own if given the opportunity for more active participation in exhibitions abroad. Meanwhile, one must spread the good news as I intend to do in this short review and as I do

when I address the International Council of the Museum of Modern Art in New York each year. From amongst my fellow members from all over the world I have found a remarkable response to and a wonderment at the extent of the development of modern art throughout this small island.

Anyone revisiting Ireland after a period of twenty-five years would be frankly amazed at the lively upsurge which has taken place in the visual arts, and the interest and enthusiasm which has added a new dimension to the already attractive qualities of life in Ireland. One might question why the visual arts have remained so long a Cinderella. To answer such a question one must briefly recall the background of rural life in Ireland since the population was decimated by the famine in the last century: it is quite easy to envisage how folklore and accumulated historical experience of a poor struggling country dominated our educational system, while at the same time inspiring inherently intelligent Irishmen to express themselves in words, more often than not in their native language as well as in English.

Whilst Irish drama, literature and wit thrived through natural communication during the first half of this century, educational facilities in the visual arts were almost non-existent. Most of the pictures that were hung in the schools or the average home were of a religious nature or perhaps cheap reproductions of an old master. Despite widespread visual 'illiteracy' a quiet but steady evolution emerged during the late 1950s, strangely enough, towards the end of a period of economic depression and emigration. Until then, with the exception of Yeats, any Irish modern artists made their name by going to live abroad, such as Louis le Brocquy, William Scott and sculptor F. E. McWilliam. Thus during the maturing years of our national independence the influence of the visual artist in Ireland on the general public was minimal.

For over a century there have been annual exhibitions at the Royal Hibernian Academy and the Royal Ulster Academy, but these are normally rather a mixed bag of acceptable quality similar to exhibitions elsewhere which sustain conservative followers, many of whom are attracted for social reasons and the safe haven of respectability.

Motivating Influences

Several complementary influences gradually changed attitudes

199

towards modern art in Ireland and helped to mould a section of public taste. The superb technique and surrealistic paintings of Patrick Hennessy and the skill and vigour of Oisin Kelly's realistic sculptures provided an academic link with the annual exhibitions of Irish Living Art. These exhibitions brought a whole new generation of painters and sculptors to the fore including women artists like Mainie Jellet, Evie Hone, Mary Swanzy and Nano Reid who were ahead of their time, and a group of artists from Northern Ireland who really stirred the Irish public into accepting modern art in its proper context – George Campbell, Arthur Armstrong, Basil Blackshaw, Gerald Dillon, Daniel O'Neill, Terry Flanagan, Colin Middleton, Norah McGuinness (originally from Derry). The quality and consistency of their works gradually reassured a doubting public that artistic professionalism and modern art in its varied forms were here to stay. When in 1960 Fr Donal O'Sullivan, a friend of Henry Moore, was appointed Director of our Arts Council he tried to awaken a greater visual consciousness in the Irish people by initiating a new purchasing policy which greatly assisted Irish modern artists. In retrospect I believe the most important artist in formulating a new standard of appreciation through educating one's eye and exercising one's imagination in a quiet subconscious way was Patrick Collins. He is undoubtedly Yeats' successor in interpreting the mystical climate of the Irish scene with gentle truth and vision; however, it has taken almost thirty years for him to earn his rightful place in the history of Irish art.

Two major contributors to this period of Irish modern art were Leo Smith and David Hendriks, whose galleries became the centre of the social art scene in Dublin. Two distinct personalities, they competed with yet complemented each other, both set a high standard of integrity when dealing with their artists and their public and exhibited their artists' work with impeccable care and taste teaching us that presentation in itself is an art. By showing only work of the highest quality they helped to formulate a more discerning appreciation of modern art; we are greatly in their debt for the prestigious promotion of the visual arts in Ireland as we enjoy it today.

In 1966 a major exhibition of kinetic art organized by Cyril Barrett, SJ, and presented by David Hendriks, revealed some of the best work by foreign artists such as Albers, Bury, Calder, Le Parc, Mack, Morellet, Rickey, Riley, Sedgley, Soto and Vasarely. This

coincided with a period of growing affluence in Irish society which helped to make it a commercial proposition to exhibit works by international artists; indeed some of these found their way into Irish collections thus helping to invigorate the perception of artists and viewers alike.

Yet another influence was Basil Goulding, who by sharing his exhilarating relationship with the visual arts acted as a catalyst in drawing factions together. He became founder Chairman of the Contemporary Irish Art Society in 1962, which through members' subscriptions provided the Dublin Municipal Gallery with a representative collection of works by Irish artists during the next twelve years until the Corporation granted its own purchasing fund. Basil Goulding was an avid collector of two young artists, Barrie Cooke and Camille Souter. In 1971 I joined with him in organizing an exhibition of their work called 'Two Deeply'. Both artists have grown in stature and like many of the other artists mentioned in this review, Camille Souter has been honoured by a retrospective. However, we still eagerly await a comprehensive view of the amazing versatility and development of Barrie Cooke. I predict that the variety and virtuosity of his paintings and drawings, together with the extraordinary unique bone sculptures which are made of clay, fired and delicately coloured, will identify Barrie Cooke as Ireland's most outstanding artist over the past twenty-five years.

The Concise History of Irish Art by Bruce Arnold, was published in 1969; it was a sad reflection that this book did not feature in a survey undertaken by the Irish Management Institute on what business people were reading at that time. It was, however, an interesting revelation that the momentum of modern art in Ireland continued despite the evidence of such tunnel vision in the business community and the complete indifference of politicians. This book has just been republished and provides a useful reference together with a new publication on contemporary Irish art by Roderic Knowles.

Other artistic motivators have included James White, the former Director of the Municipal Gallery, then of our National Gallery and current Chairman of our Arts Council; Cecil King the painter, whose personal popularity throughout these years has made him a man for all art seasons; and Anne Cruickshank, former curator of the Ulster Museum and subsequently Professor of Fine Arts at Trinity College Dublin.

The first ROSC (the Poetry of Vision), in 1967 had a startling effect. It was the brainchild of Michael Scott and James Johnson Sweeney. The latter with his worldwide reputation as connoisseur, curator and promoter of international art had the requisite contacts and influence to select an exhibition which was acclaimed as the most comprehensive review of world art of that time. ROSC 67 was stunningly presented at the Royal Dublin Society. The quiet evolution of the fifties and sixties became almost a revolution as the Irish public became exposed to international visual horizons, and all the ideas and concepts which were seeding themselves in the minds of a younger generation of Irish artists got a well-deserved boost.

Sophisticated Irish moderns like Patrick Scott, Cecil King, Michael Farrell and Deborah Brown gained wider appreciation which added to the revitalization of Irish living art in company with Brian King's elegantly composed aluminium wall pieces, Erik van der Grijn's hard-edged realism, Michael Ashur's meticulous cosmic paintings, Brian Burke's narcissistic nudes and turbulent landscapes, Charles Tyrrell's exciting abstracts and the innovative and provocative work of Robert Ballagh. Ballagh was spearheading a new and exciting chapter in Irish art and today enjoys an eminence that is highly respected by critics, artists and collectors alike and has just been honoured by his first mid-term retrospective in Lund, Sweden.

In the early seventies David Hendriks presented exhibitions of Italian artists from Studio Marconi and led the way to an understanding of conceptual art. He showed works by Kounellis, Mario and Marisa Merz, Paolini, Penone and others foremost in this field, together with one of our own artists, James Coleman, who was making a reputation for himself in Milan. This avant-garde exhibition was introduced by renowned Italian art expert and entrepreneur Germano Celant in person. Mention of such a well-known name on the international art scene recalls our own Dorothy Walker, the much-travelled and knowledgeable doyenne of Irish art critics, who was mainly responsible for enticing the World Congress of AICA (Association of International Art Critics) to Dublin in 1980.

Irish sculptors had been finding it difficult to make a living because of insufficient commissions for large-scale outdoor pieces. They gradually attracted support from some financial institutions, particularly the Bank of Ireland, who pioneered such patronage and thereby helped them to gain a market in the homes of collectors on a domestic scale. Edward Delaney with his controversial public

bronzes, John Behan, Michael Bulfin, John Burke in steel, Clifford Rainey, a master of intellectual sculpture in glass, and the stylish sculpture of Michael Warren who was chosen for the 1982 Carnegie International Exhibition in Pittsburgh.

Throughout this period the Trinity College Gallery, fostered by George Dawson, played a significant part in bringing the student population and Dublin citizens along with the modern art movement as well as forming its own collection. The opening of its new Douglas Hyde Gallery has provided a welcome venue for the retrospectives of Irish artists and visiting exhibitions from abroad, notably one of the most comprehensive ever exhibitions of works by Keinholz and 'Mirrors and Windows', the American photography exhibition from MOMA.

The Present

In a divided Ireland the arts continue to be a unifying force because they transcend social status, income levels and political and religious differences. As I have reported, artists from Northern Ireland have played a major part in the evolution of Irish modern art which is exhibited to their advantage on both sides of the border. Although citizens of the United Kingdom they seem to be ignored by the various authorities who select work for exhibitions in Great Britain. For example it was a blatant disappointment that no Northern Ireland artist was included in the Jubilee Exhibition at Burlington House: some of the finest modern art emanates from Northern Ireland.

Fortunately closer co-operation between the Arts Councils each side of the border now flourishes through mutual goodwill. Both are wisely providing increasing incentives to young artists to gain experience abroad, but the shadow of gerentocracy still prevails in the promotion of our contemporary artists. Once this trait is ultimately overcome there will be a more hopeful future for those who look forward to steady self-employment, and to making a professional career of art in a country which is beginning to recognize that an active cultural life must go hand in hand with economic progress and prosperity.

I must point out that the Ulster Museum in Belfast has one of the finest collections of modern art in these islands, from Morris Louis to Bacon, to Gilbert and George. It is the envy of those living in the

Republic who are continually advocating the need for a Gallery of Modern Art to match the prestigious National Gallery in Dublin. The Ulster Museum innovates many exciting exhibitions. Last year the poet Seamus Heaney was invited to select and comment on his personal choice of paintings in the Ulster Museum Collection. The catalogue of this exhibition exemplifies a most fruitful interaction between the poet and the painter.

In the Republic, the Arts Council provides substantial subsidies for the Douglas Hyde and the Project Galleries, as well as for Art Centres throughout the country. A taxation scheme for creative artists was introduced some years ago which has not been of great benefit to the visual artists because so few of them are able to make a full-time living out of their art. However, the more recent introduction of the 'Aosdana' Scheme provides an income for some creative artists which enables them to proceed with their creative life without worrying where the next crust is coming from. The Guinness Peat Aviation Awards for emerging artists also provides funds for artists to pursue their creative career more fully as was recently acknowledged by the talented award-winning sculptor Eilis O'Connell in a television interview.

What of the Future?

Irish artists have never been used to any wealth. Because of this fact we are witnessing how the arts in general can become the sustainers of morale during the difficult times ahead. Whilst everyone must accept a lowering of living standards, there is a growing awareness of the importance of the creative arts in providing a balance between the economic realities and the quality of life which the arts can provide.

The potential in Ireland is limitless and there are many encouraging signs which include the appointment of a new Minister of State for Arts and Culture in the Taoiseach's Department, who has made a positive commitment to do all in his power to foster the arts. The signing of cultural agreements with other members of the EEC should ensure a similar commitment in the promotion of Irish arts abroad; hopefully our legislators will strive for harmonization of VAT rates on works of art throughout the European Community or amend our 'discouraging' disadvantage. The recent relocation of the National College of Art and Design at newly converted premises in Power's old distillery, headed by Noel Sheridan, has engendered a

new wave of optimism because of the improved environment in which students can now work. An increase in the number of commercial galleries is helping to provide more outlets for emerging Irish artists.

On a broader front there has been an impetus from the announcement that the Guinness Group will be the main sponsors of ROSC 84 and are providing the venue in one of their hop stores which; when renovated will have all the spacial and technical facilities for large-scale exhibitions. Credit for this elevating news goes to Pat Murphy, the new Chairman of ROSC, himself a perceptive collector and genuine lover of the visual arts, who has absorbed all the commitment and enthusiasm of his predecessors and is now playing a constructive role in the fulfilment of our hopes for the elevation of the visual arts in Ireland to its proper status nationally and internationally.

We have come a long way from the conservative academic objection to a Henry Moore reclining figure, presented to the Dublin Municipal Gallery over two decades ago, to Nigel Rolfe's naked body performances in flour which have earned contemporary Irish art recognition in the Pompidou Centre!

The challenge is therefore now open to those in authority to co-ordinate this startling upsurge in the visual arts in Ireland by redistributing financial resources available, by promoting more public and private patronage, by foreseeing the vital necessity to plan for adequate housing of the arts and for the promotion of our talented artists abroad to complement the illustrious reputation of our writers, playwrights and poets.

The National Gallery of Ireland

Holman Potterton

Holman Potterton, Director of the National Gallery of Ireland, was formerly Assistant Keeper of the National Gallery in London and is a graduate of Trinity College, Dublin.

The National Gallery of Ireland opened in 1968, nearly a century after the first attempts to open a public picture gallery in Dublin. From a nucleus of 105 paintings which barely filled their august setting, it has grown to over 2,200 works. In addition there is a major collection (about 5,000 items) of drawings and watercolours, over 2,000 engravings and an increasing number of sculptures. Today it attracts tourists from all over the world and school visits from the length of Ireland.

Research for a fully illustrated *Summary Catalogue of Paintings* (published 1981) revealed the good judgement and fortune of earlier Directors, invariably working with limited means and competing against other European museums. Similarly the graphic collection (to be published in a companion summary catalogue this year), has a group of Old Masters and outstanding British/Irish watercolours, which owe much to donors' generosity and perceptive purchases.

Outside, the Gallery has a stern nineteenth century classical facade, with an imposing portico (added 1903) and statuary on the lawn. Here the links between commerce and the arts are highlighted by the adjacent figures of railway magnate William Dargan and the familiar features of George Bernard Shaw. Funds for a museum sprang from Dargan's generosity in subsidizing the 1853 Industrial Exhibition on this site, under a temporary structure. A century later Shaw bequeathed a third part of his future royalties to augment the picture collection. One earnestly hopes for another Mycaenas to appear before the year 2000 when the copyright expires.

Although the building is stone-faced and has decorative plaster-work within, its construction is a major example of Victorian technology, with a cast-iron fireproof frame hidden in the walls. The architect was Captain Fowke of the Royal Engineers, who later designed the Victoria and Albert Museum and the Albert Hall in London. His meticulous drawings even include sketches for heating grills and the striking floor tiles, made at the Minton factory in Staffordshire. From the ground floor, once filled with casts of classical sculptures and patrolled by warden-like attendants, an internal staircase leads to the picture galleries. This works well on plan, but is too steep for an elegant ascent.

Before a Director was even appointed, the Governors had astutely purchased sixteen Italian and French pictures from a Roman dealer, Signor Aducci. His business card promised a complete refund if items were found to be unsatisfactory on arrival, but since the highlights were from the collection of Cardinal Fesch, Napoleon's uncle and a noted connoisseur, they were all retained. Today Fowke's room is dominated by Procaccini's *Apotheosis of St Charles Borrommeo* and two Lanfrancos originally for the Blessed Sacrament chapel of St Paul Outside the Walls. In the former, St Charles floats up to heaven with Counter-Reformation ease while an elegant St Michael holds the devil in check. *The Last Supper* and *The Miracle of the Loaves and Fishes* which flank it rely also on gesture and the impact of life-size figures.

It is indicative of how tastes change that these pictures lay forgotten in the cellars from the later nineteenth century until the 1960s, when they emerged so dark as to be indistinguishable. Cleaning has now revealed the wealth of Seicento painting in Dublin with works by Rosa, Giordano, Dolci and others, added by later acquisitions, to form one of the most important collections outside Italy.

The Italian Renaissance is represented by an almost *trompe l'oeil* Uccello *Virgin and Child* where Christ seems to reach over a (painted) frame, and an exquisite Fra Angelico *Martyrdom of SS. Cosmas and Damian*. Here divine intervention halts their immolation on a burning pyre. From Siena there is a haunting Crucifixion by contemporary Giovanni di Paolo, with finely balanced violence and extreme beauty. In the same room there are good examples of lesser-known contemporaries and a remarkable series of twenty-four Greek and Russian icons, part of an Irish collection, built up over

many years of travel in the Middle East and purchased in 1971.

Dublin boasts no Raphael or Michelangelo, but there is ample compensation in works by every leading Venetian painter of the sixteenth century – Bellini, Titian, Sebastiano, Veronese and Tintoretto. The earliest Grand Tourist painted by Batoni in the eighteenth century was Dublin's 1st Earl of Milltown, displayed alongside portraits of his son and wife, the latter left behind in Ireland to supervise the building of their country house and copied from a miniature. Their entire family collection is now in the Gallery. The finest paintings range from the austerity of Poussin's *Holy Family* to delightful pastels by Rosalba and Roman views by Panini.

The Milltowns commissioned young Joshua Reynolds to record the Anglo-Irish community of Rome in 1751 and he produced a remarkable series of satires, the principal one composed following Raphael's *School of Athens*, but peopled by tourists and *cicerone* rather than the great minds of the classical world. One feels his more formal full-length of the flamboyant Earl of Bellamont, dressed in pink with a plumed headpiece was conceived with a certain tongue in cheek. This hangs in company with fine Gainsboroughs, Hogarths and Wheatleys (often with Irish sitters in the portraits), and two views of Tivoli. These early masterpieces by Wilson belonged to the Earl of Milltown's nephew. The outstanding Elizabethan painting must be Segar's *Earl of Essex*. Politics were unfortunately not conducive to easel painting at that date in Ireland.

George Mulvany, the first Director, was a contemporary of fellow Irish artist Sir Frederick Burton, then Director of the London National Gallery. He laid the foundation of the broad Dutch collection which now fills six rooms with ease. Rembrandt's *Portrait of a Lady* is a reserved formal portrait that may be by a close associate, but the *Rest on the Flight into Egypt* is a masterpiece, a rare night landscape whose dense forest (entirely painted in black and white) contrasts with the glowing light of the central fire. There is also a good selection of artists working in his studio or under his influence in Amsterdam. Landscapes dominate several walls with the golden tones of Cuyp, Both and Berchem recalling Italy; those of Salomon and Jacob Ruisdael are the more familiar Dutch climate. A selection of the innumerable genre and still-life painters lead to Hals' *Fisherboy* holding a still-dripping fish and Stomer's *The Betrayal of Christ* by an artist steeped in the Italian tradition.

From Germany there is an interesting group of portraits by Faber,

Huber, Strigel and Aldegrever. Dating from a time of civil and moral disorder they record with minute detail their owner's possessions and status. Pencz's masterpiece of *Georg Vischer* is a northern equivalent to the frozen images of Bronzino in Florence. A small *Crucifixion* is a Cranach copy of Durer's picture in Dresden, where the landscape has been altered for a different client. His court milieu is shown by *Judith with the Head of Holofernes* where a detached young lady demonstrates the power of women over men.

Spanish painting can be studied from the spiritual world of Nicolas' *St Jerome Translating the Gospels* painted about 1450 to the post-Renaissance world of Picasso's 1913 *Collage*. Navarette, the Spanish Titian, painted *Abraham and the Three Angels* for the Escorial Palace/Monastery near Madrid, after training in Venice. Murillo's *Holy Family* has an immediacy that is now revalued, while Zurbaran's *Immaculate Conception* (literally rediscovered after cleaning in 1980) shows a popular Spanish composition with delicate pastel-like colours. Coello's *Prince Farnese* and Pantoja's *Juana de Salinas* represent the highly detailed formal portraiture of Phillip II's court: Goya's *Conde del Tajo* is observed with deeper penetration. The identity and date of his mysterious *El Sueno* remain unsolved.

Rubens dominates the Flemish Rooms as he did in his time. *The Annunciation* with its sweeping figures and gestures sums up all one Baroque. *Christ in the House of Martha and Mary* is more intimate and very small, especially against the wall-size *Allegory* by Jordaens, inspired by lost street decorations devised by Rubens. A table groans with the surfeit included in Snyder's *A Breakfast* while Van Dyck's *The Red Boy* is no doubt a prince's son. There are no pictures from the birth of Flemish painting in the fifteenth century, but an interesting group from the end of the century when patronage moved from Bruges to Antwerp. David's *Christ Bidding Farewell to the Virgin* is one wing of a lost altarpiece, with no history before being purchased in Waterford. Ijsenbrandt, Pourbus and Van Orley demonstrate the growing penetration of Italian art.

Bernard Shaw's legacy has frequently been used to augment the French collection. From a rare fifteenth century Annunciation by Yverni there are pictures up to the post-Impressionist School in Paris. Claude, Poussin, De la Tour and Rigaud in the seventeenth century and Boucher, Chardin and Fragonard in the eighteenth are but a few of the names. Deavid David's *Funeral of Patroclus* is a student days' masterpiece discovered in France. *Julie Bonaparte and*

Her Children by Baron Gerard stare down with the self-assurance of royalty. A striking Géricault horse and Delacroix's *Demosthenes on the Seashore* are the preparation for a major group of nineteenth century landscapes and subject pictures. Many are part of Sir Alfred Chester Beatty's gift in 1950. It seems he collected these for enjoyment while amassing the incomparable library of manuscripts, books and papyri now also in Dublin. Several of the fine Impressionist pictures were collected by Irish visitors to Paris before they became widely popular.

The Irish collection comprises about a third of the entire number of paintings. Suffice it to say that while there are gaps, it offers the most comprehensive selection of artists working from the late seventeenth century to the present day of any museum. Each year, as with the continental paintings, there are additions and as with all institutions it is only lack of exhibition space that prevents even more from being on show.

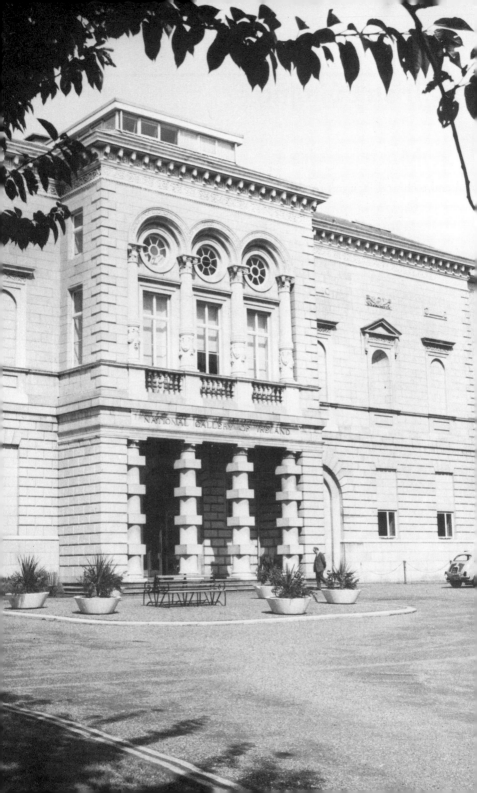

Irish Building

Maurice Craig

Maurice Craig is the foremost authority on Irish buildings and the author of several definitive books on the subject. Formerly Inspector of Ancient Monuments, Ministry of Works, London, he is currently Consultant to An Foras Forbartha, the Irish National Institute for Physical Planning and Construction Research, and a member of the Royal Irish Academy.

It is commonly said, and with truth, that the Irish are a people of the word, or at least of the voice. Song and story, saga and anecdote, satire and wit and, in recent years, the drama, are the forms in which the national genius has traditionally shown itself, not least in taking over and moulding to its own purposes the language of the conqueror: a language, which, greatly to Ireland's advantage, has become one of the three or four major languages of the world. It is also commonly said, and unreflectively accepted, that Irish people are deficient in the visual sense. The proofs of this deficiency are all about us, for anyone to see.

But these proofs, although abundant and distressing, are all of relatively recent date. Anything more than about a century old is more likely to be beautiful than not: well-designed and well-made, however simple; and often the simpler the better.

In part Ireland shares this experience with all industrialized or partly industrialized countries. Putting out of our minds, if we can, the false equation between mere antiquity and beauty, there remains the very real difference between things made by hand and things made by machine. All over Ireland we can be ashamed at the contrast between stone walls of all kinds (from the dry unmortared walls of the west to the subtlest fine-jointed ashlar of Dublin or Cork), and

212

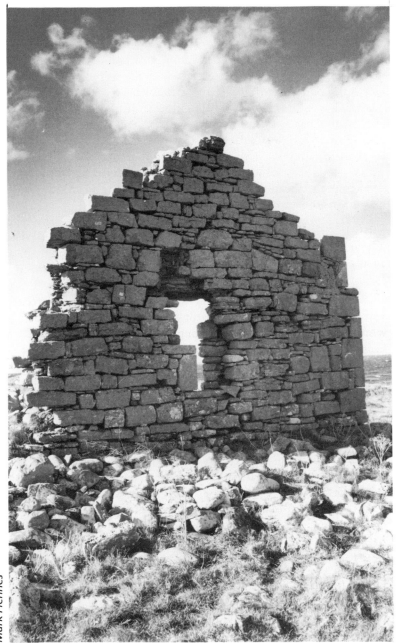

the stepped walls of concrete blocks which are everywhere replacing them. The same goes for the obsessional use of cement, in and out of season. The Irish climate is not flattering to cement. Yet there coexists with the cement-cult a tradition of colour-wash which is much more grateful and in accordance with the latitudes in which we live, as the Norwegians (for example) know very well.

Ireland was never part of the Roman Empire, but adopted Christianity barely more than a century after its adoption by the Empire itself. These two facts go a long way towards explaining the peculiarities of Irish architecture through the centuries. Though almost a founder-member of Christian Europe (in sharp distinction, for example, to Scandinavia) Ireland did not fully absorb the secular institutions of Europe until the seventeenth century.

The earliest surviving Irish Christian churches are unlike anything to be seen elsewhere. Scattered all over the country but surviving best in the extreme western seaboard, and on islands, they are extremely small and extremely simple. They are built of stone, often most ingeniously fitted together. In a few cases they had, and in still fewer still have, roofs of solid stone. Yet it is certain that the first Irish churches were of timber, and reminiscences of timber construction persist in their details.

They stood originally in round enclosures which greatly resembled the forts of the pagan Iron Age, and often were such forts, adapted for ecclesiastical purposes. Besides the tiny churches there were 'bee-hive' cells or clochans (*clocháinn*), seen at their best-preserved in the remote settlement which clings to the side of the Great Skellig out in the Atlantic.

These little churches have a touching beauty in their simplicity. The earliest of them may perhaps be of the seventh or eighth century. By about the year 1000 they began to be accompanied by the Round Towers which are the best-known characteristic class of Irish building. Like the primitive churches, they have an extraordinary subtlety of outline and of texture. In the years preceding the Anglo-Norman invasion of 1169 the Irish romanesque developed, still small in scale and still subtle, but more ambitious in its decorative scope.

All that was a long time ago, and eight centuries now lie between that distant time and ours. What, then, are the characteristic building modes of late twentieth-century Ireland? Quantitatively, at one end of the scale, a rash of small bungalows built for the most part out of popular pattern-books and of non-traditional materials: at the other

end, and especially in urban contexts, a mass of anonymous office-blocks much like those to be found in any other country.

Qualitatively there are a handful of ambitious public buildings which can stand comparison with similar buildings in other countries (and indeed invite comparison by rather obvious references), as well as a rather large number of churches which vary widely in merit. The best of these show a sensitive use of modern materials and constructional techniques, and have enlisted the work of sculptors and other artists to good purpose, and some have succeeded in establishing a relationship to the vernacular tradition, ignored (in both the English and French senses of the word) by most of the others.

As in any country which has recently experienced a period of economic expansion, the older buildings are now outnumbered by the more recent; likewise, the duller buildings outnumber the more interesting. Yet in the field of local-authority housing, some success has been achieved in reconciling quantity and uniformity with humanity – perhaps the most pressing problem which faces modern architects anywhere.

Unlike most other Western European countries, Ireland has hardly any medieval parish churches. In England they are numbered in thousands: in Ireland there are less than a dozen. Even the rather large number of church ruins include few of any great pretension. The best of the survivors is undoubtedly St Nicholas Galway, and there are four or five medieval cathedrals in Dublin, Kilkenny, Limerick, Killaloe and elsewhere. But these would pass unnoticed in England or continental Europe.

Not so with the late-medieval friaries which survive in fair numbers and in a remarkable state of completeness though roofless. Unlike the houses of the mendicant orders in other countries, those of Ireland, and especially in the west of Ireland, are sometimes isolated in the middle of the countryside. From Moyne in Co. Mayo to Muckross in Co. Kerry, by Rosserrily in Galway, Quin and Ennis in Clare, Askeaton and Adare in Limerick, they are the fifteenth-century foundations or re-foundations of Gaelic or Gaelicized Norman families whom the Irish resurgence of that time had temporarily brought to the top of the pile. With their tall slender towers, many-gabled silhouettes and small secretive cloisters (at Muckross entirely filled by one enormous yew-tree) they have a strong family resemblance. Some of them contain fine stone carved tombs of benefactors

Stone, and more particularly limestone, is the keynote of Irish architecture. Though at various times in the past, and in the present, Irish people have lived in houses made of other materials, everything ancient that has survived in the country is made of stone: Not for us the timber-framed farmsteads of the North German plain, the 'picturesque' parts of Bavaria or Switzerland, or the 'black-and-white' counties of England such as Cheshire and Hereford. A taste for architecture in Ireland is rarely a taste for architecture alone: amalgam of archaeology, topography, limestone, lime-wash and dark green foliage: the 'abounding foliage moistened with the dew' of Yeats.

Which brings us to the culture of the country house. On the strength of the literary evidence, Frank O'Connor assures us that 'in their dank and smoky castles, the Irish and Anglo-Irish aristocracy [between 1200 and 1700] lived a life that fundamentally differed little from the life that went on in the castles of the Loire'. However that may be, the outward forms were very different. The vertical tower-

Marino Casino

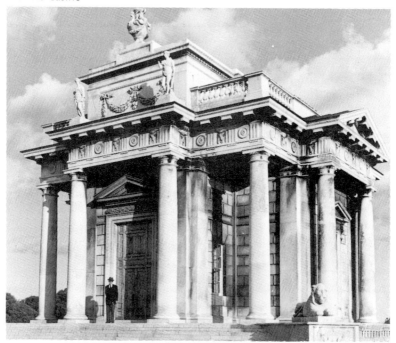

216

houses (which is what is meant by 'castles' from about 1450 to about 1650) were the country houses of their day, built and lived in by Gael and Gaelicized Norman. To this day they are the most common type of standing antiquity in the countryside and are especially plentiful in the south and west. They were defensible and only moderately comfortable, though perhaps not quite so uncomfortable as we are apt to think.

Their replacement from about 1660 onwards by the equally square-cut, but less vertical, classical type of house coincided with the downfall of the older aristocracy and their supersession by planters, adventurers and Cromwellians. But even if the land had not changed hands there is no reason to suppose that the architecture would have been appreciably different, for the craftsmen were the same plain people of Ireland, and the geology and the climate, those two major determinants of a country's architecture, did not change.

Masterpieces are few, but those few outstanding: the old Parliament House in Dublin, the two Castletowns, one in Kildare and one in South Kinkenny, the Casino at Clontarf, the Custom House and the Four Courts in Dublin, Castle Coole in Co. Fermanagh. The architect of the first was at least partly Irish, the two Castletowns were, most unusually, both designed by Italians, Chambers, of the Casino, never came to Ireland, Gandon settled in Ireland and made his whole career here. To these may be added the early eighteenth-century library of Trinity College Dublin, whose designer Thomas Burgh was a Co. Kildare gentleman, and which, surprisingly perhaps for so small a country, is one of the largest in Europe for its time. Though architects of Irish birth came increasingly to the fore in the nineteenth century, the general tendency, here as elsewhere, was towards increasing standardization and assimilation, helped on by those doubtful boons, easier travel and a periodical press.

Georgian Dublin – A Future?

Harold Clarke

Harold Clarke, who in his position as managing director of Eason's Advertising, is one of the most influential and respected figures in the Irish book world, is also hailed as an expert on Georgian Dublin. He lives in one of the city's most famous examples of Georgian architecture and is the author of a number of publications including the definitive Georgian Dublin.

The Declaration of Amsterdam which was signed by all the Ministers of the Council of Europe (including Ireland) at the Congress of Amsterdam says some very grandiose things:

> Apart from its priceless cultural value, Europe's architectural heritage gives to her people the consciousness of their common history and common future. Its preservation is, therefore, a matter of vital importance.
>
> Since these treasures are the joint possession of all the peoples of Europe they have a joint responsibility to protect them
>
> The legislative and adminstrative measures required should be strengthened and made more effective in all countries.

Europe we need you. Now.

Architectural Heritage Year has come and gone. Ireland's greatest inheritance in buildings is just a little more imperilled, the developers have 'allowed' a few more roofs to lose their slates; the bulldozers have been busy. At a meeting of Dublin City Council earlier this year a group of enthusiasts who have dedicated themselves, with no assistance from the public purse, to saving one of the most beautiful Georgian streets in Dublin were dismissed by one of the councillors

as 'the gin and tonic brigade'. So much for the *special responsibility* of local authorities which Amsterdam envisaged. But Georgian Dublin is of much more than *priceless cultural value*; it is a great economic asset. From the time the tourists arrive in mid-March until the last one shivers home in early October they flock through the eighteenth-century areas of the city, clutching the latest Georgian guide. Ireland has an architectural heritage which is the envy of many countries. Also, as *Urbana*, a recently published report from *An Taisce* – the National Trust for Ireland – pointed out, conservation avoids waste.

The Public Buildings

The great public buildings of Georgian Dublin are not in danger. In fact Gandon's two great masterpieces on the north banks of the Liffey, the Custom House and the Four Courts were faithfully restored by the Dublin government following 'The Troubles'. Gandon's other gem, the King's Inns, is lovingly cared for at the end of Henrietta St., the most beautiful street in the capital. The Incorporated Law Society have now refurbished Thomas Ivory's Bluecoat School. Leinster House, formerly the Duke of Leinster's town house, and the City Hall are well and truly used as centres of the nation's and the city's administration. The hospitals such as St Patrick's (founded by Dean Swift), Dr Steeven's and the Rotunda are too important to be threatened. The churches of the period are reasonably secure, and although not world-class they are superbly proportioned and frequently sited to close a vista, as in the case of St George's and St Stephen's. They are often more interesting externally than internally, as it has taken 150 years for the Oxford Movement to have any influence in the Church of Ireland. Many of the large Catholic churches built around the time of Emancipation in 1829 have suffered from liturgical arrangements for which they were not designed. The buildings of Trinity College and the Royal College of Surgeons are immaculately maintained.

Georgian Houses

The unique Irish inheritance however is not in the great public buildings, nor in the gracious stately homes, but in the Georgian terraces and squares which are a notable survival of domestic building at one of its high points in history. The ordered discipline of Dublin's

great streets is largely due to the benign influence of the Wide Streets' Commissioners who were Europe's first planning authority. The particular attractiveness is the soft brick which was used for building, unlike the harsher stone of some other eighteenth-century cities. The style and superb plasterwork are evidence of the affluence and peace of the last quarter of the century when Ireland had its own parliament. Their decline came with the ending of that parliament in 1800. These houses, like all great architecture in every age and every country, were built on privilege, but they were to become the setting of a great deal of Irish history for almost 200 years. In this century the writings of O'Casey and Behan brought the life in eighteenth-century Dublin houses to the English-speaking world and beyond.

The terraced houses were built as town houses for landed families to use when they visited the capital for 'the season' or when attending Grattan's parliament. After the Act of Union, when the country was ruled from across the Irish Sea, many of the homes lost their justification; but a number remained in the hands of the original families too poor or too patriotic to move to London. Sir Walter Scott wrote to the novelist Maria Edgeworth at this time:

> Dublin is splendid beyond my expectations. I can go round its walls and number its palaces until I am grilled almost into a fever. They tell me the city is desolate (as a result of the Union) of which I can see no appearance, but the deprivation caused by the retreat of the most noble and opulent inhabitants must be felt in a manner a stranger cannot conceive.

As the landed families moved out, most houses were taken over by the middle and professional classes. But many had degenerated to tenements before the nineteenth century ended.

Economic conditions in Dublin in the century following the Act of Union did not, as in other cities, demand the replacement of private houses in the city centre by industrial and commercial buildings. The lack of development was a high price for the country to pay, but as a result the heart of Dublin has private houses used for the purpose for which they were built. In the Fitzwilliam Square area many were occupied by doctors and their families using the ground floor front parlour as a surgery and the dining-room behind as a waiting-room. This was a highly practical use leaving adequate space in the rest of the house for a family home. But the doctors' families have now in

most cases moved to the suburbs while the surgeries remain and the top floors have become flats or offices.

The Future

There is no doubt that a great deal of lip-service is paid to the Georgian inheritance in Ireland – the difficulty is in getting people to preserve the past rather than imitate it. Dublin is in danger of becoming a panorama of pastiche, as planners insist that buildings have mock-Georgian fronts, with glazing bars (almost invariably too heavy), and fibreglass doorcases. Suburbs are planted with neo-Georgian villages of houses which are neither eighteenth-nor twentieth-century.

An eleventh-hour campaign is urgently required if what remains of these gracious squares and streets are to be saved. Had it not been for the trojan work of Desmond and Mariga Guinness in refounding the Irish Georgian Society in the 1950s it might already be too late. But it requires a death-bed conversion of national and local government; followed by a concerted effort to help, support and encourage private individuals who are prepared to undertake preservation or restoration.

The Problems

Listing in Dublin is haphazard and eccentric. Interiors are excluded so that fronts which are reproduced with relative ease are preserved, while the plasterwork, staircases and other details which are irre-placeable are not. List 1 in the Development Plan contains many buildings of little significance and omits houses and streets of considerable merit. The Corporation's adherence to its own rules is ambivalent, and as property-owners they have allowed listed houses to deteriorate beyond repair.

Dublin has never really come to terms with the motor car, and parking is a nightmare for drivers and for those who live in the city where streets are turned into perpetual car parks. It is not a smokeless city so the combination of chimney smoke and exhaust fumes consti-tutes a real disincentive to centre-city living.

There is no financial support for restoration, in fact quite the contrary. When domestic rates applied, a restored house was liable to have its valuation considerably increased. The last Finance Act did

create a category of Heritage Houses which allowed the cost of repairs to be deducted from income before tax, but the requirement that the public should be given access would not be practical in all cases.

There are two quite separate problems in the city, north and south of the Liffey. On the north side comparatively few of the once enormous stock of eighteenth-century houses remain, most having succumbed to neglect, poverty and poor maintenance. An imaginative government would have taken over the superb Mountjoy Square while it was still possible, and designated it an embassy area, diverting all missions which sought premises in the capital to these houses that would be eminently suitable for the purpose. The whole square could be given unified police protection rather than the pockets of security which are now scattered all over the city. This solution would still be possible for Henrietta Street which is a cul-de-sac with large mansions, some of great distinction. The rest of the north side has suffered from a slow decline which set in when the Earl of Kildare commissioned Cassels to build his town house on the south side. Fashion followed him, and later business also. There has never been any evidence of a public policy to reverse this trend and until this happens the decline of the north side will continue.

On the other hand the Georgian area south of the Liffey suffers from all the problems of affluence. Rising site values have tempted many developers to look with disfavour on the uneconomic use of space in thirteen-foot-high rooms and generous stairwells. In the last two decades over seventy houses in streets containing buildings on List 1 have been lost.

For those who seek inspiration, it is not far away in cultural or in geographical terms. In Edinburgh the decline of the unique eighteenth-century New Town has been halted and conservation has been encouraged. Dublin still has time to follow, but not much.

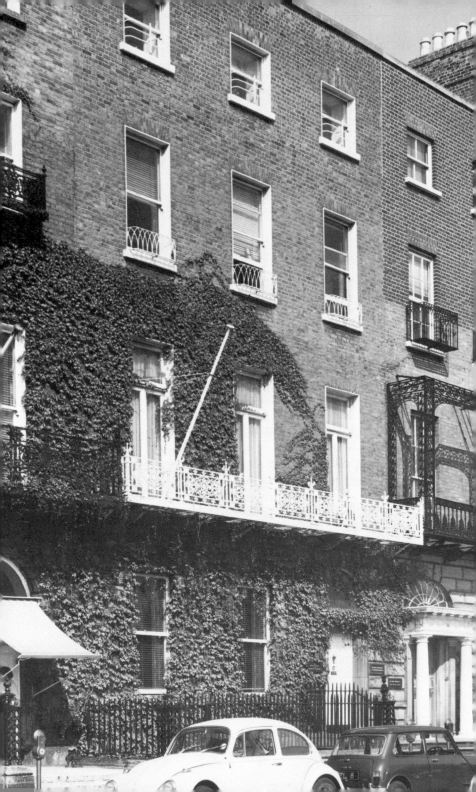

Aspects of Irish Applied Art in the Eighteenth Century

Mairead Reynolds

Mairead Reynolds is an expert with the Irish National Museum, specializing in art, ceramics and glassware.

To Irish people brought up on a past in which historical highlights were famine, military subjugation, political dictation and land penury, a national inferiority complex came easily. To many such people Gaelic culture was that of the glorious days from about 2000 B.C. when Ireland exported finely-wrought gold ornaments to Britain, Scandinavia and even Greece. It was that culture which about 600 A.D. attracted British and French scholars to Irish schools at a time when her churches owned superbly-crafted metalwork like the Ardagh Chalice. It was that culture which suffered a death-blow when Ireland's leaders were dispossessed of their lands by planters in the sixteenth and seventeenth centuries. Without patronage the Gaelic cultural system was weakened and bards and poets became farm labourers. Memory of such a cultural past remained in the minds and hearts of a proud people, many of whom lived in humble circumstances and most of whom were dependent on agriculturally-based occupations. To members of the Celtic Revival Movement of the nineteenth century and to many Irish people today that culture survives only in the better aspects of Irish folk culture.

Yet the dichotomy of Ireland's society can be seen in that there was another equally strong although younger Irish culture which was based on wealth, urban attitudes, an awareness of international fashions as well as a strong inheritance from that old Gaelic culture. This society, however, did not sympathize with the inferiority complex of the depressed people. Even from the time of Dean Swift

they protested their Irishness while they espoused international symbols of wealth and status – black lacquer cabinets and hand-painted porcelain services from China, chintz from India and Italian silks. This society was composed of a motley group of Irish, Anglo-Irish and immigrants particularly from Holland, France, England and Scotland. It included farmers, merchants, bankers, silversmiths, glass-blowers, silver-plate and tin-makers, pewterers, furniture-makers, silk and ribbon weavers etc. etc. Their principal market was the indigenous population of reasonably comfortable families but many also depended on the export market. The home market, however, was not inconsiderable as by 1730 Dublin had a population of about 150,000 making it second only to London in these islands in city-size and in importance.

Irish families aspired to owning the best – either imported or made locally to contemporary international fashions. Such items were 'provincial' not in the sense of inferior craftwork, but in the sense that the workers sometimes followed established styles rather than leading them. Yet in times of prosperity in Ireland these workers led fashions particularly in glass and textiles. This was the case in the mid-to late eighteenth century when Irish craftworkers developed distinctive designs; when they catered to international demands for their high-quality products; when their designs were adopted and adapted by other countries and when Irish craftworkers won acclaim in international circles.

All of these criteria are met in Ireland's glass industry of the late eighteenth and early nineteenth centuries. When Britain crippled her own glass industry with punitive taxes in 1777 and again in 1781, many of her glass-blowers fled to Ireland, established glass factories here or supplemented already existing ones.

At that time cut design on glass was usually rather simple in wide shallow diamonds or simple hollow flutes and facet-cutting. Ireland's contribution was to introduce a wide variety of motifs to the glass-cutter's repertoire, producing profusely cut glass. This rich cutting was done particularly on tableware – drinking glasses, plates, bowls and containers, and on lighting equipment – candlesticks, chandeliers, hall-lamps and table-lights – items which could make maximum use of the beautiful play of soft candlelight on the various cut surfaces. Later this style of richly cut glass was adopted by glass-houses in the USA, France, Bohemia and Britain.

These brightly cut Irish flint glass items were in demand not only at

home but also in Canada, the USA, the West Indies, France, Spain, Portugal and Britain. Although these factories could be small – as some like the famous Waterford factory employed only about seventy people – yet they developed not only original cutting styles but also new shapes. For example one of the most successful items developed was the distinctive Irish wall mirror which is oval in shape and the rim of which is decorated with faceted glass studs. These studs in blue, green, opaque and clear glass on a gold-leaf backing were placed in one or two rows around the rim edge. A chandelier was hung in front of them on occasions. The whole ensemble was hung at shoulder height and the light from the few beeswax candles was magnified by the mirror. An extra bonus was the play of candlelight on the various cut and coloured surfaces.

Irish glass-workers added their own shapes to many other items such as large fruit/salad bowls and their diminutive versions for salt which were made in attractive boat-shaped round bowls with turn-over rim. Strong richly cut water jugs and distinctively shaped decanters were other important items in Irish glass factories.

Another ware which was sold to Germany, Spain, Portugal and the West Indies was delftware produced at Henry Delamain's pottery in the World's End, Dublin between 1753 and 1757. The importance of Delamain's delftware was not just in the quality of the tin-glazed earthenware but principally in the high standard of painting which was done by the talented young artists who were trained in the drawing school of the Dublin Society. Their work enjoyed a considerable contemporary reputation internationally. Indeed these artists, trained in pattern drawing for industrial application, made major contributions to other aspects of the applied art scene. For example the beauty and originality of the designs in Irish printed linen/cotton fabrics was due to them.

Ireland's claim to excellence in ceramic painting was further enhanced by the work of Irish artist Jefferyes Hammet O'Neale (1734–1801) who developed a unique style of ceramic painting which ignored the then fashionable Chinese, Japanese and floral designs. He decorated Chelsea and Worcester porcelains in strong colours using scenes from Aesop's fables and animals in dramatic landscape scenes. It has been suggested that those landscapes bear a resemblance to O'Neale's native landscape in the Glens of Antrim. He had a number of imitators in his own day but more importantly it could be said that he established a new attitude to ceramic decoration.

Like Jefferyes Hamett O'Neale, other Irish artists and craftworkers were in demand in factories in other countries and many of them made major contributions to the development of their craft. For example it is now accepted that it was John Brookes (*c.* 1710–56) an engraver from Cork Hill, Dublin who invented the system of transfer-printing from paper to enamel or porcelain. This invention was revolutionary since it allowed fast, inexpensive and uniform decoration, yet Brookes had difficulty in having his patent accepted until he became manager of the Battersea enamel works in 1753. Indeed Brookes was extremely hard done by, as ceramic historians have only acknowledged his achievement relatively recently.

Brookes' pupil in engraving, Thomas Frye (1710–62) was another Irish artist who won fame through ceramics. He moved to London and there abandoned his profession temporarily so as to experiment with ceramic pastes at the Bowe glassworks in East London. In 1748 he patented his first porcelain which was all the more exceptional as he added bone ash to the porcelain mix and produced an embryonic bone china. This discovery was of major importance since bone ash gave porcelain a plasticity which ensured less failures in the kiln and allowed potteries in these islands to compete with the more heavily subsidized potteries in Europe. Frye's porcelain mix was not improved upon until the end of the eighteenth century when another hybrid bone porcelain was mass-produced.

Another Irish invention, about 1752, was a system whereby copper plates were used instead of wood blocks to print textiles. This copper-plate printing heralded a new and glorious era in textile decoration because it allowed complicated and fine designs on linen or on linen/cotton mixtures. So successful was this invention by the proprietors of the Drumcondra (Dublin) works, Francis Nixon and Theophilus Thompson, that a contemporary recorded that 'the Manufacture grew into such immediate Repute that the Proprietors were prevailed on, by large Sums, to transfer the manufacture to another Kingdom'. In that way the glory of the discovery was for long given to another nation.

Apart from linen the other fabric usually identified with Ireland is poplin, a fabric of silk warp and usually worsted weft. As it was woven with the silk outermost it had an attractive appearance but the worsted ensured strength and durability. So attractive was this fabric in all its various designs that it was in demand by the royalty and aristocrats of Europe from at least the early eighteenth century.

Indeed even in the late nineteenth century Irish periodicals boasted that every royal house of Europe was furnished with poplin from 'the looms of the Liberties of Dublin'.

I have confined myself here to looking briefly at some aspects of the Irish applied art field in the eighteenth century. This restriction is necessary as each specialist trade, and there were indeed many of them, contributed to the development of its own art. Taking just a few examples we can see that Irish silversmiths developed spool-shaped dish-rings so as to raise bowls of hot food off the polished surface of dining-tables, a practical device which was quickly adopted by English and other silversmiths. Dublin stocking weavers, it is said, invented the 'tuck pressers' which allowed the mass-production of patterned hose about 1740. This, a commercial success, was adopted immediately by Nottingham hosiers. The standard of design and craftsmanship in Ireland was extremely high too. For example, the furniture trade produced a variety of work

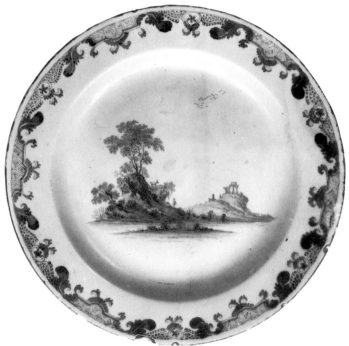

Charger, delftware painted in blue by Peter Shee and made in Henry Delamain's factory, Dublin, about 1752. *National Museum, Dublin.*

varying from exquisitely refined mahogany tea-tables in which the beauty lies in elegantly sinuous lines and refined decoration, to ornamental and functional side-tables with bizarre-masks and naturalistically carved paw feet.

In a sense Ireland has been badly served by recorders over the centuries. They were not helped, though, by the fact that the inferiority complex mentioned above encouraged too many successful workers to pretend association with wealthier nations. Because of this historians have often glibly accepted superficial attributions.

Cotton printed in purple and signed on the pillar base, 'Robinson, Balls Bridge' (Dublin), lage eighteenth century. *Mairead Reynolds*

Ice Pail, glass, made probably in Dublin about 1800–1810. The shape of this cut and moulded glass is based on the Irish piggin, a stave-built long-handled drinking vessel. *National Museum, Dublin*

Fruit bowl, boat-shaped, probably Cork, about 1790. *National Museum, Dublin*

Two plates, tin-glazed earthenware, made by John Stritch, Limerick, 1761. *National Museum, Dublin*

Fruit bowl with turn-over lip, Irish, about 1790. *National Museum, Dublin*

Contemporary Crafts

Justin Keating

Justin Keating, broadcaster and veterinarian is a former Minister for Industry and Commerce and Chairman of the Crafts Council of Ireland.

'History,' says Weston La Barre, 'is something to be recovered from.' Especially in Ireland, one might add. But in the sphere of the crafts, our inheritance is an advantage. There was a very early but tiny beginning to the process that in the neighbouring island of Britain quickly became the Industrial Revolution, and which made her, for centuries, the most exciting and powerful place in the world. Here there was little or no coal, the charcoal ran out, and the rise of English industry inhibited a similar Irish development. Over much of Ireland the landlord system only came to an end around the turn of the century, and a capital-starved peasant proprietorship was rapidly born.

In all these circumstances the craft persisted to a remarkable degree, and when the new State came into existence sixty years ago, the extent to which traditional skills were still normally practised, especially in rural areas, was much greater than in more prosperous countries, where industrial manufacture and the retail distribution system were more advanced.

The new State however was not interested. The whole thrust of our cultural preoccupations was verbal. Remarkable playwrights, novelists, poets, a great focus on the Irish language and on traditional music and song, but concern with material culture was slight. The brightest children of the new proprietors of small farms were busy making money in the retail trade, primarily drink, and their grand-children were rushing to become doctors, lawyers and priests. Their ideal of a beautiful house was a 'desirable bungalow residence' the type that would have been at home in Cheltenham or Croydon. They furnished this in the style of the British mass-produced furniture and

textiles of the time, either imported directly or copied here. There was no 'William Morris' strand in the national revolution. The thirties, forties and fifties were a time of terrible pious petty bourgeois respectability; for the craftsman and the artist, a period of disaster.

In this mass of vulgarity there were few beacons. The Royal Dublin Society had always been interested in manual skills, in training people to do things well, rather than talking about them well.

A certain weaving and knitting tradition persisted as a result in part of the work of the congested District Board and its enlightened staff.

And the Irish Countrywomen's Association, godchild of the enlightened vision of Sir Horace Plunkett, was toiling throughout the whole countryside. To all, it must at times have seemed hopeless. The middle fifties, as for so many other things in Ireland, was the low point. And then, slowly, improvements began.

The Kilkenny Design Workshops were established in 1963. The Folk Park at Bunratty, even if it has some inadequacies, has the great merits of existing and growing. In 1971 the Crafts Council was formed. All these were external manifestations of a deeper change. The traditional craft workers began to find a new respect for what they did, their markets stopped shrinking and even began to grow a little. Indefatigable people like Fr McDyer in Glencolmkille and Patsy Duignan in Strokestown began to see the crafts as part of the movement of rural renewal, but the State and its organs remained persistently indifferent. It was only in 1976 that the Crafts Council received its first State grant; and still the immense and priceless National Museum collection of folk objects awaits a home. It is not displayed to the public and it continues to deteriorate from lack of proper care. (The bright spot is the superb Ulster Folk Museum, just outside Belfast.) The National College of Art and Design, after a period of travail became in the seventies a happier and more successful place, and all over the country the teaching of various sorts of craft skills increased.

The new breed of artist-craftsman was compounded of indigenous Irish, trained here or overseas, and craft workers from many European countries who came to settle and work here, bringing welcome skills and attitudes. Production was scattered all over the country, with the highest concentration in Co. Cork. As always with dispersed rural production, marketing is a problem. Craft shops have grown remarkably in the last twenty years. The Kilkenny shops, first

in Kilkenny itself, and then in Dublin, have been a bench mark of quality and good taste. And in the Cork Craftworkers' Shop the craft workers themselves have marketed their wonderful products excellently, all of consistently high quality.

The first National Crafts Fair, aimed not at the public but at buyers, domestic and overseas, was held in 1977 and did £50,000 worth of business from thirty-four stalls. This year, from 205 stall-holders, business was just over two million pounds, and that in the middle of a deep recession, with many exhibitors gravely dissatisfied.

The various State agencies charged with the promotion of the economy now understand the importance of crafts very well, economically and culturally, cooperating admirably.

Bord Failte, the National Tourist Board, has produced an excellent guide to craft workers and craft shops. The Industrial Development Authority has been involved in the setting up of craft workshops in many parts of the country, and local authorities have co-operated in establishing such innovative new developments as Kilworth Craft Workshops in Co. Cork and Grennan Mill in Co. Kilkenny. An-Co the Industrial Training Board, SFADC, and Udaras na Gaeltachta are all now supportive and interested; and while compared to manufacturing industry employment in the crafts will never be enormous, the annual value of production is now reckoned to exceed twenty million pounds and is rising rapidly.

A number of events mark the coming of age of the Irish Crafts Movement. At last there is a major and scholarly book worthy of the subject-matter. *Ireland's Traditional Crafts*, edited by David Shaw-Smith and published by Thames and Hudson is due to appear. It is comprehensive, admirably illustrated and among many leading experts contains three articles by Dr Kevin Danaher who has been one of the great scholars of the crafts area. In September of this year the Crafts Council of Ireland is host to the European Region of the World Crafts Council in a major conference which will bring many of Europe's most distinguished artists/craftsmen here. Preparation for this inevitably involves a review of what exists, strengths and weaknesses. Of course standards are uneven, and judgments subjective, but I believe that the visitors will find a level of work much higher than they expected, showing immense vitality and very rapid progress.

If I list certain areas it is simply a reflection of my own preferences. I think that the range and quality of ceramic work is absolutely

extraordinary, and the same is true in textiles and weaving. Only now is the beauty of Irish traditional vernacular furniture being recognized, and the revival of work in willow, rush and straw is exciting too.

The vitality and creativity within the crafts movement inevitably brings to the forefront problems of taste and of aesthetics. There has been much in our tradition of pastiche Book of Kells. The great Celtic tradition is there, and it is remarkable, but it ceased to have any living reality a very long time ago. Pastiche is not interesting, either Celtic or Scandinavian. Our tradition is not rectilinear or stark. It seems to me that we have the beginnings of an indigenous style, based on our old traditional crafts.

We were always exuberant about colours and forms, and that sets us apart from North European models. The great houses and the landlords were not interested, so the crafts are based on a poorer, simpler, use-dominated tradition which is surely a strength.

I believe that we are in the course of forging a new style which is relaxed enough to make room for all our traditions, which is simple and direct and honest and lets the material speak, but which also shows the exuberance and courage and ornament which are such features of our verbal art.

In a culture-shocked society, we used to use words to try to make reality go away, or to change reality magically without working. Notwithstanding the urbanization and alienation of modern society, in the course of building a new State we are coming to possess our material culture again, we are coming to re-create our environment, we are coming again into full possession of ourselves.

It is this element, the affirmation of a new control over our own lives, which makes Irish craft so vital and so vigorous.

Publishing in Ireland Today

Liam Miller

*Liam Miller is one of Ireland's foremost
publishers, and spokesperson for the Irish
Publishers' Association.*

Ireland is a land of two traditions. In literature the older, Gaelic
tradition can be traced back, as a living force, to the earliest times in
our recorded history. Epic tales of great power, often couched in
language of inspired beauty, which have their origins in a culture
older than Rome's still arouse admiration even though their
transmission almost to our own day did not depend on the
technology of the printer. Passed down the centuries, this old Irish
literature was served first by the *seanachie*, the storyteller, and later
by the scribe.

Ireland's second cultural heritage, which today would be called
'the Anglo-Irish tradition' can be traced down the turbulent course
of our island's history to the coming of the Normans some eight
centuries ago, in 1169, an event which was followed by a claim of the
British to sovereignty over Ireland – a claim bolstered by the writings
of the Welsh monk, Gerald, whose *History and Topography of
Ireland*, compiled about the year 1200, might be dubbed the first
Anglo-Irish book. From that date the split in Irish tradition widened,
even though English was not for some hundreds of years the common
language of the conquerors. Indeed the Statute passed at Kilkenny in
1366 decreeing the official use of English and banning Irish was
composed in Norman French – the conquerors had become 'more
Irish than the Irish themselves'.

The old Irish culture was preserved mainly away from the towns
and cities which were, after all, chiefly Norman foundations. The
hereditary bardic families continued to relate the old tales and
chronicle the Irish past and their repertory was written down in folio

books which were treasured by the ancient families. The imposition of the craft of the printer in the sixteenth century did not have any effect on this process, which carried on right into the nineteenth century. But the growth of Dublin as a commercial centre in the eighteenth century led to the development of a large publishing industry which profited by its freedom from England's copyright restrictions, producing unlicensed reprints of English best sellers as soon as copies could be had via the Holyhead packet boat and delivered to the waiting compositors in Dublin.

However, before the 1830s little of this print increase reflected any nationalist viewpoint. The Anglo-Irish contribution to the development of English literature and the profitability of English publishing was enormous, and continues so today. Certain writers, notably Swift and Berkeley in eighteenth-century Ireland, published attacks on the abuse of Ireland, but without any great effect. However, from the Act of Union of 1800 a nationally-minded press gradually developed in Ireland, despite severe opposition and by the 1830s was a force to be reckoned with. The influential *Nation* newspaper of the following decade was only part of a growing Irish publishing industry which included both popular works and scholarly editions of the old Irish literature edited by such learned men as John O'Donovan, George Petris and other members of the Royal Irish Academy, while the poets of the national movement, among them Davis, Mangan and Ferguson, were the spiritual ancestors of Yeats and Hyde and the other creators of the Irish Renaissance at the end of the century. From that early flowering the imprints of Duffy and Gill are still figuring in Ireland's publishing scene today.

The twentieth century saw a second revival in Irish publishing, mainly through the house of Maunsel, later Maunsel and Roberts of Dublin who issued a list of international quality including Yeats, George Moore, Lady Gregory, Padraic Colum, introduced Synge to the world and almost succeeded in publishing *Dubliners* by James Joyce. The changing circumstances, economic and political of the 1920s and 1930s had an adverse influence on Ireland's tiny publishing industry and more and more of the best writers had to seek publication in the major centres, London and New York, to earn their living. The introduction of the restrictive Censorship Act in 1929 spelled the death knell of effective Irish publishing for three decades.

Since the 1950s a new revival in Irish publishing has taken place, one which promises to last and which seems to have grown in strength contrary to the trend in larger centres over the past ten years of a decline. At first a couple of small literary presses produced new work from Ireland which claimed notice in international reviews, and led to a growing awareness of writers that being published from an Irish house did not necessarily bear the disadvantage it had some years before. The economic growth of the country during the 1960s probably had something to do with the encouragement of the movement, without seeing any financial input into the infant industry. But by the late sixties a few publishers were going to the Frankfurt International Book Fair to show their books.

By 1970 Irish publishing had acquired enough confidence to form its trade association, the Irish Book Publishers' Association, known as CLE from the initials of its name in Irish, reflecting the numbers of its members who publish exclusively in Irish. The purpose behind CLE was to achieve better recognition for Irish publishing both at home and abroad. The yearly presence at Frankfurt was developed as a national stand, which over the years has become a centre of attention. From the beginning CLE has mounted promotions both in Ireland and abroad. The introduction of Value Added Tax on books led to representations to the Revenue Commissioners to plead the case – a plea unheard at the time, but perhaps an opening of the case for later consideration.

In International Book Year 1972, the influential *Times Literary Supplement* published a special issue on Irish Writing, which included a survey of publishing. By then membership of CLE had grown from the seven founder firms to eighteen, of which four published exclusively in Irish. The Association has continued to grow so that in its recently published *Directory of the Irish Book Trade* (CLE, Dublin, 1983, £15 to non-members), the hundred or so separate imprints identified as Irish reflect graphically a phenomenal growth in this small industry.

This growth must, in the greater part, be attributed to support from the home market. Books from Irish houses seem to have a growing appeal to the book-buyers, perhaps because the subject-matter can be more local in its appeal than books which have to appeal to a non-Irish readership as well. Economic factors have also a big influence. Since the Irish currency has broken from parity with sterling conversion of London prices has been in favour of the Irish

published book and, in the past year, the rerating of the Value Added Tax on books to a zero rate has had a large influence on book sales in Ireland.

The Irish publishing industry is still small enough to have room for all its member firms. There is little of the trade rivalry which characterizes the industry in larger bases. Nor is there bidding for the international 'best-seller'. Each house is largely specialist in its interests, some in local history, some in fiction, poetry, drama, educational work, statistical and business affairs, religion, and so on. And there are still areas where development is possible, reflecting aspects of Irish life, among them farming and food, little dealt with in Irish lists as yet.

The strength in Irish publishing is, as ever, its literary content. More and more Irish writers have been attracted back to publish their new work from Irish houses and this in turn gives added bargaining power to the Irish publishers in placing their books internationally, as co-editions with English-language publishers, or sold as translation rights. The Arts Council has assisted the process with its help to creative writing and, of recent years has made direct grants to publishers available to assist with the publication of specific titles. A more general form of funding to publishers is, I understand, to be developed in the near future.

Ironically the creation of Ireland as a tax haven for many international best-selling authors has caused little input into Irish publishing. The tax-free resident writers who benefit by this bounty may be precluded by their contractual arrangements from giving rights to Irish publishers in any worldwide way but surely, in co-operation with the big publishers abroad, Irish publishing could benefit largely by servicing the home market with some of the best-sellers generated by these writers.

Co-operation with publishers abroad seems to be the key to the continuing growth in Irish links with world publishing. A recent example of this is the co-operative arrangement between Ar-len House, the Irish women's press, with Marion Boyars in London which has resulted in some Irish fiction from new writers being widely noticed, and has helped the revival, from an Irish base, of the novels of Kate O'Brien. More and more new fiction from Ireland is finding outlets in London and New York with occasional translations into German, Dutch, Swedish and other languages.

The growth of Irish publishing has been greatly helped by the Irish

Ireland and the arts

newspap̶e̶r̶s̶. ̶E̶a̶c̶h̶ ̶o̶f̶ ̶t̶h̶e̶ ̶t̶h̶r̶e̶e̶ ̶D̶u̶b̶l̶i̶n̶-̶b̶a̶s̶e̶d̶ ̶d̶a̶i̶l̶y̶ ̶p̶a̶p̶e̶r̶s̶ devotes at least a page each week to book reviews, with similar space allocated by the Cork daily paper and two of the national Sunday papers. While Irish publishers compete for attention with the many submissions from English houses, the local interest of the books usually achieves notice. The national radio and television services are also generous with the space allocated to books, with a major review programme, 'Folio', weekly on television. *Books Ireland*, a monthly devoted to news and reviews of Irish books, edited by Bernard Share and published by Jeremy Addis has a good readership both in Ireland and abroad and is in its seventh year. One national daily, the *Irish Press* has a weekly page of New Irish Writing, which, edited by David Marcus, has over the fifteen years since it started introduced many of the best new writers to the publishing scene. David Marcus is also a director of the Poolbeg Press, one of the paperback houses which specializes in fiction, while the other main paperback list, Mercier Press, Cork-based, has an extensive list firmly rooted in Irish traditional culture.